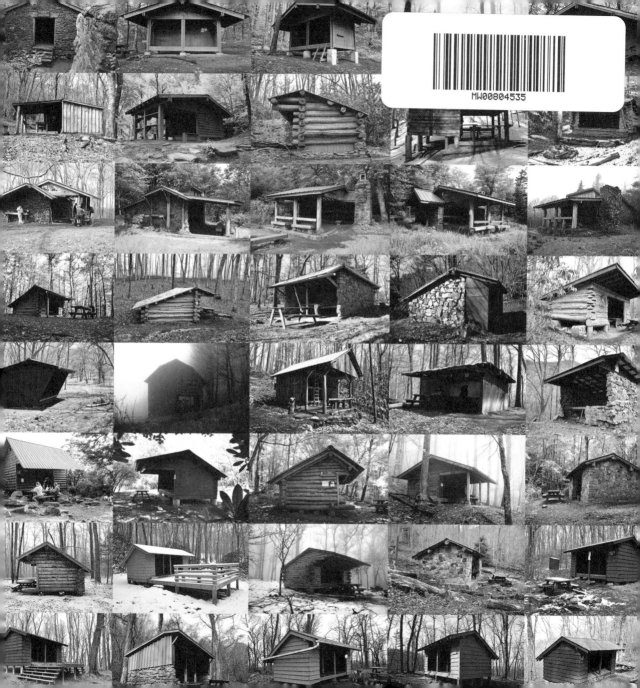

THE
APPALACHIAN TRAIL
BACKCOUNTRY SHELTERS, LEAN-TOS, AND HUTS

THE
APPALACHIAN TRAIL
BACKCOUNTRY SHELTERS, LEAN-TOS, AND HUTS

Sarah Jones Decker

RIZZOLI
NEW YORK

New York · Paris · London · Milan

First published in the United States of America in 2020 by
Rizzoli International Publications, Inc.
300 Park Avenue South
New York, NY 10010
www.rizzoliusa.com

Disclaimer: This book is a historical document of the shelters that existed on or near the Appalachian Trail in 2018–2019. The trail is always evolving, with reroutes and trail maintenance happening year-round. Even the total distance changes by minor reroutes and closures every year. New shelters will be built and some of the old classics may eventually be torn down.

There is a lot of information (some outdated, some incorrect) about shelter facts and figures. For example, a build date for a shelter could be recorded as when it was started, when it was completed, or when it was dedicated. The information included here has been fact checked with the Appalachian Trail Conservancy and the trail clubs who maintain these shelters.

It has been an honor to photograph and document these structures for the first time in one place. I have confirmed the information enclosed in this book to my best knowledge and efforts. I hope it can be a valuable resource for years to come.

Appalachian Trail Conservancy
P. O. Box 807
Harpers Ferry, WV 25425

Publisher: Charles Miers
Associate Publisher: James Muschett
Managing Editor: Lynn Scrabis
Editor: Candice Fehrman
Design: Lori S. Malkin
Endpapers: Sarah Jones Decker, Give Me Shelter Poster

Printed in China

2020 2021 2022 2023 / 10 9 8 7 6 5 4 3 2 1

ISBN: 978-0-8478-6772-1
Library of Congress Catalog Control Number: 2019950385

Visit us online:
Facebook.com/RizzoliNewYork Instagram.com/RizzoliBooks Youtube.com/user/RizzoliNY
Twitter: @Rizzoli_Books Pinterest.com/RizzoliBooks Issuu.com/Rizzoli

CONTENTS

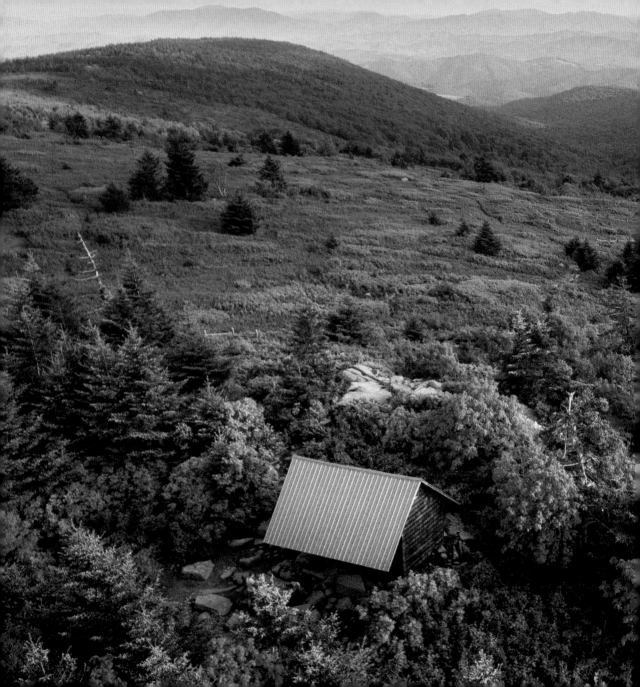

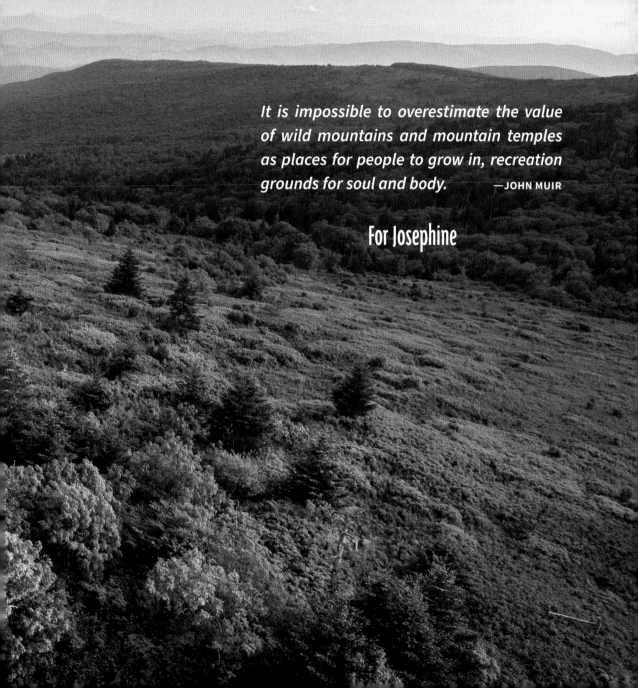

It is impossible to overestimate the value of wild mountains and mountain temples as places for people to grow in, recreation grounds for soul and body. —JOHN MUIR

For Josephine

INTRODUCTION

I was 16 the first time I spent the night on the Appalachian Trail (AT). I stayed at the famous Lakes of the Clouds Hut in the White Mountains of New Hampshire—far from a simple lean-to. My 71-year-old grandpa, Clint Jones, showed me the ropes of above-tree-line hiking in the Presidential Range. A B-26 navigator in Korea and an adventurer at heart, he had taken all of his children, my young father included, and some of his grandchildren up and over those rocky peaks for decades.

The iconic hut system run by the Appalachian Mountain Club (AMC) predates the completion of the AT. The AMC, founded in 1876, opened Madison Spring Hut in 1888 and hired a "care-keeper" for the hut. This role evolved into hutmaster and, eventually, into the multiperson crews (referred to as "croos") that are still in use today. Some of the AMC huts are right along the trail corridor and can be an epic experience for hikers. At Lakes of the Clouds, the AT passes directly in front of the large stone hut that rests on the edge of a rocky ridge at 5,125 feet. The trail continues to climb its way up to Mount Washington and the famous observatory at 6,288 feet. The king of the Presidential Range, Mount Washington is the highest point in both New Hampshire and the Northeast. It is world renowned for its extreme weather. The observatory

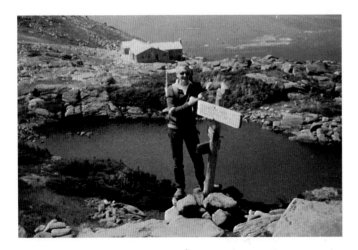

LEFT: My hiking inspiration, Grandpa Jones, is pictured on one of his many family hikes in the 1970s.

RIGHT: This is the iconic view upon leaving Lakes of the Clouds Hut in New Hampshire.

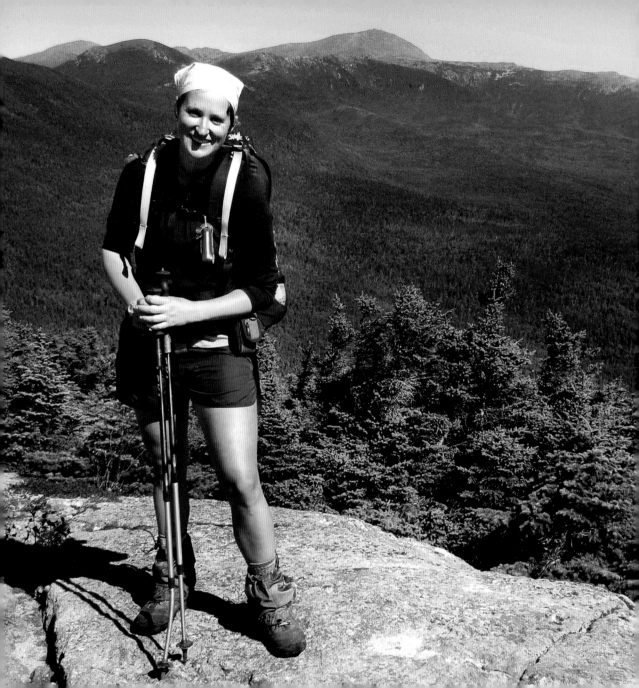

LEFT: This photo was taken on my 2008 thru-hike of the AT. Mount Washington is in the distance.

RIGHT: The original refuge near Mount Washington, built in 1901, was located higher than the current Lakes of the Clouds Hut.

BOTTOM: Lakes of the Clouds Hut is closed to visitors in the late fall and winter months. It is open self service in May and full-service from early June to mid-September.

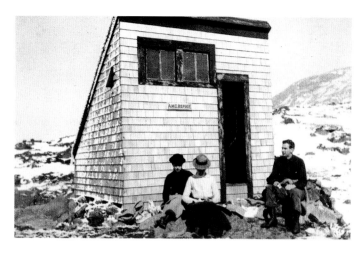

has recorded snow every month of the year and experienced one of the highest wind gusts ever recorded at 231 miles per hour. With stats like these, an enclosed shelter high up on the ridge can be the difference between life and death.

The original refuge structure, built in 1901, was a small shelter constructed in response to the deaths of two hikers caught in a storm on their way to an AMC meeting on the summit. However, the structure was very small and situated higher than the lakes—not where the AMC hut was built just

below the two lakes in 1915. The current hut has been expanded a number of times since its original construction.

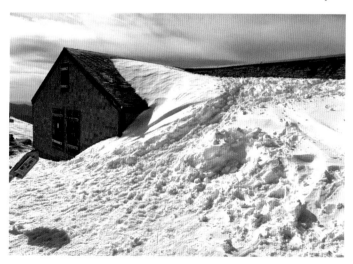

More than just a dry roof over weary travelers, the shelters along the iconic AT provide a gathering place and a sense of community on America's most famous foot-path. Dotted an average of every eight miles along the 2,192-mile route, more than 270 backcoun-try shelters have welcomed hikers

on a first-come, first-served basis since the beginning of the trail's inception and eventual completion in 1937.

The Appalachian Trail Conservancy defines the term *shelter*, sometimes referred to as a lean-to, as a "three-sided structure, with or without bunks or floors, intended as overnight housing for hikers." The term *shelter* on the AT can also include enclosed structures, unlocked cabins, and the AMC hut system in the Whites. Built, maintained, and preserved with thousands of hours by dedicated trail clubs, ridgerunners, and volunteers, shelters have always been and continue to be an integral part of the trail experience.

The basic three-walled structure with one open side and an overhanging roof is a consistent design, but each shelter is unique and its construction method varies from state to state and region to region. Some are built with stone, some with wooden boards or planks, and others with logs—either downed nearby or sometimes brought in by helicopter. Many sit directly on the AT, while others are located down a spur or side trail, ranging from a few yards to more than a mile. Most hikers—even thru-hikers, who hike the trail in its entirety—won't see every shelter because all of the side trails would add more than 65 miles to the already 2,190-mile journey.

Some shelters have sleeping lofts, multiple stories, wooden bunks, or platforms; some have large front porches; and a rare few even have solar showers or the possibility of having a pizza delivered. Most shelters have a picnic table and a privy and are typically near a reliable water source.

The shelters can get a bad rap for many valid reasons that definitely ruin a shelter experience—loud snorers, loud people, loud mice, etc. Depending on the time of year, hikers could have the place to themselves, or multiple hikers could be sleeping pad to sleeping pad with people they just met. Even if you don't stay at a shelter, it is still part of the trail experience. It would be impossible to hike the entire AT and not at least walk by a shelter. You might just stop for lunch, sign the trail register, use the privy, gather water at a confirmed source, and move on. A shelter can also be used as a meeting point or a mental mileage point for the day.

There are many other options for sleeping on the trail. Hikers carry tents, tarps, and hammocks, and there are hotels and hostels located off the trail. Most shelters have established camp-

My hiking gear is hung up for the night at Gentian Pond Shelter in New Hampshire.

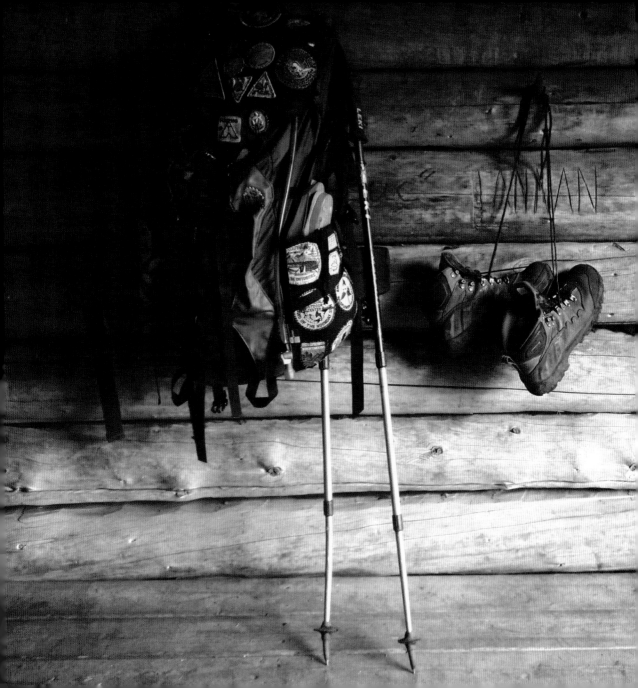

sites nearby, and some have raised wooden platforms, tent pads, and group camping areas. These sites and shelter locations help keep the impact on the forest and surrounding areas to a minimum. There are also established campsites along the trail to help spread out the overnight traffic. Different camping regulations exist along the trail, so hikers should research information for the section they plan to hike before making camp for the night.

The majority of AT shelters sleep an average of six or eight hikers. Lakes of the Clouds is the largest, highest, and most-visited hut in the White Mountains. Sometimes it is called "Lakes of the Crowds" because of its huge size. Today, it can sleep 90 people a night in several bunkrooms and house a hut staff of eight. Due to the extreme weather in the area, the basement of the hut also contains a cement bunkroom known as The Dungeon, which never closes.

This is me and my hiking buddy, Josephine, at Springer Mountain, Georgia. I carried her and my camera equipment for more than 350 miles in eight states.

My grandpa and I arrived at the hut on a sunny August afternoon, but heavy snow started falling outside that night. We were welcomed with a warm, dry place to stay in the bunkrooms and a budding camaraderie with hikers of all ages from around the world. After eating a delicious dinner cooked by the croo, my grandpa and I perused the large collection of journals stacked on a shelf. I couldn't believe it when we saw my nine-year-old dad's signature scribbled in the fading pages. I felt like a time traveler. Countless droves of hikers have found solace within these stone walls for more than 100 years. It's hard not to feel the immense history of a place like that.

We met a towering hiker named "Lorax," a gentle, bearded traveler who was on his way to finishing the whole trail from Georgia to Maine. He was the first thru-hiker I had ever met. Months

later, he sent me his summit photo of Katahdin from when he finished. And, just like that, I was hooked. Eleven years later, in 2008, I thru-hiked from Georgia to Maine myself with my friend Kris "Scout" Powers after we both finished graduate school. My grandparents helped with all of our food mail drops and were connected with us for our entire trip.

When we passed Lakes of the Clouds on that trip, as late-in-the-season hikers in September, the hut was silent and shuttered for the season. We had the mountain to ourselves and stayed in the dank Dungeon while we listened to the wind howl outside. That night, we were able to get a call out from a small flip phone to my grandpa, then in his 80s. I described to him the sunset that was slowly setting in front of us, warming the hut and the surrounding lakes with deep yellows and oranges in the cold mountain silence. It was like he was there on top of the world with us, sharing two totally different experiences together in the same special place.

No two hikers have the exact same AT adventure, even if they travel the whole trail side by side. The same could be said of shelter experiences. Severe weather, seasonal challenges, and an ever-changing cast of characters are all factors for a unique experience at these structures that wait silently in the woods for their next visitors.

Those shelters contain more stories than could ever be written in one book. Back on the trail for my 10-year "trailsversary," I set out to photograph and document these structures as a time capsule of the AT as it stood in 2018–2019. The trail is constantly changing. During this two-year project, two shelters were removed and two were closed. Inevitably, new shelters will be built and old ones will be torn down. Presenting all of these structures together for the first time in one book, the small, sometimes subtle differences in shelter styles found between the states, trail clubs, time periods of construction, locations, and materials are more apparent.

It was fantastic being back out on the trail. I rehiked hundreds of miles in all 14 states with my husband, family, and friends. For more than 350 miles, I carried all my camera equipment and my nine-month-old daughter, Josephine. She even took her first steps as a one-year-old on the AT in Pennsylvania. Being out there with her is an experience I will treasure forever. It was truly an honor to put all of this information in one place and share it with the trail community I love so much. I hope this collection of images rekindles your own stories and inspires you to get out and create new ones.

Sarah Jones Decker, "Harvest," GA–ME '08, '18–19

SHELTER HISTORY

THE VISION

I n 1921, a simple idea for a continuous footpath along the spine of the ancient Appalachian Mountains was born. American forester and conservationist Benton MacKaye envisioned developing a trail that would allow people to revitalize themselves and escape the mechanisms of modern society. This vision would eventually become the famous AT, which millions of people a year continue to enjoy almost 100 years later.

MacKaye's original proposal argued for the creation of "shelter camps" that would place trail shelters, commonly referred to as lean-tos at the time, at easy walking distances from one another. They would be used as congenial places for volunteers and hikers to gather near water sources. The purpose of a shelter was and continues to be a means of concentrating impact; providing a dry place to stop for a break or stay for the night; and, when used effectively, creating social experiences.

The AT shelter system was inspired by many of its trail predecessors, like the three-sided lean-tos in the Adirondack Mountains in New York, the cabins and shelters on the Long Trail in Vermont, the chain of Dartmouth Outing Club ski cabins, and the Appalachian Mountain Club (AMC) hut system in New Hampshire. Inspired by the high-mountain huts in the Swiss Alps, the AMC huts—the oldest hut-to-hut system in the United States—have been hosting travelers for more than 125 years with exceptional off-the-grid service.

At the 1937 meeting of the Appalachian Trail Conference (ATC), Chairman Myron Avery announced (a few months prematurely) that the AT was complete through 14 states from Mount Oglethorpe in Georgia to Katahdin in Maine. Ed Ballard, an AMC member and the NPS program manager, successfully proposed that, after more than a decade of labor to build the trail, it was time for clubs to concentrate their efforts on preserving the established route and starting the construction

of a continuous chain of trail shelters. At the time, fewer than 100 shelters, cabins, and huts existed along the entire length of the trail. In order to have a complete system of shelters located at convenient intervals, trail clubs would have the immense task of building more than 200 new shelters.

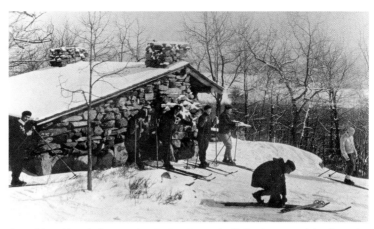

One of the oldest shelters on the AT, West Mountain Shelter in New York has hosted a variety of guests since 1928.

Avery already had a great deal of experience with the building of trailside shelters. In addition to being ATC chairman, he was also the president of the Potomac Appalachian Trail Club (PATC) at the time. By 1937, the club had built 28 lean-tos and cabins along its stretch of the trail in Virginia, Maryland, and Pennsylvania.

The majority of the early shelters were open to any hiker, but it was expected that primarily long-distance hikers would use them. Some shelters at the time had to be reserved and paid for in advance. Avery and MacKaye had significantly different views about the nature of the AT, but they shared a vision of the shelters as central to the form the trail finally took.

THE BUILDING

In 1938, the National Park Service (NPS) published guidelines authored by architect Albert Good on the proper types of structures that should be built in the national park system. The NPS description of the lean-to design read, "In New York State the Adirondack shelter is a tradition, a survival of the primitive shelter of the earliest woodsmen and hunters of this region. The end and rear walls are tightly built of logs, the front is open to the friendly warmth and light of the campfire. The roof slopes gently to the rear and sharply to the front to give a protective overhang."

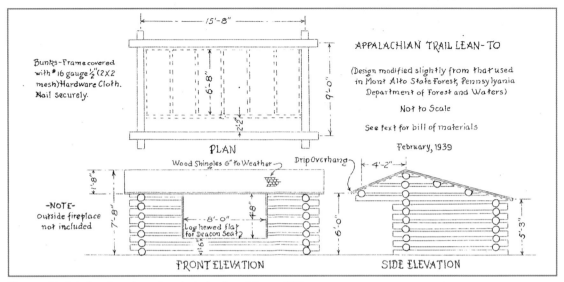

These archival shelter plans show a lean-to design from February 1939.

Leaders of the Civilian Conservation Corps (CCC) also used these guidelines for the shelters they built during the building boom of the 1930s. The CCC, a public work-relief program, was a major part of President Franklin D. Roosevelt's New Deal. Providing unskilled manual labor jobs to three million unemployed, unmarried young men (ages 18 to 25, and eventually expanded to 17 to 28), the CCC operated from 1933 to 1942. The CCC crews lived in strictly supervised camps run by the military and worked long, hard hours to earn their pay—$30 a month, plus $25 sent home to their families. After work, many men attended classes covering basic reading and writing as well as vocational training for marketable trades. The CCC aided in the conservation and development of natural resources on rural lands owned by federal, state, and local governments and left a continuing imprint on the nation's parks, forests, historic sites, and other public lands.

The CCC set strict building requirements that greatly limited where the crews could construct the shelters. For example, work could only take place within a 30-minute drive of existing CCC camps. Of the 36 AT shelters built by the CCC, only a few—like Blood Mountain in Georgia, Cold Spring in North Carolina, and Manassas Gap in Virginia—survive today.

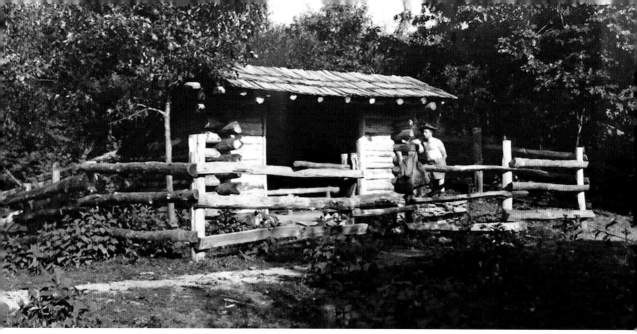

This 1940 image of Walnut Mountain Shelter in North Carolina shows an example of the stock fences that were common around early shelters located on grazing lands.

In 1939, the ATC issued its own shelter construction guidelines to its member clubs. These early guidelines also followed the classic design of the Adirondack shelter, described as a three-walled structure with a steeply sloping roof and a stone fireplace for heat. The goal was to place shelters approximately 10 miles apart because, "such spacing avoids undue exertion for travelers carrying heavy packs and yet permits 'skipping' a lean-to by more strenuously inclined travelers for their day's journey." These structures were to be built as close to a water source and the trail as possible and provide a privy and trash pit.

The early shelters were built from stone or a mix of stone and logs. The original Adirondack-style shelters were built directly on the ground with dirt floors, and almost all had wire-frame cots with canvas covers. Some had internal fireplaces, but most had semicircular fire pits located at the front of the structure to provide light and warmth inside. Some older shelters, like many in Shenandoah National Park, still have these semicircular fire pits. Because many early

shelters were located on private land often used for agriculture, most had stock fences in place to keep grazing animals out.

Local trail clubs constructed many of the early shelters and also collaborated with the CCC and state and federal park and forest services. There was a preexisting process for obtaining permission to build a structure in national and state forests and parks, but much of the trail passed through private property. Trail clubs therefore had to negotiate leases and easements with landowners along the trail corridor to make the shelter system a reality.

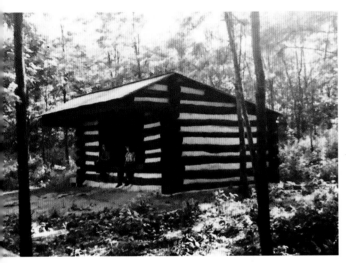

Mosby Shelter in Virginia, shown here in 1939, was "stolen" in 1980, presumably for its prized chestnut logs. Hikers arrived to find the shelter had been dismantled and removed without permission. It was never recovered.

Many early shelters, including most of the CCC structures, were built using the dead trunks of the great American chestnut trees. By the late 1920s, chestnut blight—a fungal disease accidentally imported to the United States from Asia—began decimating the American chestnut population. First detected in 1904, it spread quickly along the East Coast. Billions of mature chestnut trees were eliminated by the 1950s. Because so many trees succumbed to the disease, there was an abundance of available wood at shelter-building sites. The older chestnut shelters that still stand today owe much of their longevity to the strength and insect resistance of those chestnut logs.

The prized chestnut logs are believed to be the motive behind the disappearance of a shelter in Virginia in 1980. Built by the CCC in 1939, Mosby Shelter has the unique title of being the only shelter to be "stolen" from the AT. Hikers arrived at the site to find the shelter had been taken apart and removed, and rangers couldn't find any sign of it or its thieves. Mosby Campsite, south of Manassas Gap, is now located where the shelter once stood.

Early construction efforts had builders cutting and peeling logs on-site at makeshift lumber-yards and then building the shelter in place. Otherwise, materials had to be brought in by vehicle or mules or carried in on foot by trail volunteers. In remote locations, materials and equipment would have to be hauled in for miles. Some shelters, such as Plumorchard Gap in Georgia and the remote Speck Pond in Maine's Mahoosuc Range, required materials to be brought in by helicopter. Prefabricated pieces were built off-site, which allowed for quicker assembly in the backcountry. The United States Forest Service (USFS) wooden-plank design, still common in Virginia and parts of Vermont, became popular because the lighter building materials eased the process of bringing supplies to the shelter site and did not require the specialized knowledge of building techniques used to construct log shelters.

By the end of 1939, there were 129 shelters recorded along the trail corridor. New Hampshire and Vermont had the most shelters completed; many of them had been built by the AMC and Green Mountain Club before the AT was even started. South of the Pennsylvania line, there were only 29 total shelters.

When the United States entered World War II, the effects were felt in every corner of the country—even along the AT. As the nation's attention became focused on the global war, the CCC closed so its men could join the military or work in war production, and the trail ultimately fell into disrepair. Gas shortages and available man-hours across the country resulted in little to no trail maintenance done by any of the trail clubs during that time. For example, the Carolina Mountain Club noted that it stopped meeting altogether between 1943 and 1946. During the war, members of the PATC—many of which were female—took the lead in maintaining the AT in the club's section. Members pooled gas-ration coupons and spent them for weekend work trips to continue efforts to maintain the Shenandoah section of the AT, as well as its side trails.

After the war, the main efforts of the trail clubs were directed at reopening the trail. Not many shelters were built during the immediate postwar period. The trail itself was not considered complete again until 1951, and the ATC could not officially claim the continuous chain of shelters was complete until the early 1960s. Trail visionary Avery never saw the completion of this chain; he died in 1952.

After the initial push to build shelters in the 1930s, there was another surge in shelter construction during the 1950s and 1960s. Use of the shelters soared in the 1970s with the onset of the

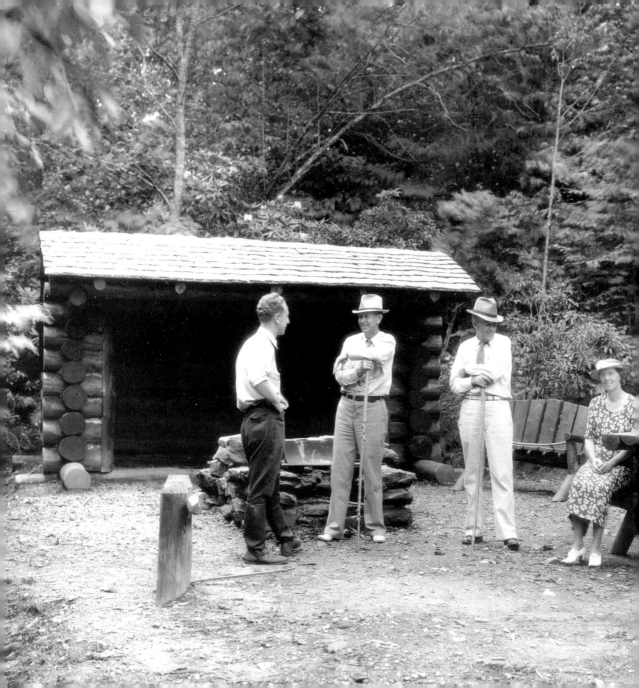

backpacking boom. There are fewer than 60 shelters in use today that were built before 1950. The biggest concentrations of shelters still in use were built between 1980 and 1999, and fewer than 35 new shelters have been built in the last 20 years.

THE EVOLUTION

The AT continues to evolve constantly, with the ATC (now known as the Appalachian Trail Conservancy) estimating that nearly the entire trail has been rebuilt or relocated since its initial completion in 1937. Over the decades, shelters have evolved from simple dirt floor lean-tos to a wide variety of designs, materials, and building styles. Many shelters have come and gone, with some having been dismantled, burned, or removed for various reasons, such as reroutes, increased bear activity, being too close to the road, or because they had fallen into disrepair or were no longer needed. Unfortunately, a few—like Ore Hill Shelter in New Hampshire and one of the double shelters located at Toms Run in Pennsylvania— were burned down by users and not rebuilt. Tucker-Johnson Shelter in Vermont, located just a quarter mile from the AT on the Long Trail, is one of the newest shelters along the trail corridor. It was rebuilt in 2018 after a hiker built a fire inside the original one in 2011.

Some locations, like Tray Mountain in Georgia, have had their shelters built and rebuilt over the years. The CCC built the first shelter on Tray Mountain in 1934; the USFS built

Hikers enjoy a break at the now-removed Deep Gap Shelter in North Carolina.

the second in 1960 and moved it back to the original location in 1971. The current shelter was moved back to the top of the hill near the site of the original one. While many shelters are simply torn down, sometimes trail clubs use the salvaged materials toward new shelter construction. Calf Mountain Shelter in Virginia was built, in part, out of remains of Riprap and Sawmill Run Shelters, both of which had been dismantled due to overuse. Cove Mountain Shelter in Pennsylvania was built with timbers salvaged from a barn, with some beams dating more than 100 years old.

In 1968, ensuring the future protection of the AT and other trails, Congress passed the National Trails System Act, which provided for the acquisition of land along the trail corridor. This began the major shift of the trail from private properties onto federally purchased and protected public lands. After federalization, many shelters vanished and countless others became landlocked by private land, cancelled easements, and trail reroutes.

With the backpacking boom of the 1960s and 1970s, the number of day and overnight hikers grew. When the shelter system was created, the early visionaries of the trail could never have imagined so many people would one day be using it. Many shelters, including some built by the CCC, were located too close to roads and became party locations for non-hikers. Litter and vandalism were also becoming problems along the trail in the early 1970s, and, at the time, trash barrels were still located at many shelters. Some had areas where hikers would burn their trash on-site. Piles of trash were being left behind, and the overuse of some of the popular shelters was taking its toll.

These growing problems led the ATC to start a conversation with its members about the future of the shelters, up to and including the possibility of removing the shelter system altogether. They surveyed trail clubs and eventually the general membership and asked for pros and cons of keeping the shelters. The decision to keep them was definitely not unanimous, but ultimately the shelters survived.

During that same decade, the shelter system in Shenandoah National Park was closed for almost nine years. Shelters were only to be used in an emergency, and a ranger could issue fines to hikers found sleeping in them in non-emergency situations. The decision to close the shelters was made by the superintendent of the park, who saw them as party locations, not necessities. After years of lobbying by the PATC, the shelters in the park were finally reopened to hikers in 1979 and 1980.

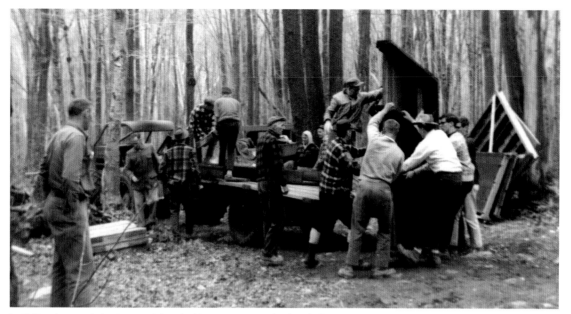
In 1965, volunteers bring in materials to build George W. Outerbridge Shelter in Pennsylvania.

The many problems occurring at these sites resulted in the decision to remove a number of the shelters. The first to be torn down or removed were those located close to a road or on private land. Some shelters were relocated or built farther in the backcountry to make them less accessible to non-hikers. During the 1970s, as many as 60 shelters were either torn down or relocated. Two shelters have been removed as recently as 2019. Watauga Lake Shelter in Tennessee, built in 1980, was removed due to increased bear activity, and Antietam Shelter in Pennsylvania was dismantled and rebuilt as a display in nearby Cowans Gap State Park after housing hikers since 1940.

Despite the many inherent challenges of maintaining a shelter system along a 2,190-mile route through 14 states, AT shelters continue to embody MacKaye's and Avery's vision of stopping points for hikers and gathering places for volunteers. More than just structures sitting in the woods, these shelters exist as places where people can gather, rest, make friends, and find refuge from the elements.

AT SHELTERS AT A GLANCE

Total distance: 2,192 miles

Number of official shelters recognized by the ATC: 276

Highest elevation:
Roan High Knob Shelter, North Carolina, 6,285 feet

Lowest elevation:
Ten Mile River Shelter, Connecticut, 290 feet

State with the most shelters:
Virginia, 63

State with the fewest shelters:
West Virginia, 0

Trail club that maintains the most shelters:
Appalachian Mountain Club (in five states), 37

Smallest shelters (sleep 4):
McQueens Knob Shelter, Tennessee (emergency use only);
Toms Run Shelter, Pennsylvania

Largest hut (sleeps 90):
Lakes of the Clouds Hut, New Hampshire

Largest (non-hut) shelter (sleeps 24):
Fontana Dam, North Carolina

Average number of sleepers: 6 or 8

Average distance between shelters:
8 to 10 miles

Shortest distance between shelters:
0.1 miles, between The Hemlocks and Glen Brook Shelters, Massachusetts

Farthest distance between shelters:
32.2 miles, between West Mountain and RPH Shelters, New York

Oldest hut:
Carter Notch Hut, New Hampshire, built in 1904

Oldest (non-hut) shelters: Fingerboard Shelter and West Mountain Shelter, New York, built in 1928

Newest shelters:
Nahmakanta Stream Lean-to, Maine, built in 2017, and Tucker-Johnson Shelter, Vermont, built in 2018 (located 0.4 miles from the AT on the Long Trail)

Harpers Creek Shelter, Virginia

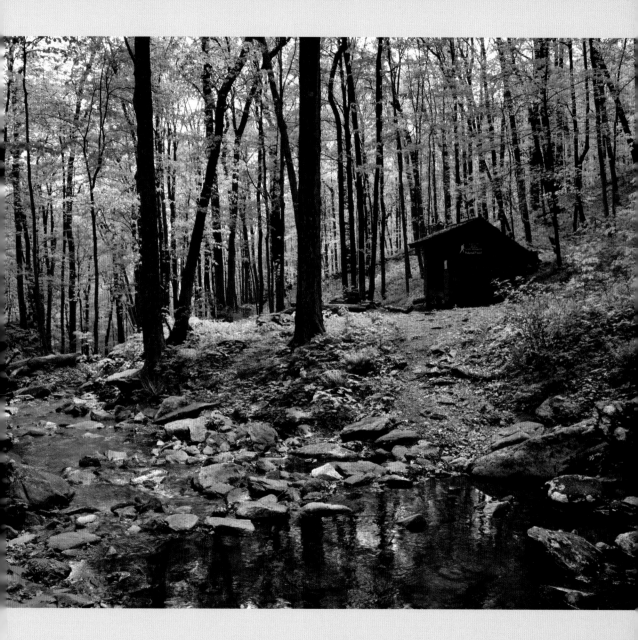

TRAIL CLUBS (in order from Georgia to Maine)

GATC •	Georgia Appalachian Trail Club	georgia-atclub.org
NHC •	Nantahala Hiking Club	nantahalahikingclub.org
SMHC •	Smoky Mountains Hiking Club	smhclub.org
CMC •	Carolina Mountain Club	carolinamountainclub.org
TEHCC •	Tennessee Eastman Hiking and Canoeing Club	tehcc.org
MRATC •	Mount Rogers Appalachian Trail Club	mratc.org
PATH •	Piedmont Appalachian Trail Hikers	path-at.org
OCVT •	Outdoor Club at Virginia Tech	outdoor.org.vt.edu
RATC •	Roanoke Appalachian Trail Club	ratc.org
NBATC •	Natural Bridge Appalachian Trail Club	nbatc.org
TATC •	Tidewater Appalachian Trail Club	tidewateratc.com
ODATC •	Old Dominion Appalachian Trail Club	odatc.net
PATC •	Potomac Appalachian Trail Club	patc.net
MCM •	Mountain Club of Maryland	mcomd.org
CVATC •	Cumberland Valley Appalachian Trail Club	cvatclub.org
KTA •	Keystone Trails Association	kta-hike.org
YHC •	York Hiking Club	yorkhikingclub.com
SATC •	Susquehanna Appalachian Trail Club	satc-hike.org
AHC •	Allentown Hiking Club	allentownhikingclub.org
BMECC •	Blue Mountain Eagle Climbing Club	bmecc.org
AMC-DVC •	Appalachian Mountain Club Delaware Valley Chapter	amcdv.org
BATONA •	Batona Hiking Club	batona.wildapricot.org
WTC •	Wilmington Trail Club	wilmingtontrailclub.org
NYNJTC •	New York-New Jersey Trail Conference	nynjtc.org
AMC-CT •	Appalachian Mountain Club Connecticut Chapter	ct-amc.org/trails
AMC-BK •	Appalachian Mountain Club Berkshire Chapter	amcberkshire.org/at
GMC •	Green Mountain Club	greenmountainclub.org
DOC •	Dartmouth Outing Club	outdoors.dartmouth.edu
AMC •	Appalachian Mountain Club	outdoors.org
RMC •	Randolph Mountain Club	randolphmountainclub.org
MATC •	Maine Appalachian Trail Club	matc.org

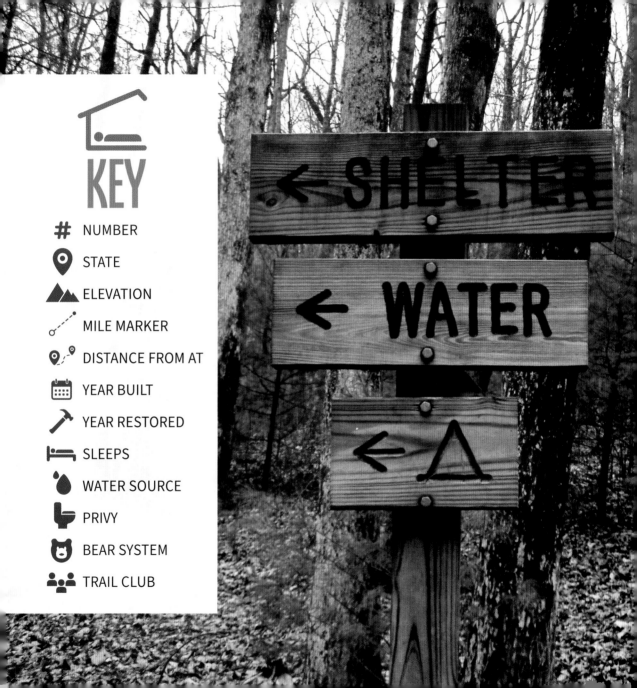

KEY

#	NUMBER
⦿	STATE
⛰	ELEVATION
⸰⸳⸰	MILE MARKER
⦿⸳	DISTANCE FROM AT
📅	YEAR BUILT
🔨	YEAR RESTORED
🛏	SLEEPS
💧	WATER SOURCE
🚽	PRIVY
🐻	BEAR SYSTEM
👥	TRAIL CLUB

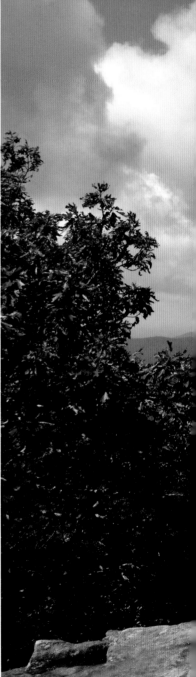

GEORGIA

TOP: Southern terminus plaque at Springer Mountain; **MIDDLE:** Foggy spring forest; **ABOVE:** North Carolina-Georgia border; **RIGHT:** View from Blood Mountain Shelter, the highest point on the AT in Georgia

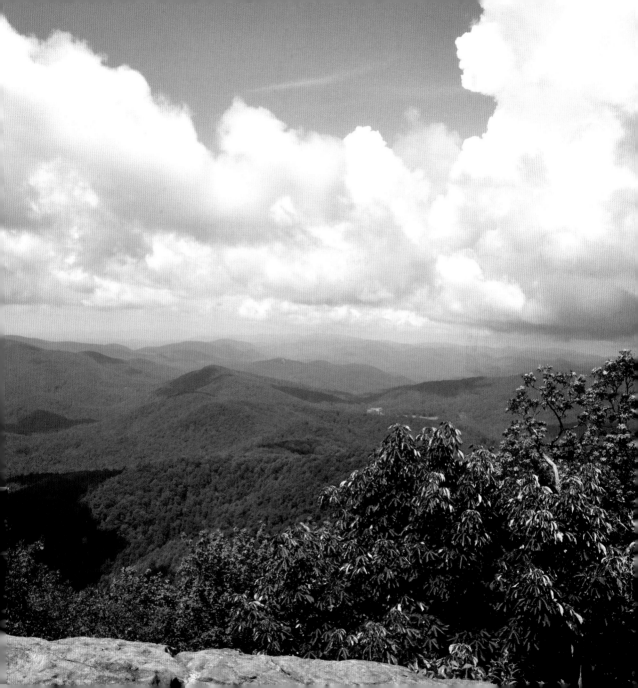

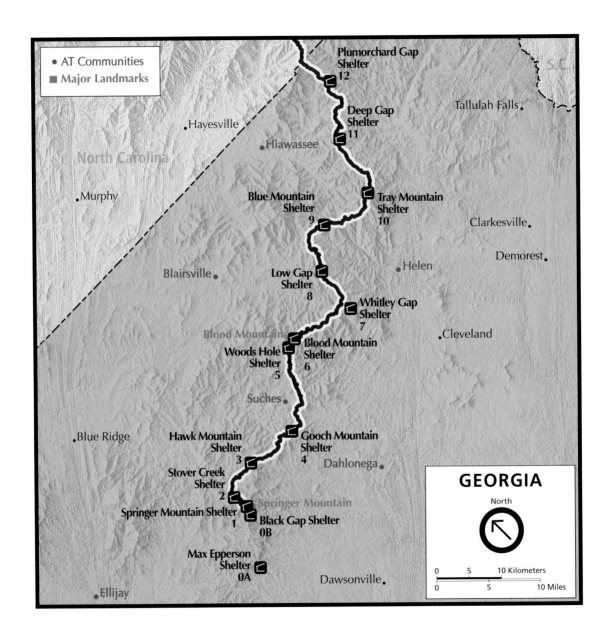

- • AT Communities
- ■ Major Landmarks

S.C.

Plumorchard Gap
Shelter
12

Tallulah Falls.

Deep Gap
Shelter
11

.Hayesville

.Hiawassee

North Carolina

.Murphy

Blue Mountain
Shelter
9

Tray Mountain
Shelter
10

Clarkesville.

Demorest.

Blairsville.

Low Gap
Shelter
8

Helen

Whitley Gap
Shelter
7

Blood Mountain

Cleveland.

Woods Hole
Shelter
5

Blood Mountain
Shelter
6

Suches.

Blue Ridge.

Hawk Mountain
Shelter
3

Gooch Mountain
Shelter
4

Dahlonega.

Stover Creek
Shelter
2

Springer Mountain Shelter
1

Springer Mountain

Black Gap Shelter
0B

Max Epperson
Shelter
0A

Dawsonville.

Ellijay.

GEORGIA

North

0 5 10 Kilometers

0 5 10 Miles

MAX EPPERSON SHELTER

0A

📍 GA

⛰ 1,858 ft

⸰ On Approach Trail

📍 8.8 mi from Springer Mountain

📅 1993

🔨 N/A

🛏 12

💧 Available at park visitors center

🚻 Bathrooms at park visitors center

🐻 N

👥 Amicalola Falls State Park

▲ This shelter, located 50 yards behind the visitors center at Amicalola Falls State Park, is the first one on the Approach Trail—an 8.8-mile hike, mostly uphill, to the first official white blaze of the AT on Springer Mountain. It was named for Max B. Epperson Sr., a retired poultry farmer turned hiker and trail supporter. The "AT Gang," a group of Epperson's backpacking friends, spent 800 hours building it. For thru-hikers only, it has wooden bunks and is the only completely screened-in shelter on the trail. Until 1958, the Approach Trail was an official part of the AT; the route continued south to Mount Oglethorpe, the AT's original southern terminus. The Appalachian Trail Conservancy (ATC) strongly encourages northbound thru-hikers to start at the park. Hikers can begin at the headquarters with a photo at the famous stone arch, register their hike, weigh their pack, and catch the ATC's thru-hiker orientation class. Registering a thru-hike is voluntary, but signing in at the park assists the ATC in tracking yearly thru-hiker counts.

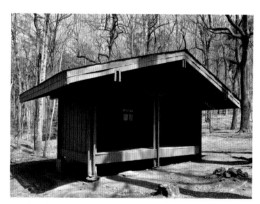

BLACK GAP SHELTER

0B

📍 GA

⛰ 3,200 ft

⸰ On Approach Trail

📍 1.5 mi from Springer Mountain

📅 1953

🔨 1993

🛏 8

💧 Spring 300 yd downhill from shelter

🚻 Y

🐻 Bear box

👥 GATC

▲ This shelter is located on the Approach Trail 1.5 miles before the summit of Springer Mountain, the southern terminus of the AT. In 1993, the shelter was dismantled and moved to the Black Gap location by helicopter with the help of Army Rangers from Camp Frank D. Merrill. This basic three-walled shelter design has a large, overhanging roof and uses the wooden floor as the sleeping area.

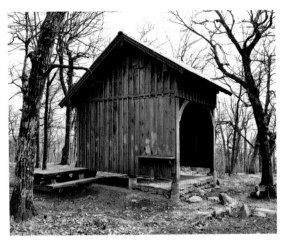

SPRINGER MOUNTAIN SHELTER

#	1	🛏	12
📍	GA	💧	Spring on blue-blazed trail in front of shelter
⛰	3,730 ft	🚽	Y
⟋	0.2	🐻	Bear cables and 2 bear boxes
📍	0.2 mi E	👥	GATC
📅	1993		
🔨	N/A		

▲ The first official shelter on the AT, this tall, two-story plank design with a sleeping loft is located near the summit of Springer Mountain (3,792 feet), the southern terminus of the AT and the nearby Benton MacKaye Trail. Mount Oglethorpe was the southern terminus until Springer became the official end in 1958. There are established tentsites nearby. It is the first shelter on the AT maintained by the Georgia Appalachian Trail Club (GATC). Established in 1930, the club maintains 13 shelters and 78.3 miles from Springer Mountain to Bly Gap on the AT and a total of 125 miles of trails in Georgia.

STOVER CREEK SHELTER

#	2	🛏	16
📍	GA	💧	Stover Creek on blue-blazed trail near shelter
⛰	2,982 ft	🚽	Y
⟋	2.8	🐻	2 bear boxes
📍	0.2 mi E	👥	GATC
📅	2006		
🔨	N/A		

◀▲ This two-story timber-frame shelter is the newest in Georgia, and it replaced the oldest wooden shelter in the state. It was designed by Goshen Timber Frame of Franklin, North Carolina, and built by the GATC. It features a sleeping loft, covered porch area, picnic table, wooden benches, and wooden windows.

HAWK MOUNTAIN SHELTER

#	3	🛏	12
📍	GA	💧	Source 0.1 mi on blue-blazed trail behind shelter
🏔	3,200 ft		
⟋	8.1	🚻	Y
📍	0.2 mi W	🐻	Bear cables and 2 bear boxes
📅	1993		
🔨	N/A	👥	GATC

▼ This tall, two-story shelter with a sleeping loft and an uncovered picnic table was built by the GATC, United States Forest Service (USFS), and Upper Loft Designs. It was the third shelter built at this site. The first, built in 1960 by the USFS, was located near the summit and relocated in 1979. There is limited camping outside the shelter. Hawk Mountain Campsite, located 0.7 miles south on the AT, has 30 tent pads, three food-storage boxes, and a privy. Army Rangers from Camp Frank D. Merrill can be found training in this area.

GOOCH MOUNTAIN SHELTER

#	4	🔨	N/A
📍	GA	🛏	14
🏔	2,778 ft	💧	Excellent source behind shelter
⟋	15.7	🚻	Y
📍	0.1 mi W	🐻	Bear cables and 2 bear boxes
📅	2001	👥	GATC

▶ ▼ Built to replace the original 1960 shelter at nearby Gooch Gap, this tall, two-story shelter with a sleeping loft and a covered picnic table area is located south of Gooch Gap, one of the first easy road crossings that can lead hikers to a town. Suches is 3.3 miles west. It is the lowest-elevation

shelter on the AT in Georgia, and it was dedicated in loving memory of hiker Kurt von Seggern. Funds were donated by his family, and his sister, Dolly Hawkins, was the architect for the project.

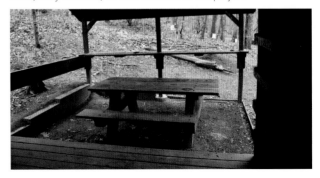

WOODS HOLE SHELTER

#	5	**🔨**	N/A
📍	GA	**🛏**	7
⛰	3,650 ft	**💧**	Unreliable spring on side trail to shelter
⟋	27.7	**🚽**	Y
📍	0.4 mi W	**🐻**	Bear cables and 1 bear box
📅	1998	**👥**	GATC

▼ Built by the GATC and USFS, this is the first Nantahala-style shelter on the trail. This design has a roof covering the sleeping area and an open porch area, typically with a picnic table. The shelter was built to help with the overflow from popular Blood Mountain Shelter. It is dedicated to Roy and Tillie Wood of Roswell, Georgia, the original owners of the famous Woods Hole Hostel in Virginia. The hostel is now run by their granddaughter, Neville. A shelter plaque reads, "In recognition of their service to the hikers of the Appalachian Trail. Donated by Jerry and Minnie Bowden." The Bowdens are thru-hikers who donated funds for the project. Due to increased bear activity, bear canisters are required if camping from Jarrard Gap to Neel Gap from March 1 to June 1. It is currently one of the first and only places on the AT where bear canisters are required.

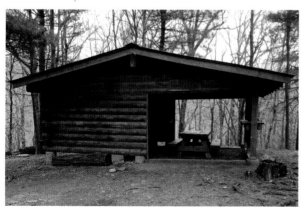

Georgia

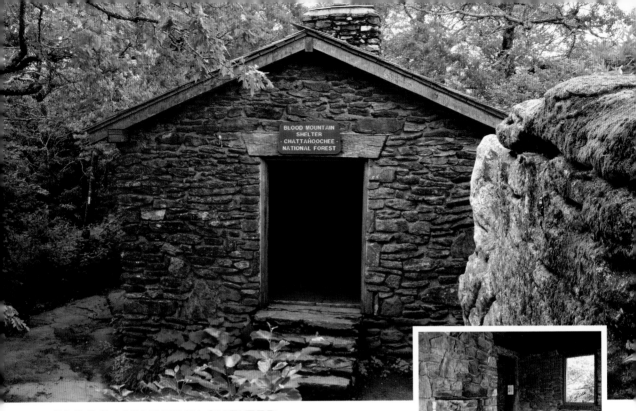

BLOOD MOUNTAIN SHELTER

 # 6

 GA

 4,461 ft

28.9

On AT

1934

1981; 2011

 8

 None at shelter; get water beforehand if staying the night; closest water is creek at junction of AT and Slaughter Creek Trail

 Y

 N

 GATC

▲ ▲ Located on top of the tallest mountain on the AT in Georgia, this is the highest-elevation and oldest-standing shelter in the state. From the rocks at the shelter, there are great views on a clear day. Built by the Civilian Conservation Corps (CCC) for the Georgia State Parks system, this two-room stone shelter with a fireplace was transferred to the USFS in 1956. With more than 40,000 visitors a year, Blood Mountain is the most-visited spot on the trail south of Clingmans Dome. Vandalism to the shelter is a chronic problem.

WHITLEY GAP SHELTER

7
⚲ GA
⛰ 3,600 ft
⸱⸱ 38
⚲⸱ 1.2 mi E
📅 1973

🔨 N/A
🛏 6
💧 Spring 0.3 mi behind shelter
🚽 Y
🐻 Bear cables
👥 GATC

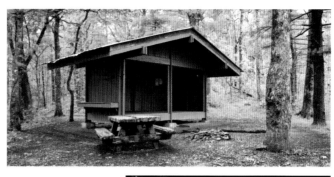

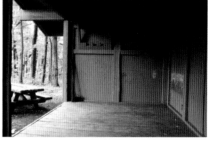

▲ ▶ Built by the USFS, this shelter is located 1.2 miles from the AT down a steep side trail. The wooden-plank wall and large, overhanging roof design is similar to Black Gap and Tray Mountain Shelters, and its reddish-pink color is similar to Low Gap Shelter to the north. The wooden floor is used as the sleeping area.

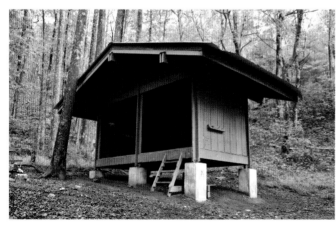

LOW GAP SHELTER

8
⚲ GA
⛰ 3,050 ft
⸱⸱ 42.8
⚲⸱ 0.1 mi E
📅 1953
🔨 1972

🛏 7
💧 Water crossed on way to shelter and 30 yd in front of it
🚽 Y
🐻 Bear cables
👥 GATC

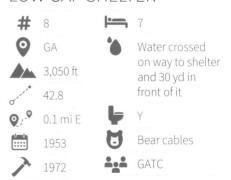

▲ Built by the USFS and located between Sheep Rock Top (3,575 feet) and Poplar Stamp Gap (3,350 feet), this reddish-pink wooden-plank shelter has an overhanging roof design with large concrete footings.

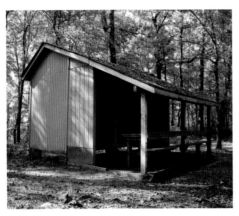

TRAY MOUNTAIN SHELTER

#	10	🔨	N/A
📍	GA	🛏	7
🏔	4,233 ft	💧	Spring 0.1 mi behind shelter
⸱⸱⸱	58.2	🚽	Y
📍	0.2 mi W	🐻	Bear cables
📅	1971	👥	GATC

▼ Built by the USFS, this is the third shelter on Tray Mountain (4,430 feet). The first was built in 1934 by the CCC, and the second was built in 1960 by the USFS. The current shelter was moved back to the top of the hill near the site of the original one. Fantastic sunrise or sunset views are available from the summit of Tray Mountain or from the clearings along the approach trail to the shelter. The structure is a blue-gray wooden-plank design with an overhanging roof.

BLUE MOUNTAIN SHELTER

#	9	🔨	N/A
📍	GA	🛏	7
🏔	3,900 ft	💧	Spring 0.1 mi south on AT
⸱⸱⸱	50.1	🚽	Y
📍	On AT	🐻	Bear cables
📅	1988	👥	GATC

▲ Located south of Blue Mountain (4,025 feet) and Unicoi Gap (2,949 feet), this tall, single-story shelter with a wooden sleeping floor was built by the GATC and USFS after the removal of Rocky Knob Shelter. Two Georgia trail towns are accessible from the gap: Helen to the east and Hiawassee to the west.

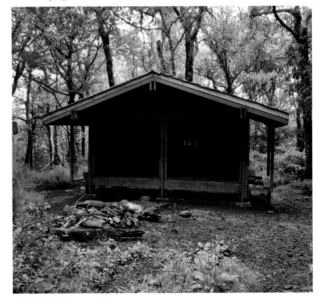

DEEP GAP SHELTER

11

Location GA

Elevation 3,550 ft

Distance 65.6

Side trail 0.2 mi E

Built 1991

Renovated N/A

Sleeps 12

 Piped spring 0.1 mi on blue-blazed trail near shelter

 Y

 Bear cables and 1 bear box

GATC

▲▼ This unique two-story shelter with double sleeping lofts, triangle skylights, and a partially covered front porch is located north of Kelly Knob (4,085 feet). A three-way cost-share project with the GATC, USFS, and Upper Loft Designs, it was built to replace the original 1983 shelter near Addis Gap.

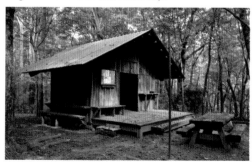

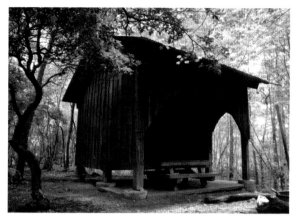

PLUMORCHARD GAP SHELTER

12

Location GA

Elevation 3,050 ft

Distance 73.7

Side trail 0.2 mi E

Built 1993

Renovated N/A

Sleeps 14

Water Creek crosses trail to shelter and spring located opposite of side trail, west of AT; all water should be treated

Privy Y

Bear Bear cables and 1 bear box

GATC

▲ This is a tall shelter with a sleeping loft and a covered concrete slab with a picnic table. The northernmost shelter in Georgia, it was a replacement for an older shelter that was built in 1959 by the USFS and constructed by soldiers from nearby Camp Frank D. Merrill. It was built through a partnership of the USFS, GATC, Upper Loft Designs, and the Army 5th Ranger Training Battalion.

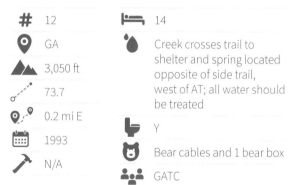

SHELTER ETIQUETTE

Shelters on the AT have always been available on a first-come, first-served basis and can be crowded at times. They are public communal environments, and space can be limited with a full house. Hikers can't assume a shelter will have room, and they should be prepared for their overnight stay. Shelter etiquette becomes important when these small spaces suddenly become shared places. Leave No Trace principles should be always be followed when using a shelter and its facilities. The Appalachian Trail Conservancy outlines basic shelter etiquette as follows:

- **Make room for other hikers.** Concentrate your gear into a small space.

- **Keep the grounds litter-free.** Carry out all your trash and leftover food.
- **Make phone calls and smoke away from the shelter.** These activities may be pleasurable for you, but, for your shelter mates, not so much.
- **Don't cut down trees.** For kindling, collect sticks and downed small limbs along the trail's edge as you approach your destination. Keep fires small to conserve wood and avoid unsightly unburned logs.
- **Dispose of waste liquids.** Walk at least 100 feet away from the shelter and 200 feet from water sources.
- **If a shelter has a privy, use it.** If not, dig a "cathole" 200 feet from the shelter (six to eight inches deep and three to four inches wide). Bring a trowel or tent stake for this purpose.
- **If you have a dog, consider tenting.** It's not a requirement, just a courtesy, especially if your dog barks, growls, drools, is wet or muddy, or is overfriendly. Also consider that your dog may

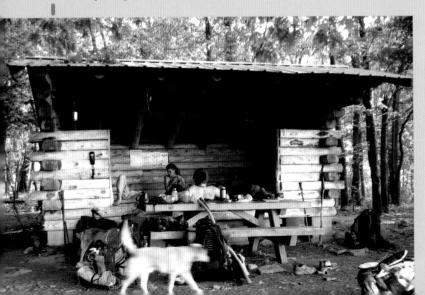

Rice Field Shelter, Virginia

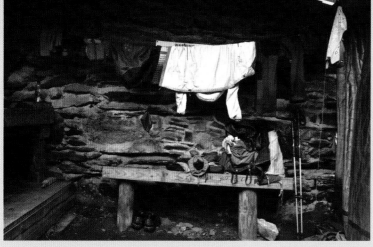

Tri-Corner Knob Shelter, North Carolina

- **Do not leave or burn trash or garbage in the fire pit.** Don't leave extra food in the shelter, in any storage boxes, or hanging from trees.
- **Sweep out the shelter when you arrive and leave.** Even the smallest crumbs can attract rodents. Many shelters have brooms provided for hikers.

have ticks. Keep your dog on a leash at all times and on a short leash if you bring him or her to the shelter to meet hikers.

- **If you snore, tent.** Not everyone realizes that they snore, so bring earplugs just in case.
- **Don't tag (graffiti) the shelter.** You can express yourself and get artistic in the shelter register instead.
- **Avoid eating in the shelter if at all possible.** Spilled food can attract rodents and other animals.
- **Use proper bear equipment when provided.** It is no longer recommended to hang your food in a shelter.

- **Be considerate of other hikers.** All shelter etiquette boils down to is common courtesy in a very small, shared space. Honor "Hiker Midnight"—many overnight guests have to hike the next morning—so be considerate of others who need to get to sleep when the sun sets.

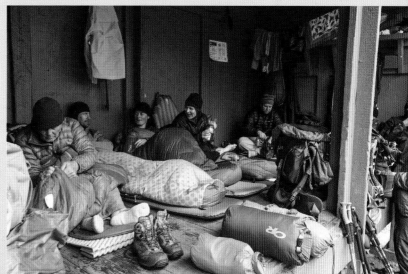

Low Gap Shelter, Georgia

NORTH CAROLINA/ TENNESSEE

TOP: Clingmans Dome in Tennessee, the highest point along the entire AT; **MIDDLE:** Newfound Gap, Great Smoky Mountains National Park; **ABOVE:** Max Patch, heading toward Hot Springs, North Carolina; **RIGHT:** Sunrays at Max Patch

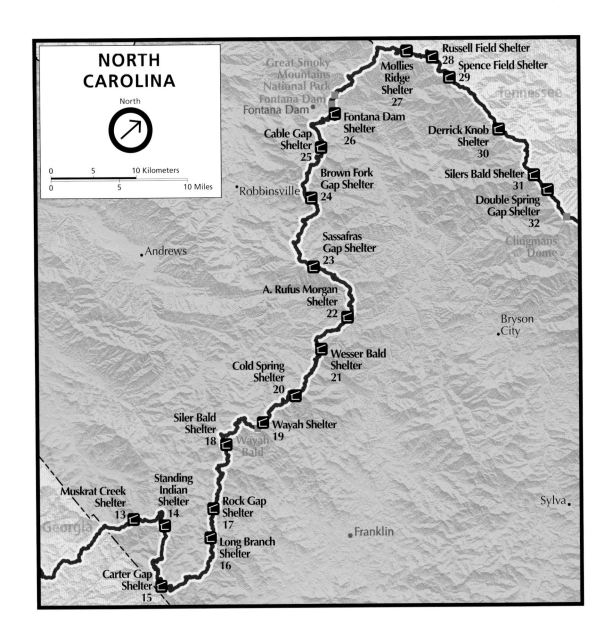

NORTH
CAROLINA

North

0 5 10 Kilometers
0 5 10 Miles

Great Smoky
Mountains
National Park
Fontana Dam
Fontana Dam

Robbinsville

Andrews

Tennessee

Russell Field Shelter
28
Spence Field Shelter
29

Mollies
Ridge
Shelter
27

Derrick Knob
Shelter
30

Silers Bald Shelter
31

Double Spring
Gap Shelter
32

Clingmans
Dome

Fontana Dam
Shelter
26

Cable Gap
Shelter
25

Brown Fork
Gap Shelter
24

Sassafras
Gap Shelter
23

A. Rufus Morgan
Shelter
22

Bryson
City

Wesser Bald
Shelter
21

Cold Spring
Shelter
20

Wayah Shelter
19

Siler Bald
Shelter
18

Wayah
Bald

Sylva

Muskrat Creek
Shelter
13

Standing
Indian
Shelter
14

Rock Gap
Shelter
17

Franklin

Georgia

Long Branch
Shelter
16

Carter Gap
Shelter
15

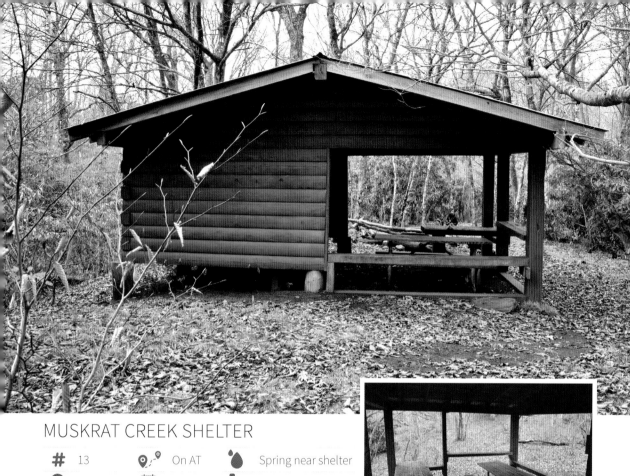

MUSKRAT CREEK SHELTER

#	13	**⌖**	On AT	**💧**	Spring near shelter
⌖	NC	**📅**	1972	**🚻**	Y
⛰	4,600 ft	**🔨**	1995	**🐻**	N
⟋	81	**🛏**	8	**👥**	NHC

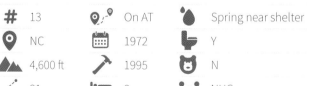

This is the first shelter in North Carolina and the first of many Nantahala-style shelters that are common in the area. The roof covers a sleeping platform and an open porch, typically with a picnic table. The new shelter replaced the old A-frame one built by the United States Forest Service (USFS) in 1972. It is the first shelter maintained by the Nantahala Hiking Club (NHC). Established in 1968 by Rev. A. Rufus Morgan, the club maintains 10 shelters and 58.5 miles of the AT from Bly Gap to the Nantahala River at Wesser, North Carolina. The club also maintains several trails that connect to the AT.

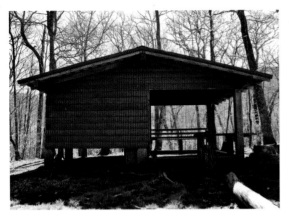

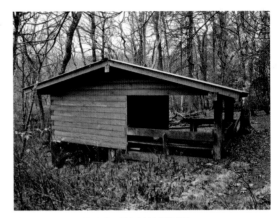

STANDING INDIAN SHELTER

#	14	🛏	8
📍	NC	💧	Stream opposite side trail to shelter and 70 yd downhill
⛰	4,760 ft		
⸱⸱⸱	85.9	🚻	Y
📍	< 0.1 mi	🐻	N
📅	1995	👥	NHC
🔨	N/A		

▲ Named for nearby Standing Indian Mountain (5,498 feet), which offers clifftop views toward Blood Mountain and the "Grandstand of the Southern Appalachians," this Nantahala-style shelter has wooden benches and a picnic table. The area can be heavily trafficked, so please be cautious if camping.

CARTER GAP SHELTER

#	15	🛏	8
📍	NC	💧	Spring 100 yd downhill from shelter
⛰	4,540 ft		
⸱⸱⸱	93.5	🚻	Y
📍	< 0.1 mi	🐻	N
📅	1998	👥	NHC
🔨	N/A		

▲ This Nantahala-style shelter with wooden benches and a picnic table is located south of Mooney Gap, one of the wettest places in the eastern United States. The area receives an estimated average of 93.5 inches of precipitation a year.

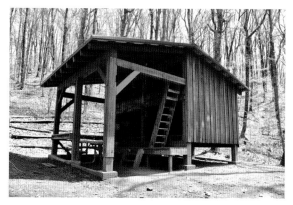

LONG BRANCH SHELTER

#	16	🔨	N/A
📍	NC	🛏	8
⛰	4,503 ft	💧	Water on trail to shelter
⊶	102.2	🚽	Y
📍⊶📍	< 0.1 mi	🐻	N
📅	2012	👥	NHC

▲ This unique two-story timber-frame design with a large sleeping loft has wooden benches and a picnic table. The newest shelter in North Carolina, it replaced the plank-sided Big Spring Gap Shelter that was located nearby. It was built with contributions from the Appalachian Trail Conservancy (ATC), Goshen Timber Frames, USFS, and NHC.

ROCK GAP SHELTER

#	17	📍⊶📍	< 0.1 mi	💧	Spring behind shelter
📍	NC	📅	1965	🚽	Y
⛰	3,760 ft	🔨	1995	🐻	N
⊶	105.6	🛏	8	👥	NHC

▲This smaller shelter with a wooden-plank design is located only 0.1 miles from the road. The covered eating area and picnic tables were added in 1995, but destroyed by a fallen tree in 2015 and removed.

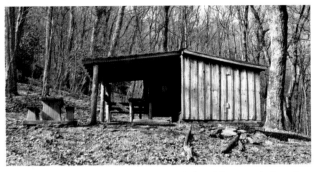

SILER BALD SHELTER

#	18	🛏	8
📍	NC	💧	Spring 80 yd down blue-blazed trail near shelter
⛰	4,700 ft		
🔗	113.1	🚽	Y
📍📍	0.5 mi E	🐻	N
📅	1959	👥	NHC
🔨	1995		

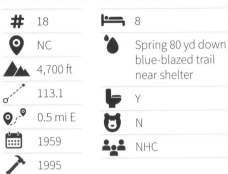

▲ Located on a 0.5-mile shelter loop trail, this older Nantahala-style shelter with a picnic table and benches has the first privy built in the Nantahala section of the AT.

WAYAH SHELTER

#	19	🛏	8
📍	NC	💧	Little Laurel Creek 0.2 mi west on blue-blazed trail
⛰	4,480 ft		
🔗	120.4	🚽	Y
📍📍	< 0.1 mi	🐻	N
📅	2007	👥	NHC
🔨	N/A		

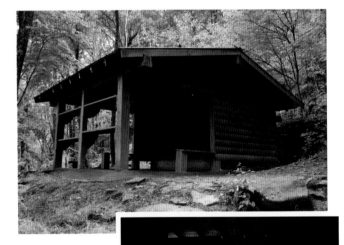

◀◀ This Nantahala-style shelter is one of the newest in North Carolina. Built in memory of Ann and Larry McDuff, thru-hikers and Appalachian Long Distance Hikers Association (ALDHA) members, it is located north of the Wayah Bald stone lookout tower (5,342 feet), which was built by the Civilian Conservation Corps (CCC) in 1937, renovated in 1983, burned by wildfire in 2016, and reopened in 2018.

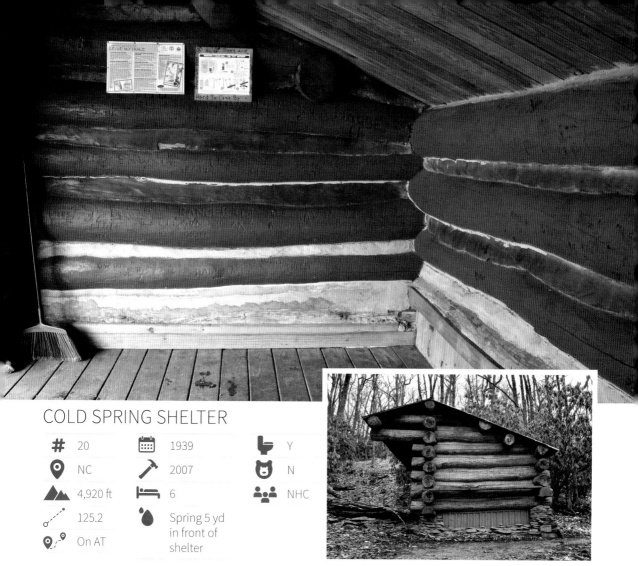

COLD SPRING SHELTER

#	20	📅	1939	🚽	Y
📍	NC	🔨	2007	🐻	N
⛰	4,920 ft	🛏	6	👥	NHC
⸰⸱	125.2	💧	Spring 5 yd in front of shelter		
📍	On AT				

▲ ▶ This Adirondack-style log shelter, built by the CCC with local chestnut logs, is one of the oldest-standing shelters in North Carolina and the oldest on the NHC section of the AT. A new stone foundation was completed with the restoration to raise the structure. The shelter and spring are located directly on the AT, and campsites are located above the shelter. The logs inside of the shelter are now painted red as designed in the original shelter specifications.

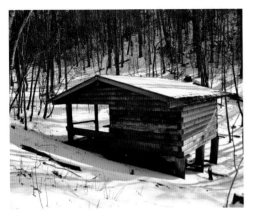

WESSER BALD SHELTER

#	21	🛏	8
📍	NC	💧	Spring 0.1 mi south on AT down blue-blazed trail
⛰	4,115 ft		
🧭	131	🚻	Y
📍	0.1 mi W	🐻	Bear cables
📅	1994	👥	NHC
🔨	N/A		

▲ This shelter with wooden benches was the first Nantahala-style shelter built on the AT. Located north of Wesser Bald and the old fire tower (now an observation deck), which offers amazing panoramic views of the Great Smoky Mountains on clear days.

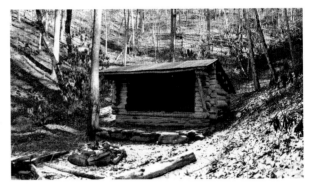

A. RUFUS MORGAN SHELTER

#	22	📍	0.1 mi	💧	Stream west of AT
📍	NC	📅	1981		
⛰	2,300 ft	🔨	1989	🚻	Y
🧭	135.9	🛏	6	🐻	N
				👥	NHC

▲▼ This shelter was named for the NHC's founder, A. Rufus Morgan. It is an Adirondack-style shelter with a stone foundation that faces into a cove.

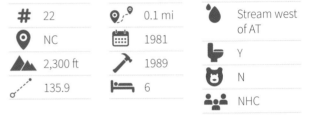

SASSAFRAS GAP SHELTER

 # 23

 NC

 4,330 ft

 143.8

 < 0.1 mi

 2002

 N/A

 14

 Reliable spring in front of shelter

 Y

 N

SMHC

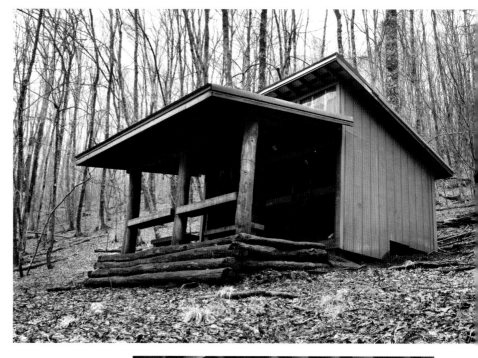

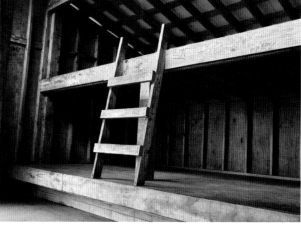

▲ ▶ Located in the Nantahala National Forest, this large shelter with a double sleeping platform, covered porch, and built-in benches has a wooden-plank exterior and clerestory windows. It is the first northbound shelter maintained by the Smoky Mountains Hiking Club (SMHC). Established in 1924, the club maintains 16 shelters and 102 miles of the AT from the Nantahala River to Davenport Gap. It is one of the oldest hiking clubs in the Southeast.

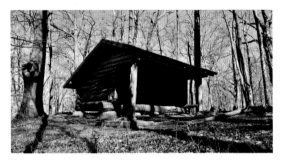

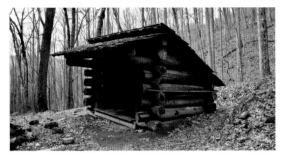

BROWN FORK GAP SHELTER

#	24	🔨	N/A
📍	NC	🛏	6
⛰	3,800 ft	💧	Reliable spring to right of shelter
〰	152.9	🚻	Y
📍	< 0.1 mi	🐻	N
📅	1992	👥	SMHC

▲ This log shelter with a raised sleeping platform and large stone footings was constructed by the SMHC, ATC Konnarock Trail Crew, and the USFS. It is located in the Nantahala National Forest.

CABLE GAP SHELTER

#	25	🔨	1988
📍	NC	🛏	6
⛰	2,880 ft	💧	Reliable stream in front of shelter
〰	159.2	🚻	Y
📍	On AT	🐻	N
📅	1939	👥	SMHC

▲ Originally built by the CCC, this older Adirondack-style shelter—common in early shelter designs—sits right on the trail. One of the smaller shelters in North Carolina, it is also one of the oldest shelters on the southern half of the AT.

FONTANA DAM SHELTER

#	26	📅	1982	🚻	Y
📍	NC	🔨	N/A	🐻	Bear boxes
⛰	1,775 ft	🛏	24	👥	SMHC
〰	165.9	💧	Nearby bathrooms and spigot		
📍	On AT				

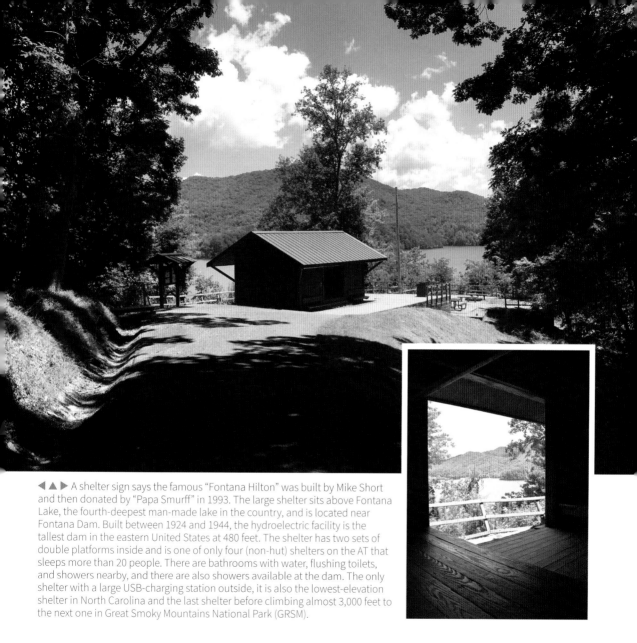

◀ ▲ ▶ A shelter sign says the famous "Fontana Hilton" was built by Mike Short and then donated by "Papa Smurff" in 1993. The large shelter sits above Fontana Lake, the fourth-deepest man-made lake in the country, and is located near Fontana Dam. Built between 1924 and 1944, the hydroelectric facility is the tallest dam in the eastern United States at 480 feet. The shelter has two sets of double platforms inside and is one of only four (non-hut) shelters on the AT that sleeps more than 20 people. There are bathrooms with water, flushing toilets, and showers nearby, and there are also showers available at the dam. The only shelter with a large USB-charging station outside, it is also the lowest-elevation shelter in North Carolina and the last shelter before climbing almost 3,000 feet to the next one in Great Smoky Mountains National Park (GRSM).

North Carolina/Tennessee

MOLLIES RIDGE SHELTER

#	27	🔨	2003
📍	TN	🛏	12
⛰	4,570 ft	💧	Unreliable spring 200 yd to right of shelter
⋰	177.7	🚽	N
📍	On AT	🐻	Bear cables
📅	1961	👥	SMHC

▲ This is the first shelter in GRSM and Tennessee. The AT crosses the North Carolina-Tennessee border many times. A stone-walled design with two-level sleeping bunks, a fireplace, and a covered eating area, it is different than the other shelters in GRSM, where the covered area is an extension of the pitched roofline in front of the shelter rather than on the side under an extension of the gable roof. Park regulations require hikers to stay in shelters. Section hikers must make shelter reservations and cannot tent at the shelters; thru-hikers are exempt from this rule from March 15 to June 15. Thru-hikers should tent if the shelter is full of registered campers. All the shelters in the Smokies section were renovated in the 2000s. Except for Davenport Gap Shelter at the northern end of the park, the shelters no longer have chain-link bear fences to keep the local bears out. Most of them now have large tarps covering the open side of the shelter in cold weather. Local lore says a Cherokee maiden once froze to death looking for a lost hunter, and she still haunts the ridge.

RUSSELL FIELD SHELTER

#	28	🛏	14
📍	NC	💧	Spring 0.1 mi west on Russell Field Trail toward Cades Cove
⛰	4,360 ft		
⋰	180.8	🚽	N
📍	On AT	🐻	Bear cables
📅	1961	👥	SMHC
🔨	2010		

▲ This is the first of many large stone and wooden shelters with two-story sleeping platforms, a fireplace, and a covered wooden bench area in front, which are common in GRSM. There is a small covered overhang with a built-in standing-height table to use as overflow when the benches are crowded. A short walk behind the shelter reveals an open, grassy spot with a view into Cades Cove; the Russell Gregory family grazed stock in the area in the 1800s.

SPENCE FIELD SHELTER

#	29	🛏	12
📍	NC	💧	Reliable spring down Eagle Creek Trail
🏔	4,915 ft	🚻	Y
🧭	183.7	🐻	Bear cables
📍	0.1 mi E	👪	SMHC
📅	1963		
🔨	2005		

▲ This shelter is a large stone and wooden design with a double sleeping platform, gable windows, wooden benches, a standing-height table, and a fireplace. This section of the AT is popular with both horseback riders and bears. Spence Field, located nearby, offers views into North Carolina and Tennessee from the tallest bald in GRSM.

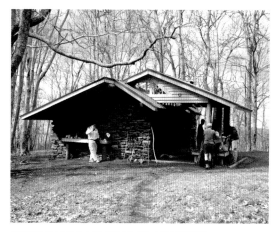

DERRICK KNOB SHELTER

#	30	🛏	12
📍	NC	💧	Reliable spring near shelter (on TN slope)
🏔	4,880 ft	🚻	N
🧭	189.8	🐻	Bear cables
📍	On AT	👪	SMHC
📅	1961		
🔨	2007		

▲This large stone and wooden shelter has a double sleeping platform, gable windows, wooden benches, a standing-height table, and a fireplace.

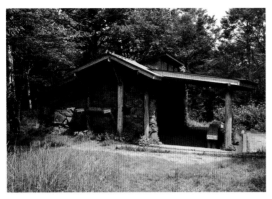

SILERS BALD SHELTER

#	31	🛏	12
📍	NC	💧	Reliable spring 75 yd down side trail to right of shelter
⛰	5,460 ft		
↗	195.5	🚽	N
📍	On AT	🐻	Bear cables
📅	1961	👥	SMHC
🔨	2001		

▲ This large stone and wooden shelter has a double sleeping platform, skylights, wooden benches, a standing-height table, and a fireplace. A bald located 0.3 miles north offers views of Clingmans Dome and sunsets over Cove Mountain.

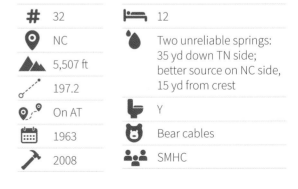

DOUBLE SPRING GAP SHELTER

#	32	🛏	12
📍	NC	💧	Two unreliable springs: 35 yd down TN side; better source on NC side, 15 yd from crest
⛰	5,507 ft		
↗	197.2		
📍	On AT	🚽	Y
📅	1963	🐻	Bear cables
🔨	2008	👥	SMHC

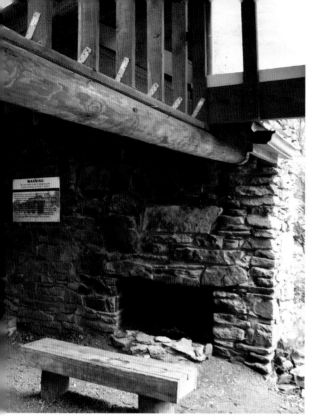

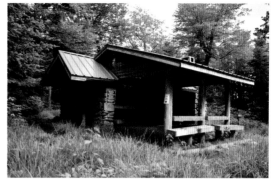

MOUNT COLLINS SHELTER

#	33	🛏	12
📍	TN	💧	Small spring 75 yd down Sugarland Mountain Trail
⛰	5,900 ft		
⊶	202.8	🚻	Y
⊶📍	0.5 mi W	🐻	Bear cables
📅	1960	👥	SMHC
🔨	2009		

▲ This large stone and wooden shelter with a double sleeping platform, skylights, wooden benches, a standing-height table, and a fireplace is located in a spruce thicket north of Clingmans Dome—the highest point on the AT—and its observation tower. At 6,643 feet, the winding observation deck on the dome offers 360-degree views and is one of the most-visited spots on the AT. It is the highest point in Tennessee. It is also the highest point along the AT, but your feet are above the actual trail below, and technically the tower is not on the AT. A parking lot with bathrooms is 0.5 miles from the tower.

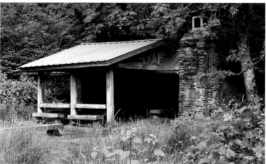

▲▲ This large stone and wooden shelter has a double sleeping platform, skylights, wooden benches, and a fireplace. The gap was named for two springs, now unreliable, one on each side of the state line.

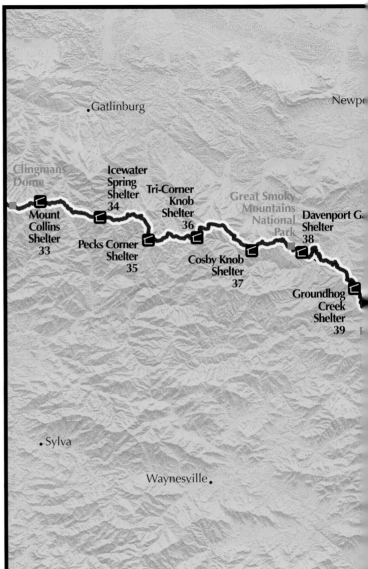

Clingmans
Dome

Gatlinburg

Newp

Icewater
Spring
Shelter
34

Tri-Corner
Knob
Shelter
36

Great Smoky
Mountains
National
Park

Davenport G
Shelter
38

Mount
Collins
Shelter
33

Pecks Corner
Shelter
35

Cosby Knob
Shelter
37

Groundhog
Creek
Shelter
39

Sylva

Waynesville

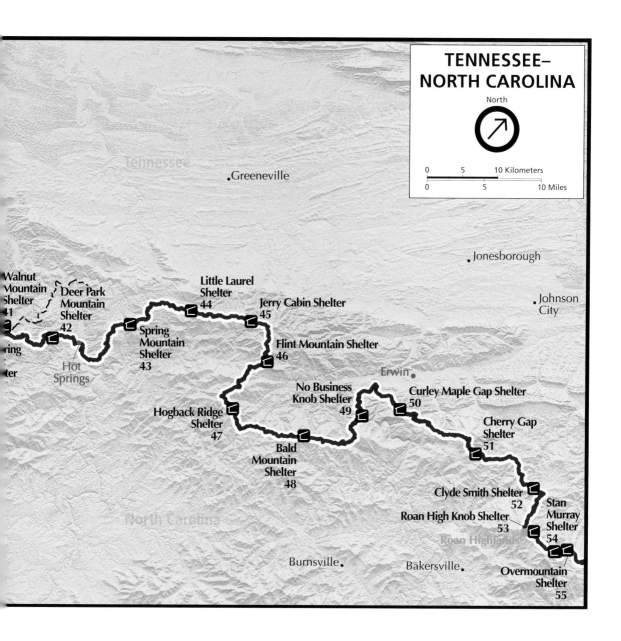

ICEWATER SPRING SHELTER

#	34	🔨	1999
📍	TN	🛏	12
⛰	5,920 ft	💧	Piped spring 50 yd north on AT
⟋	210.8	🚻	Y
📍	< 0.1 mi	🐻	Bear cables
📅	1963	👥	SMHC

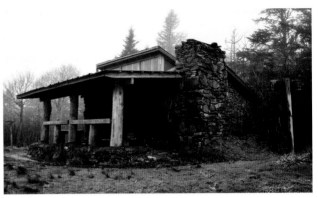

▶ This large stone and wooden shelter has a double sleeping platform, skylights, wooden benches, and a fireplace. It can be heavily trafficked due its close proximity to Newfound Gap, the only road that crosses the AT in the park, just three miles away.

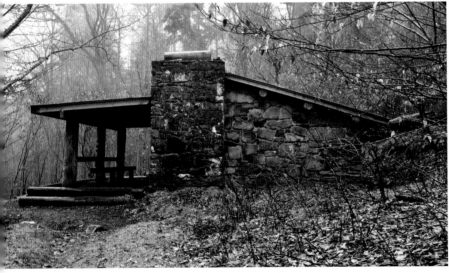

PECKS CORNER SHELTER

▲ This is a large stone and wooden shelter with a double sleeping platform, skylights, wooden benches, and a fireplace. Located 0.4 miles down the Hughes Ridge Trail, Pecks Corner is one of the only shelters in the park not a short distance from or directly on the AT.

#	35
📍	TN
⛰	5,280 ft
⟋	218.2
📍	0.4 mi E
📅	1958
🔨	2000
🛏	12
💧	Spring south of shelter trail turnoff; water also in front of shelter
🚻	Y
🐻	Bear cables
👥	SMHC

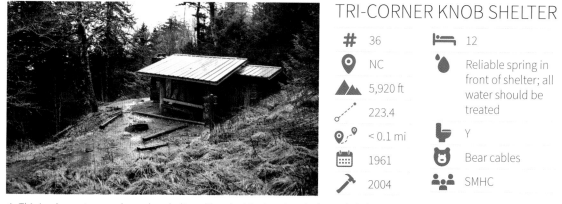

TRI-CORNER KNOB SHELTER

#	36	🛏️	12
📍	NC	💧	Reliable spring in front of shelter; all water should be treated
⛰️	5,920 ft		
⋯	223.4		
📍	< 0.1 mi	🚻	Y
📅	1961	🐻	Bear cables
🔨	2004	👥	SMHC

▲ This is a large stone and wooden shelter with a double sleeping platform, skylights, wooden benches, and a fireplace. It is the only shelter in GRSM to have the stone fireplace on the left side of the structure. Located on the North Carolina border, it is the highest-elevation shelter in the state and the most remote one in the park.

COSBY KNOB SHELTER

#	37	🛏️	12
📍	NC	💧	Reliable spring 35 yd downhill from shelter
⛰️	4,700 ft		
⋯	231.1		
📍	100 yd E	🚻	Y
📅	1959	🐻	Bear cables
🔨	2006	👥	SMHC

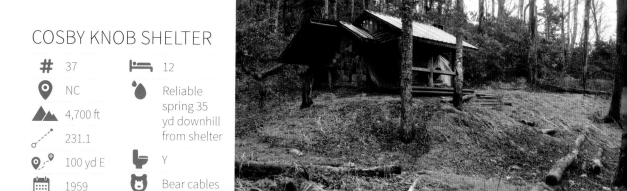

▶ This large stone and wooden shelter with a double sleeping platform, skylights, wooden benches, a standing-height table, and a fireplace sits above a large cove. It is located south of the Mount Cammerer Trail, which leads to the Mount Cammerer fire tower. The historic stone-and-timber tower, built by the CCC in 1939 and rebuilt in 1994, offers panoramic views.

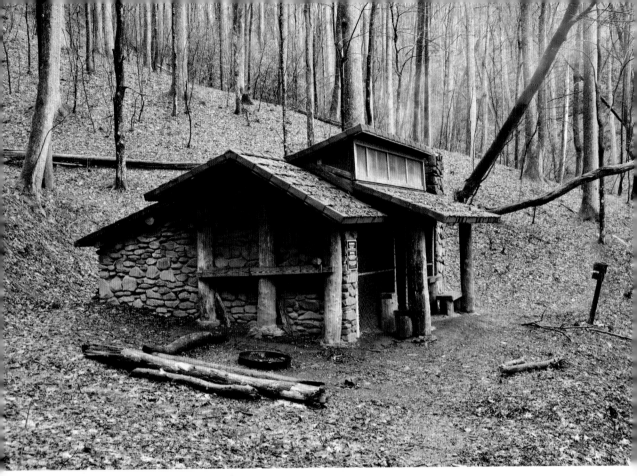

DAVENPORT GAP SHELTER

#	38	**⚲**	238	**🔨**	1998; roof replaced in 2019	**🚽**	N
📍	TN	**📍**	< 0.1 mi	**🛏**	12	**🐻**	N
⛰	2,600 ft	**📅**	1961	**💧**	Spring to left of shelter	**👥**	SMHC

▲ Named for William Davenport, who surveyed the state line in 1821, this is the only shelter in the park that still has a bear cage installed in front. Nicknamed the "Smokies Sheraton," it is a large stone and wooden shelter with a double sleeping platform, gable windows, wooden benches, a standing-height table, and a fireplace.

GROUNDHOG CREEK SHELTER

39

📍 NC

⛰ 2,900 ft

↗ 248.7

📍 0.2 mi E

📅 1939

🔨 N/A

🛏 6

💧 Reliable spring to left of shelter

🚻 Y

🐻 Bear cables

👥 CMC

▼ The small roof of this stone shelter, which also has a wooden floor, overhangs to cover half of the picnic table. It is the first shelter maintained by the Carolina Mountain Club (CMC). Established in 1923 and merged with the Carolina Appalachian Trail Club in 1930, the club maintains 10 shelters and 94 miles of the AT from Davenport Gap to Spivey Gap. The club also maintains sections of the Mountains-to-Sea Trail and a total of 450 miles in western North Carolina.

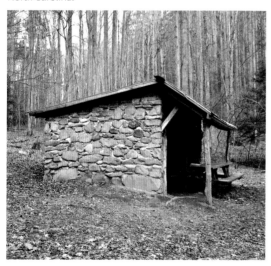

ROARING FORK SHELTER

40

📍 NC

⛰ 3,950 ft

↗ 257

📍 < 0.1 mi

📅 1989

🔨 2005

🛏 8

💧 Two water sources: 0.4 mi south or 0.1 mi north

🚻 Y

🐻 Bear cables

👥 CMC

▼ Built by the CMC with donations by the Mountain Marching Mamas, this log shelter with a wooden sleeping platform is one of the newest shelters in North Carolina. It has a roof with a gutter that covers the picnic table and is a memorial to designer and builder Howard McDonald. It is located 1.9 miles north of the popular Max Patch bald (4,629 feet), which offers amazing 360-degree views. Originally forested and then cleared for grazing, the bald is now maintained with mowing and controlled burning by the USFS. On clear days, you can see the Smokies to the south and Mount Mitchell—at 6,684 feet, the tallest mountain east of the Mississippi River—to the east. The new shelter was built by the CMC with lumber and logs purchased for just a little more than $2,600.

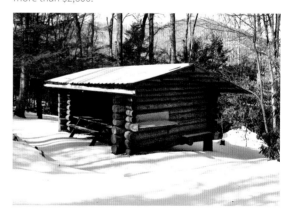

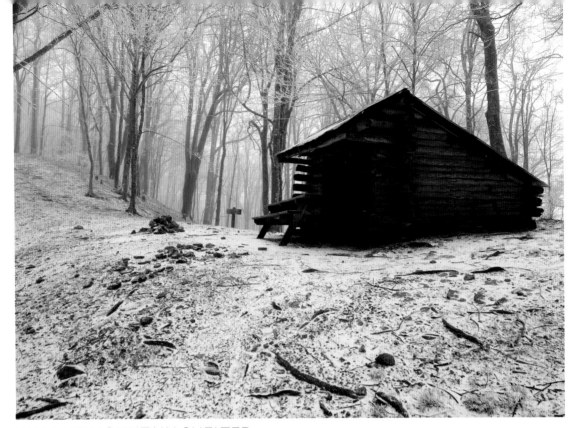

WALNUT MOUNTAIN SHELTER

#	41	🛏	5
📍	TN	💧	Source 0.1 mi down blue-blazed trail behind shelter; can be seasonal and difficult to locate
🏔	4,260 ft		
〰	261.8	🚽	Y
📍	0.1 mi W	🐻	Bear cables
📅	1938	👥	CMC
🔨	N/A		

▲ This original structure was constructed from chestnut logs cut nearby. The lean-to was constructed in the Adirondack style favored in the early years of the trail and was one of several shelters that had log-rail fences around it to keep livestock out. The simple design includes a wooden sleeping platform and a picnic table. Walnut Mountain and the next two shelters north were all built by the CCC and are three of the oldest shelters in a row on the AT. (The oldest three in a row are located in New York.) Bear activity is common at this shelter.

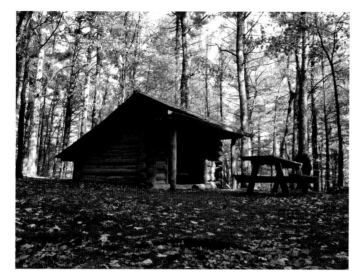

SPRING MOUNTAIN SHELTER

#	43	💧	Source 75 yd down blue-blazed trail across from shelter
📍	TN		
⛰	3,300 ft		
⟋	285.9		
📍⟋📍	On AT	🚽	Y
📅	1938	🐻	Bear cables
🔨	N/A	👥	CMC
🛏	5		

▼ One of the early structures in this region, this Adirondack-style log shelter with a wooden sleeping platform survives in its original form. Located right on the AT, it was built from logs cut and peeled nearby.

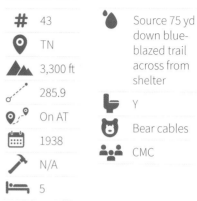

DEER PARK MOUNTAIN SHELTER

#	42	🛏	5
📍	NC	💧	Spring on trail to shelter; all water should be treated due to slow flow
⛰	2,330 ft		
⟋	271.7		
📍⟋📍	< 0.1 mi	🚽	Y
📅	1938	🐻	Bear cables
🔨	N/A	👥	CMC

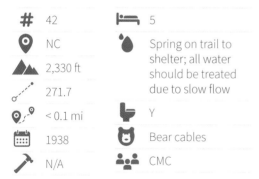

▲ Located on a former homestead, this Adirondack-style log shelter with a wooden sleeping platform is just south of the AT trail town of Hot Springs, North Carolina. The AT goes right down the town's main street, passes the famous natural Hot Springs Resort and Spa, and goes over the French Broad River, one of the oldest rivers in the world. Whitewater rafting is available from multiple outfitters.

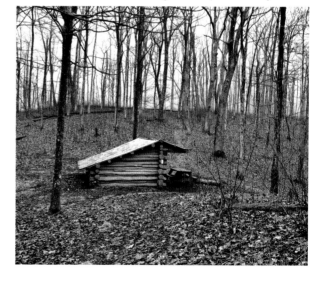

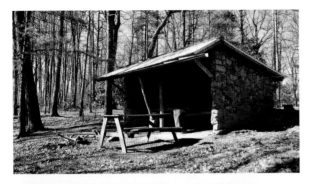

JERRY CABIN SHELTER

#	45	🛏	6
📍	NC	💧	Source on small knoll 100 yd up path found on opposite side of AT from shelter
⛰	4,150 ft		
⟜	301.8		
📍	On AT	🚽	Y
📅	1968	🐻	Bear cables
🔨	N/A	👥	CMC

▼ Similar in design to Groundhog Creek and Little Laurel Shelters located south on the trail, this is not a cabin, but rather a stone shelter with a wooden extension in front. It is dedicated to CMC member and honorary ALDHA life member Sam Waddle, who was the caretaker. Ed Garvey once described it as the "dirtiest shelter on the entire trail to one of the cleanest" after Waddle hauled out 20 bushels of litter.

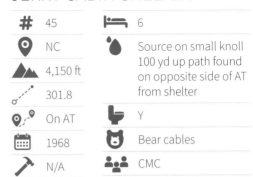

LITTLE LAUREL SHELTER

#	44	🛏	5
📍	NC	💧	Boxed spring 100 yd down blue-blazed trail behind shelter
⛰	3,300 ft		
⟜	294.5		
📍	On AT	🚽	Y
📅	1967	🐻	Bear cables
🔨	N/A	👥	CMC

▲▲ Built to replace Camp Creek Bald Shelter, this stone shelter with a wooden floor is located south of Camp Creek Bald (4,843 feet) and Big Firescald Knob (4,360 feet). Just north is Firescald Ridge, which offers 360-degree views.

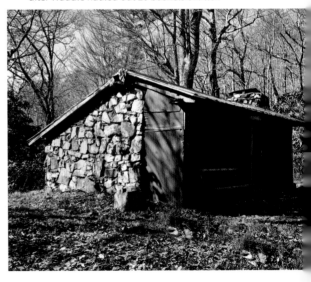

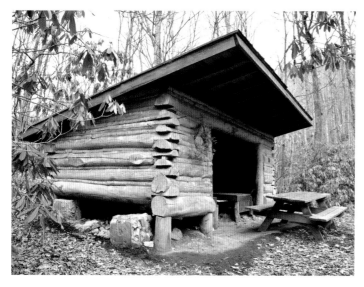

FLINT MOUNTAIN SHELTER

#	46	🔨	N/A
📍	NC	🛏	8
⛰	3,570 ft	💧	50 yd north on AT
⸱⸱⸱	308.5	🚽	Y
📍	< 0.1 mi	🐻	Bear cables
📅	1988	👥	CMC

◀ Built by the CMC and ATC board member Jack Davis, this shelter is a log design with two separate sleeping platforms. A plaque dedicates it to Mark Sperling (1952–1987) by his family.

HOGBACK RIDGE SHELTER

#	47	💧	Spring 0.3 mi down side trail near shelter
📍	NC	🚽	Y
⛰	4,255 ft	🐻	Bear cables
⸱⸱⸱	317.3	👥	CMC
📍	0.1 mi E		
📅	1984		
🔨	N/A		
🛏	6		

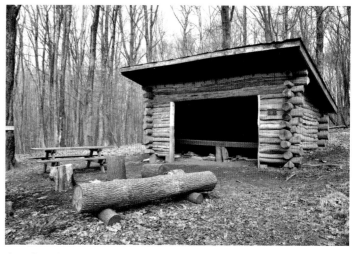

▶ Built by the CMC and ATC board member Jack Davis, this log shelter with a sleeping platform is similar to the design of Flint Mountain Shelter. It is located south of Sams Gap and I-26.

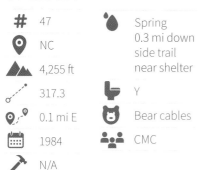

BALD MOUNTAIN SHELTER

#	48	📍	0.1 mi W	💧	Spring on trail to shelter
📍	TN	📅	1985	🚽	Y
🏔	5,100 ft	🔨	N/A	🐻	Bear cables
⊶	327.4	🛏	10	👥	CMC

▼▼ Built by CMC volunteers, this tall wooden shelter with double sleeping platforms and a covered open area is one of the highest on the AT (5,100 feet). No tenting is permitted due to the fragile environment around the shelter. It is located north of Big Bald (5,516 feet), the highest bald summit in the Bald Mountains.

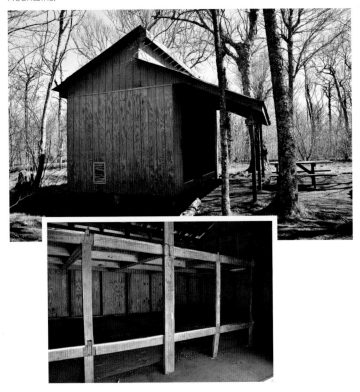

NO BUSINESS KNOB SHELTER

#	49	🔨	1990
📍	TN	🛏	6
⛰	3,251 ft	💧	Reliable source 0.2 mi south on AT
⊶	338	🚽	N
📍	On AT	🐻	N
📅	1963	👥	TEHCC

▲ This concrete-block shelter with a wooden sleeping platform was built by the USFS and is a common design in eastern Tennessee. The shelter has a "graffiti board," which is common in Tennessee shelters to try and curb vandalism. It is the first shelter maintained by the Tennessee Eastman Hiking and Canoeing Club (TEHCC). Established in 1946, the club maintains 15 shelters and 133.8 miles of the AT from Spivey Gap to the Tennessee-Virginia border. It was painted in 2014 by local Eagle Scout Tom Merrimon and repainted in 2018 by the club's "Hiking with Tools" crew, which handled the latest round of renovations across many shelters with grants from the successful Tennessee AT car-tag program. The shelter gets its unique name from a hiker who tried to climb the knob a few years after a fire and the top was impassible due to briars and brush. He decided he had "no business" being there. No Business Knob is above the Nolichucky River and the trail town of Erwin. It has a memorial plaque in memory of Arnold W. "Bill" Berry (1950–2014). Berry was a lifelong resident of Erwin and the first club member to reach 1,000 volunteer hours.

CURLEY MAPLE GAP SHELTER

#	50	🔨	2010
📍	TN	🛏	14
⛰	3,070 ft	💧	Spring south on AT
⊶	348.5	🚽	N
📍	On AT	🐻	N
📅	1961	👥	TEHCC

▲ Remodeled in 2010 by the TEHCC, with a grant from L.L. Bean providing new materials, this new structure uses the original USFS sleeping pad and concrete-block design as the foundation for a two-story shelter. The sleeping capacity was expanded from six to 14 with an upper sleeping platform, and a covered eating area was added. Curley maple is not actually a species, but simply a description of the grain pattern having ripples that appear to "curl" along the length of the board.

CHERRY GAP SHELTER

#	51	🔨	2020
📍	TN	🛏	14
⛰	3,900 ft	💧	Spring on blue-blazed trail near shelter
⟋	361.3		
📍	On AT	🚽	N
📅	1962	🐻	N
		👥	TEHCC

▲ The original concrete-block shelter at this site was built by the USFS. Plans are to replace the shelter in 2020 in partnership with Elizabethton High School as funded by a $5,000 grant from the Tennessee AT car-tag program. The older design slept six, while the new shelter will sleep 14. It is located north of Unaka Mountain (5,180 feet), between Iron Mountain Gap and the Nolichucky River.

CLYDE SMITH SHELTER

#	52	🔨	2002
📍	TN	🛏	10
⛰	4,400 ft	💧	Spring 100 yd behind shelter down blue-blazed trail
⟋	370.4		
📍	0.1 mi W	🚽	N
📅	1976	🐻	N
		👥	TEHCC

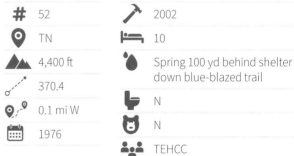

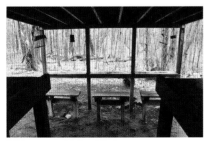

▲◀ Named for a prolific maker of wooden signs for the AT, primarily in the White Mountains of New Hampshire and this area of Tennessee, this shelter was built by the USFS and renovated in 2002. A porch with an eating area and upper-level bunks were added during a Hard Core event. Hard Core (2001–2015) was an event organized by Kincora Hostel owner Bob Peoples and the TEHCC that gave thru-hikers an opportunity to do trail work. Hikers were shuttled from Trail Days in Damascus, Virginia, to the work site. The collection system at the spring was installed as an Eagle Scout project by Curtis Baird, Piney Flats Troop 4, in 2009. The project is still in service and allows clear-water collection during drier times.

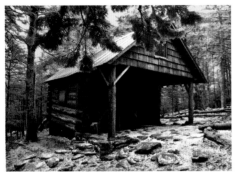

ROAN HIGH KNOB SHELTER

#	53	🔨	1980	🚽	N
📍	NC	🛏	15	🐻	N
🏔	6,285 ft	💧	Unreliable spring about 100 yd opposite shelter on blue-blazed side trail	👥	TEHCC
⟋	378.9				
📍	0.1 mi E				
📅	1934				

▲ Originally a fire warden's cabin for a now-removed fire tower, this two-story building was renovated into a shelter in 1980. The highest shelter (6,285 feet) on the AT, it is located near Roan Mountain, the coldest spot on the southern section of the trail year-round. Roan High Knob is the highest point in Tennessee outside of the Great Smoky Mountains. The former Cloudland Hotel site, built in 1885 on the summit, had a white line painted down the middle of the building to divide the hotel between the two states. At the time, alcohol was legally served only on the Tennessee side. Roan Mountain is home to the largest Catawba rhododendron gardens in the world, is the high point of the Roan-Unaka Range, and is the last point above 6,000 feet for northbound hikers before New Hampshire. The balsam and fir forest feels more like New Hampshire or Maine than a southern forest.

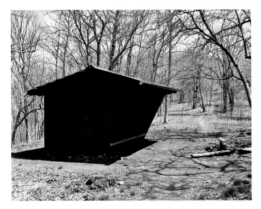

STAN MURRAY SHELTER

#	54	🛏	6		
📍	NC	💧	Unreliable source on blue-blazed trail opposite shelter; reliable source at Roan Mountain restrooms when open		
🏔	5,050 ft				
⟋	384.1				
📍	On AT	🚽	N		
📅	1977	🐻	N		
🔨	2017	👥	TEHCC		

▲ Originally known as Roan Highlands Shelter, this wooden-plank design built by the USFS was renamed for Stan Murray—a former ATC chair, longtime TEHCC leader, and founder of the Southern Appalachian Highlands Conservancy. It was renovated in 2017 to improve the foundation, level the sleeping platform, repair the rafters, install a metal roof, and receive a good coat of paint both inside and out. A plaque inside reads, "While staying at this shelter, be considerate of the needs and rights of others. It is intended for overnight stays only. Accommodate latecomers if possible. Do not damage or deface the shelter or its surroundings. Remove litter. Put out the fire when leaving. Leave wood for others."

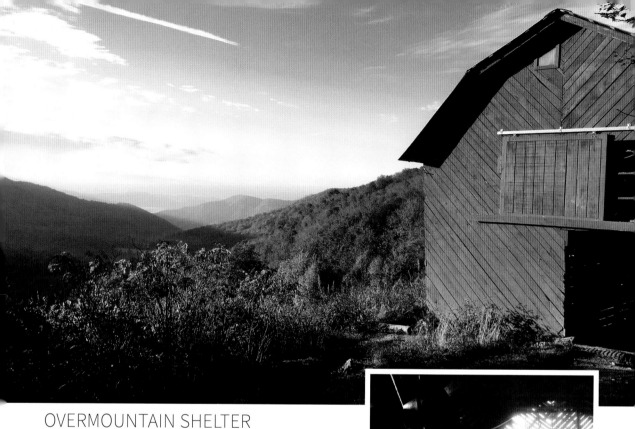

OVERMOUNTAIN SHELTER

#	55	📅	1970s	🚻	Y
📍	NC	🔨	1983	🐻	N
🏔	4,500 ft	🛏	20	👥	TEHCC
〰	386	💧	Spring to left on old road to shelter		
📍	0.1 mi E				

▲ ▲ Originally located on a private farm, this large wooden barn with two levels of sleeping areas was converted into a shelter by the TEHCC. Located just before Little Hump and Big Hump, the area offers great views into Roaring Creek Valley. In 2019, the USFS Appalachian Ranger District closed the shelter due to structural damage. The barn was not originally designed to accommodate people, and it was deemed unsafe. Further evaluations will occur to identify viable management options. The fields around the shelter are still open for tent camping; a safe distance of 40 feet from the structure is required.

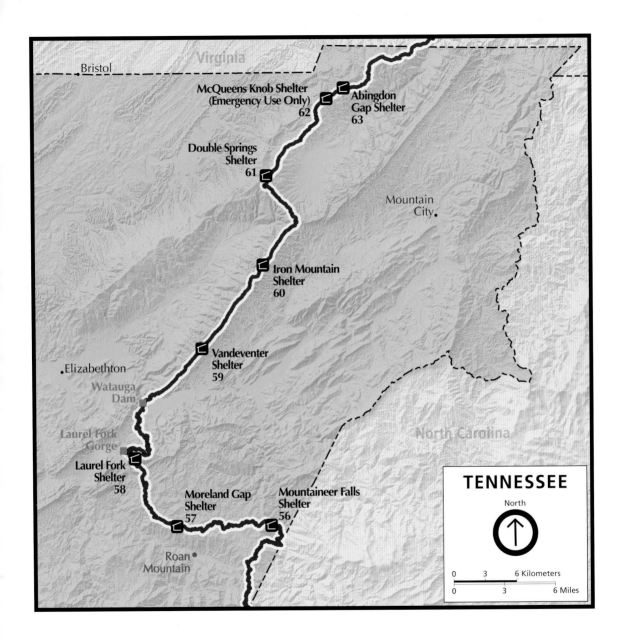

Virginia

Bristol

McQueens Knob Shelter
(Emergency Use Only)
62

Abingdon
Gap Shelter
63

Double Springs
Shelter
61

Mountain
City

Iron Mountain
Shelter
60

Vandeventer
Shelter
59

Elizabethton

Watauga
Dam

Laurel Fork
Gorge

North Carolina

Laurel Fork
Shelter
58

Moreland Gap
Shelter
57

Mountaineer Falls
Shelter
56

Roan
Mountain

TENNESSEE

North

0 3 6 Kilometers
0 3 6 Miles

THE APPALACHIAN TRAIL

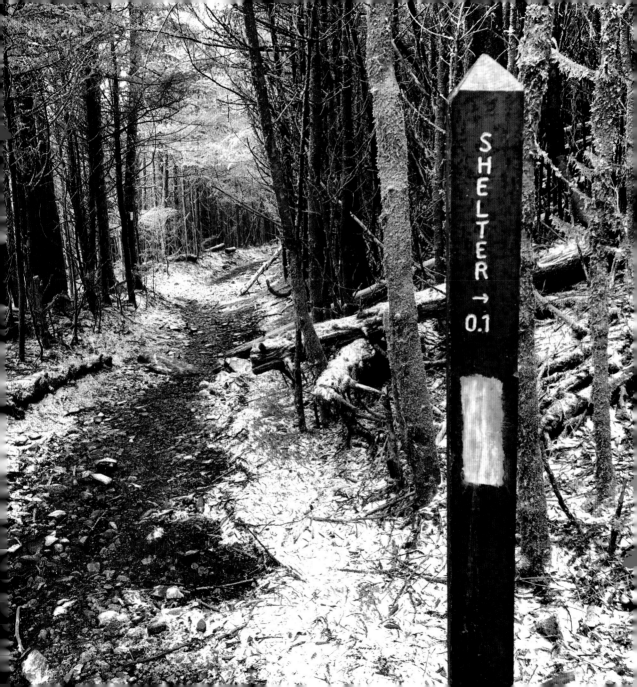

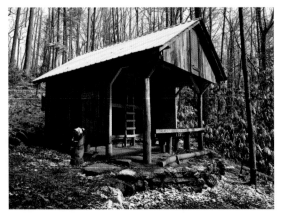

MOUNTAINEER FALLS SHELTER

#	56	💧	Mountaineer Falls 200 ft down blue-blazed trail
📍	TN	🚽	N
⛰️	3,200 ft	🐻	N
➴	404	👥	TEHCC
📍	< 0.1 mi		
📅	2006		
🔨	N/A		
🛏️	14		

▲ ▶ The newest shelter in Tennessee, this wooden A-frame design has two main sleeping platforms and a loft platform built by the TEHCC and Hard Core crew. Its name, chosen by Appalachian State University students who helped with the construction, comes from a nearby cascade. Tent camping is 0.2 miles south from the shelter.

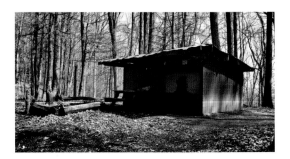

MORELAND GAP SHELTER

#	57	💧	Source 0.2 mi down steep hill across from shelter
📍	TN	🚽	N
⛰️	3,813 ft	🐻	N
➴	413.6	👥	TEHCC
📍	On AT		
📅	1960		
🔨	N/A		
🛏️	6		

▲ This basic three-sided concrete-block shelter with an open front and wooden sleeping platform was built by the USFS. The open side of the shelter faces northwest, so the inside can get wet during storms. It is located in the Cherokee National Forest.

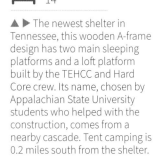

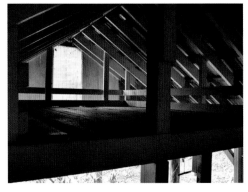

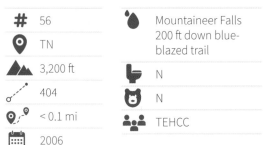

LAUREL FORK SHELTER

#	58	⚒	1994; 2008	🚽	N
📍	TN	🛏	8	🐻	N
⛰	2,450 ft	💧	Cascading stream 50 yd downhill from shelter on blue-blazed trail	👥	TEHCC
⟋	421.8				
📍⟋	< 0.1 mi E				
📅	1977				

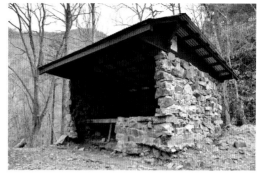

▶ This unique stone shelter with a wooden sleeping platform was constructed of native rocks by the TEHCC. It is located near Laurel Fork Falls. Please use caution if swimming near the falls, as dangerous undertows have resulted in multiple drownings there.

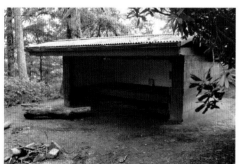

VANDEVENTER SHELTER

#	59	📅	1961	🚽	N
📍	TN	⚒	1990	🐻	N
⛰	3,510 ft	🛏	6	👥	TEHCC
⟋	437.6	💧	Source 0.3 mi straight down steep, blue-blazed trail south of shelter		
📍⟋	On AT				

◀◀ Located on Iron Mountain right on the AT, this basic three-sided concrete-block shelter with an open front and wooden sleeping platform was built by the USFS. Right behind the shelter are great views of nearby Watauga Lake, Pond Mountain, and Roan Highlands.

IRON MOUNTAIN SHELTER

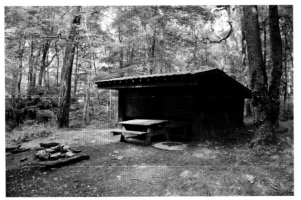

#	60	🔨	1991
📍	TN	🛏	6
⛰	4,125 ft	💧	None at shelter; source 0.3 mi south on AT
⟋	444.4		
📍	On AT	🚻	N
📅	1960	🐻	N
		👥	TEHCC

▲ Built by the USFS, this three-sided concrete-block shelter with an open front and wooden sleeping platform is located directly on the AT along the crest of Iron Mountain between Wilbur Dam Road and TN-91. It is south of the Uncle Nick Grindstaff Monument, erected in the old chimney in 1925 for the hermit who lived in the area for more than 40 years. Under his birth and death dates, it simply says, "Lived alone, suffered alone, and died alone."

DOUBLE SPRINGS SHELTER

#	61	🔨	N/A
📍	TN	🛏	6
⛰	4,060 ft	💧	Spring near shelter
⟋	452.1		
📍	On AT	🚻	N
📅	1960	🐻	N
		👥	TEHCC

▶ Built by the USFS, this shelter at the junction of Holston and Cross Mountains is located north of one of the AT sections constructed to comply with Americans with Disabilities Act (ADA) standards. Great views are available from the short section north of the TN-91 parking lot.

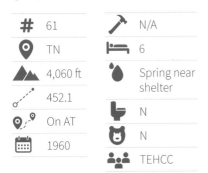

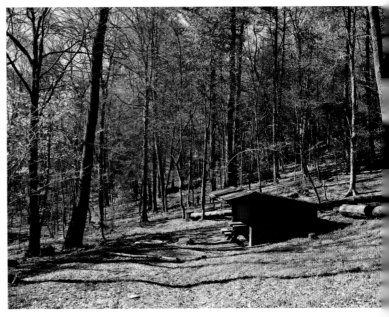

MCQUEENS KNOB SHELTER

#	62	(hammer)	1991; 2008
(location)	TN	(bed)	4
(mountains)	3,840 ft	(water)	None at shelter
(trail)	459	(toilet)	N
(on trail)	On AT	(bear)	N
(calendar)	1934	(people)	TEHCC

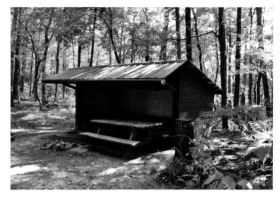

▼ This is one of the oldest-standing shelters on the AT, but it is appropriate for emergency use only. There is no water or privy located at the shelter. It is a smaller eight-by-ten-foot, four-sided log-wall structure with an open doorway, dirt floor, and newer metal roof. The walls are no longer chinked, so wind, rain, and snow can easily come through into the sleeping area. One of the smallest shelters on the trail, it is also known as the "Holiday Inn" and is located a mile from Abingdon Gap Shelter.

ABINGDON GAP SHELTER

#	63	(bed)	5
(location)	TN	(water)	Spring 0.2 mi downhill on steep blue-blazed trail behind shelter
(mountains)	3,773 ft		
(trail)	460.4		
(on trail)	On AT	(toilet)	Y
(calendar)	1959	(bear)	N
(hammer)	1989; 1992	(people)	TEHCC

▲ The last shelter in Tennessee, this is the oldest block-design shelter in the state. Built by the USFS, it is located right on the AT on Holston Mountain and 10 miles south of the famous trail town of Damascus, Virginia, home of the annual Trail Days Festival every May. It is named for the nearby town of Abingdon, Virginia, located farther to the west. Flint arrowheads have been found just north of the shelter.

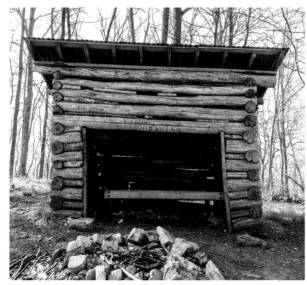

BEAR SYSTEMS

Bears inhabit nearly every part of the AT, and sightings have steadily increased at shelters and campsites. Although rarely aggressive toward humans, black bears can become crafty and aggressive in their attempts to obtain human food once habituated. As a result, overnight hikers must now take food storage seriously and come to the trail prepared to store their food and smellables safely from bears and other animals. Many, but not all, shelters on the trail provide some sort of food-storage device, especially in areas known to have frequent bear issues.

When possible, cook and eat away from the shelter. Hikers should never hang food inside a shelter or leave food or trash behind, as bears and other animals— such as raccoons, mice, and porcupines—will start to associate shelters with a snack and visit more often. Hikers should also never leave food unattended, whether in packs or not, as bears have been known to grab food bags or packs and run away with them.

Rigid bear-resistant canisters carried by hikers are the recommended method for storing food and smellables anywhere along the AT. Due to increased bear activity and hiker crowds, bear canisters are required if camping from Jarrard Gap to Neel Gap in Georgia from March 1 to June 1. Proposals for canister requirements are being considered by land managers for other areas of the trail in the South. Additional areas requiring bear canisters may be added soon; hikers should check websites for updates.

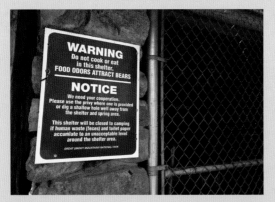

Davenport Gap Shelter, Tennessee, the only shelter in Great Smoky Mountains National Park with a bear cage still installed.

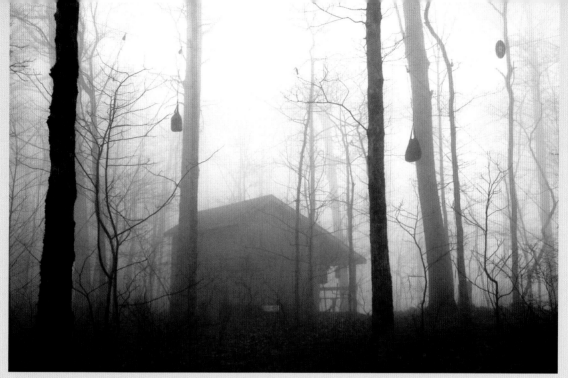
Bear bags, Blue Mountain Shelter, Georgia

If hikers are not carrying bear canisters, they should be prepared to hang their food on a tree limb at least 20 feet high, 12 feet from the ground, and 6 feet from the trunk using the PCT method, a technique that requires some practice. Over time, bears have become adept at figuring out how to obtain food from these hangs, so a canister is still the preferred method.

In areas where bear problems have been persistent, different types of systems have been installed, including bear cables, bear boxes, and bear poles from which to hang food, garbage, and other smellables. Although more of these systems are being provided, hikers still need to take personal responsibility for storing their own food safely. At peak times, provided systems at shelters may be full or they may fail. Hikers also need to be equipped if they camp in designated or non-designated sites that do not have bear systems in place.

Great Smoky Mountains National Park, which has an estimated 400 to 600 resident bears, used to have chain-link bear fencing installed on the open sides of the shelters. Currently, only

Davenport Gap Shelter has an intact fence. Food-storage cables are now available at all the shelters in the park.

Unfortunately, if hikers are not vigilant about their food storage, bears may get rewarded with food and then become a nuisance or a danger. Animals may have to be relocated or (more often) euthanized; trail sections may have to be closed to camping; and shelters may have to be closed, torn down, or removed. Watauga Lake Shelter, built in 1980, was dismantled and removed in 2019 due to continuous bear activity at the shelter, even after years of being closed to hikers.

ABOVE: Bear box, Springer Mountain Shelter, Georgia

BELOW: Bear cables, Deer Park Mountain Shelter, North Carolina

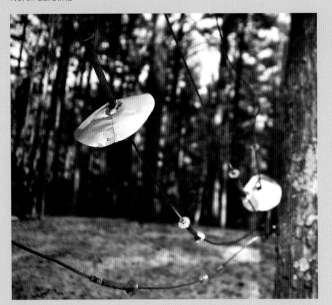

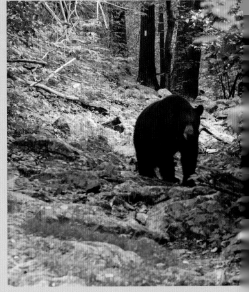

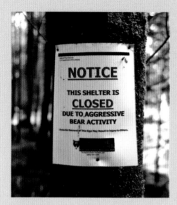

ABOVE: Bear closure sign, Mount Collins Shelter, Tennessee

RIGHT: Bear pole, Shenandoah National Park, Virginia

BELOW: Black bear along the trail, Pennsylvania

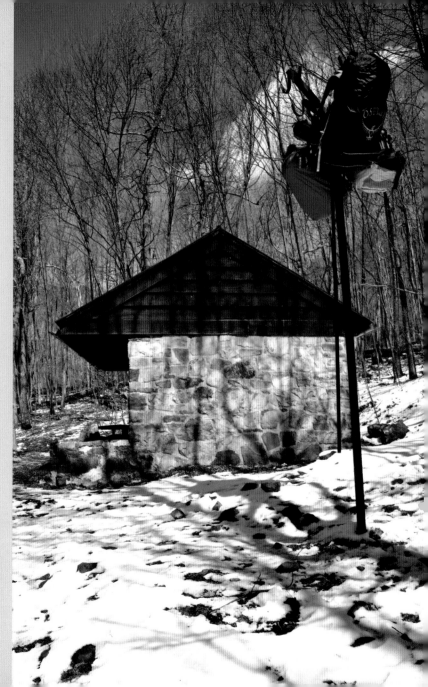

VIRGINIA

TOP: Stile over fence; **MIDDLE:** Maupin Field Shelter; **ABOVE:** Makeshift milestone along the trail; **RIGHT:** McAfee Knob, the most-photographed site on the AT

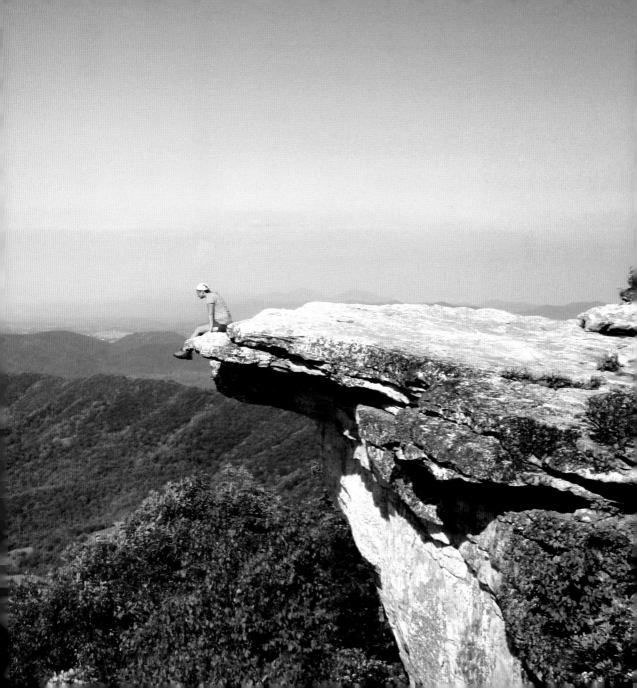

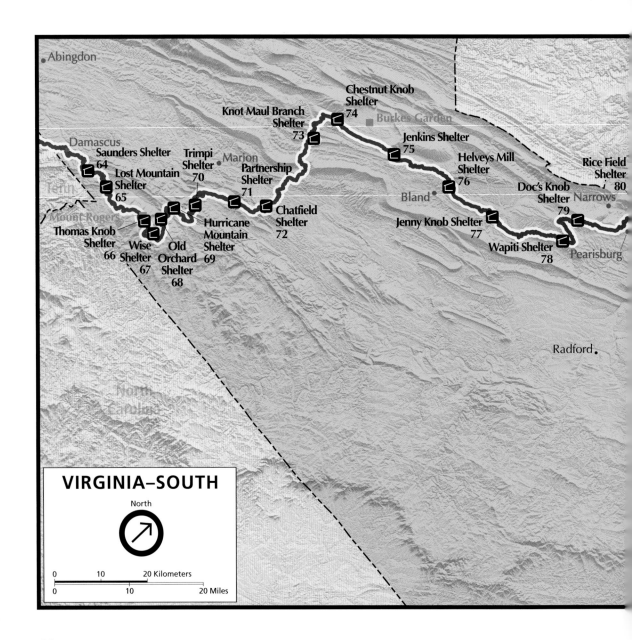

VIRGINIA–SOUTH

North

0 10 20 Kilometers
0 10 20 Miles

Abingdon

Damascus

Saunders Shelter
64

Lost Mountain
Shelter
65

Trimpi
Shelter
70

Marion

Partnership
Shelter
71

Knot Maul Branch
Shelter
73

Chestnut Knob
Shelter
74

Burkes Garden

Jenkins Shelter
75

Helveys Mill
Shelter
76

Rice Field
Shelter
80

Doc's Knob
Shelter
79

Narrows

Bland

Jenny Knob Shelter
77

Wapiti Shelter
78

Pearisburg

Thomas Knob
Shelter
66

Wise
Shelter
67

Old
Orchard
Shelter
68

Hurricane
Mountain
Shelter
69

Chatfield
Shelter
72

Mount Rogers

North
Carolina

Radford

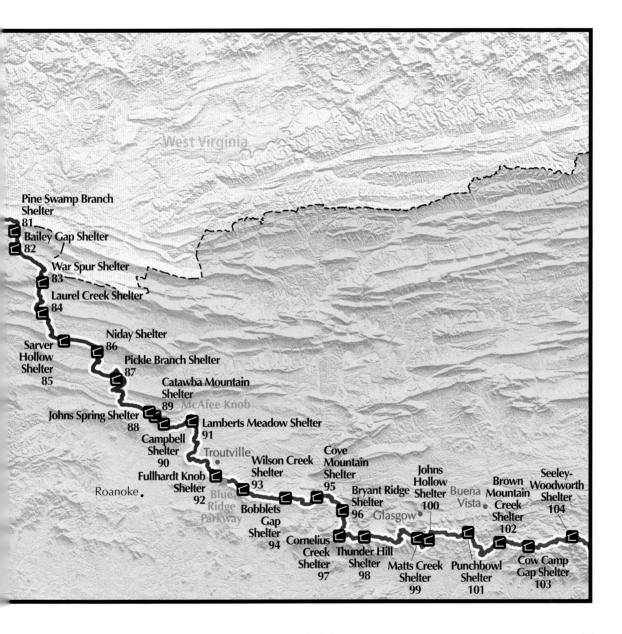

Pine Swamp Branch Shelter
81

Bailey Gap Shelter
82

War Spur Shelter
83

Laurel Creek Shelter
84

Niday Shelter
86

Sarver Hollow Shelter
85

Pickle Branch Shelter
87

Catawba Mountain Shelter
89

McAfee Knob

Johns Spring Shelter
88

Lamberts Meadow Shelter
91

Campbell Shelter
90

Troutville

Cove Mountain Shelter
95

Johns Hollow Shelter
100

Brown Mountain Creek Shelter
102

Seeley-Woodworth Shelter
104

Fullhardt Knob Shelter
92

Wilson Creek Shelter
93

Bryant Ridge Shelter
96

Buena Vista

Roanoke

Blue Ridge Parkway

Glasgow

Bobblets Gap Shelter
94

Cornelius Creek Shelter
97

Thunder Hill Shelter
98

Matts Creek Shelter
99

Punchbowl Shelter
101

Cow Camp Gap Shelter
103

West Virginia

Virginia

SAUNDERS SHELTER

#	64		0.2 mi W	💧	Reliable spring behind and to right of shelter, then down blue-blazed trail; old woods road does not lead to spring
📍	VA	📅	1987	🚽	Y
🏔	3,310 ft	🔨	N/A	🐻	N
⋰	480.1	🛏	8	👥	MRATC

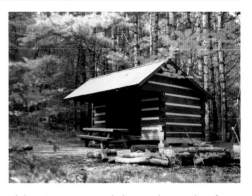

▶ The first shelter in Virginia, this log design with white chinking was constructed by the Mount Rogers Appalachian Trail Club (MRATC) and the ATC Konnarock Trail Crew in memory of Walter Teague Saunders (1950–1985). It is located north of the Virginia Creeper Trail, a 33-mile rails-to-trails route that runs from Abingdon to the North Carolina border. The AT travels along this trail for a short stretch north of Damascus and then again 10 miles down the trail before going back into the woods. Local companies rent bikes and drop riders off at the top of the trail so they can cruise the easy grade back to Damascus. This is the first shelter maintained by the MRATC. Established in 1960, the club maintains seven shelters and 59.4 miles of the AT from the Tennessee-Virginia border to Teas Road. The MRATC also maintains other trails in the area, including in the Jefferson National Forest, Mount Rogers National Recreation Area, and Grayson Highlands State Park.

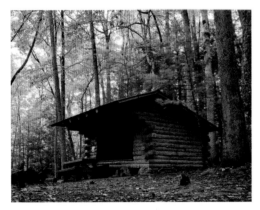

LOST MOUNTAIN SHELTER

#	65	🛏	8
📍	VA	💧	Reliable spring behind and to left when facing shelter, then 0.1 mi down blue-blazed trail
🏔	3,360 ft		
⋰	486.6		
📍	On AT	🚽	Y
📅	1994	🐻	N
🔨	N/A	👥	MRATC

▲ This shelter is located on Lost Mountain (3,592 feet) near Whitetop Mountain (5,520 feet), which is Virginia's second-highest independent mountain after nearby Mount Rogers (5,729 feet). The AT does not go over either summit. A sign on the front of it says 1995, but trail club historians say it was built in 1994. The privy was built in 1995. The nearby Whitetop community hosts many annual festivals celebrating ramps, maple syrup, and molasses, and the White Top Folk Festival was held on the mountain from 1931 to 1939 (except for 1937).

THOMAS KNOB SHELTER

#	66	🛏	16
📍	VA	💧	Reliable spring behind and to left when facing shelter, fenced in a pasture, about 0.125 mi
⛰	5,400 ft		
⟋	499		
📍	On AT	🚽	Y
📅	1991	🐻	Bear box
🔨	N/A	👥	MRATC

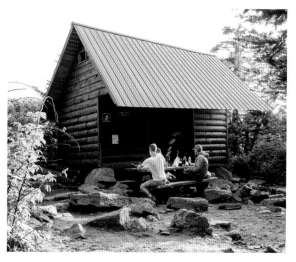

▶ A large two-level shelter built by the MRATC and Konnarock Trail Crew, this is the highest-elevation shelter in Virginia. It is located on the AT, 0.2 miles north of the spur trail to the wooded summit of Mount Rogers (5,729 feet), the state's tallest mountain. Local ponies from Grayson Highlands are known to chew on packs and other salty items. Please don't feed them. The shelter is dedicated to Nerine and David Thomas, founders of the MRATC (1960) and stewards of the AT for more than 50 years. No tenting is allowed around the shelter or on the spur trail to Mount Rogers. Bears have been spotted at all seven shelters in the MRATC section; they have bothered people near this shelter and Wise Shelter to the north. Bear boxes have been installed at some locations on a temporary basis to see if they curb activity.

WISE SHELTER

#	67	🛏	8
📍	VA	💧	Small seep spring down blue-blazed trail to left when facing front of shelter; better source is creek 0.125 mi north of shelter
⛰	4,460 ft		
⟋	504.1		
📍	On AT		
📅	1996	🚽	Y
🔨	N/A	🐻	Bear box
		👥	MRATC

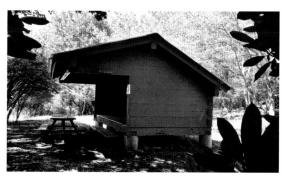

◀ Located in Grayson Highlands State Park, this shelter was built by the MRATC and the state park and is dedicated to Tom and Clara Wise, donor-designer. There is no tenting allowed near the shelter or in the state park. Wild ponies might make an appearance.

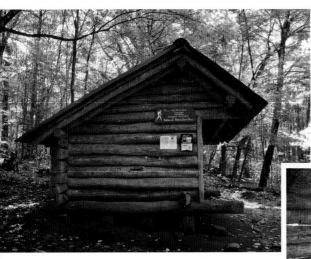

OLD ORCHARD SHELTER

#	68	📅	1970
📍	VA	🔨	N/A
⛰	4,050 ft	🛏	6
⟋	510.1	💧	Reliable spring to right when facing shelter, then down blue-blazed trail about 0.125 mi
📍	On AT		
		🚻	Y
		🐻	Bear box
		👥	MRATC

▲ ▶ One of the older Adirondack-style log shelters in the area, this structure is located near the Old Orchard Trail on national forest land.

HURRICANE MOUNTAIN SHELTER

#	69	📅	2004	🚻	Y
📍	VA	🔨	N/A	🐻	N
⛰	3,850 ft	🛏	8	👥	MRATC
⟋	515	💧	Creek opposite sign for shelter		
📍	0.1 mi W				

▶ Built by the MRATC in partnership with the Appalachian Trail Conservancy (ATC) and the United States Forest Service (USFS), this is one of the newest shelters in Virginia. It is located near Hurricane Mountain (3,850 feet) and the Tennessee-New River Divide.

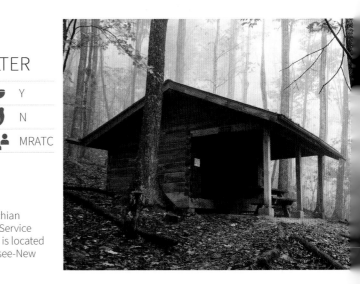

TRIMPI SHELTER

70

📍 VA

⛰️ 2,900 ft

⟋ 524.2

📍 0.1 mi E

📅 1975

🔨 N/A

🛏️ 8

💧 Spring down short blue-blazed trail in front of shelter

🚻 Y

🐻 N

👥 MRATC

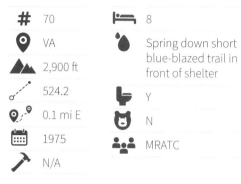
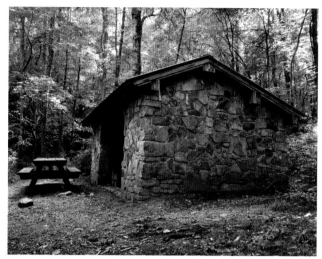

▶ This stone shelter has two bunks on each side and a big fireplace in the middle along the long wall. A plaque dedicates it in memory of Robert William Trimpi (1951–1969).

PARTNERSHIP SHELTER

71

📍 VA

⛰️ 3,360 ft

⟋ 534

📍 On AT

📅 1998

🔨 N/A

🛏️ 16

💧 Cold-water shower available during warm months; water faucet behind shelter; spigot at park headquarters

🚻 Y

🐻 N

👥 PATH

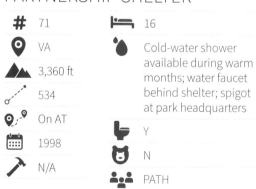
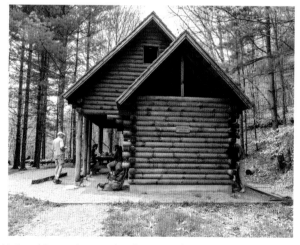

▶ Located just more than 0.1 miles from the Mount Rogers National Recreation Area headquarters, this popular shelter is known for being able to get pizza delivered to the headquarters gate. It was built in memory of Thomas R. Baldwin (1961–1995), "a lover of the Virginia Mountains," with the help and support of his friends and family. It is the first shelter maintained by the Piedmont Appalachian Trail Hikers (PATH). Established in 1965, the club maintains five shelters and 65.4 miles of the AT from Teas Road to Bland.

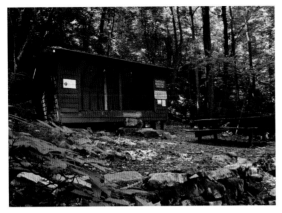

CHATFIELD SHELTER

#	72	🛏	6
📍	VA	💧	Creek in front of shower
⛰	3,150 ft		
⟋	541	🚽	Y
📍	On AT	🐻	N
📅	1970s	👥	PATH
🔨	1996		

▲ This is the first of many shelters in Virginia built in the USFS plank-sided lean-to design rather than from logs. It is a common design throughout the state and is found along the trail in USFS lands. It was built at a different location in the 1970s as Glade Mountain Shelter and then moved to its current location in 1996. It is located south of the Settlers Museum and Lindamood School. The museum, with free admission for hikers, and the unlocked school, built in 1894, show a glimpse of early life in the area.

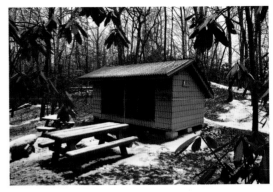

KNOT MAUL BRANCH SHELTER

#	73	💧	Intermittent, unreliable spring 300 ft to left of shelter; water 0.1 mi north of shelter way downhill to reliable stream
📍	VA		
⛰	2,800 ft		
⟋	560.3		
📍	On AT	🚽	Y
📅	1984	🐻	N
🔨	N/A	👥	PATH
🛏	8		

▲This shelter was named for the surrounding forest and the history of local farmers who collected hardwood for their maul and mallet handles. Davis Path Shelter, decimated by beetles, was located south of this shelter and was torn down in 2007. PATH plans to rebuild it in the same location.

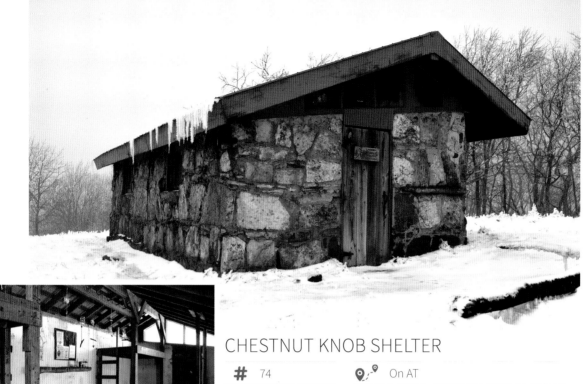

CHESTNUT KNOB SHELTER

74

◉ VA

⛰ 4,409 ft

⸰⸱ 569.7

◉ On AT

📅 1920s

🔨 1994

🛏 8

💧 None at shelter; hikers should get water at other sources before staying the night at the knob; intermittent unreliable spring 0.3 mi from shelter down jeep road

🚽 Y

🐻 N

👥 PATH

 A former USFS fire warden's cabin with a fire tower, this fully enclosed stone shelter has plexiglass windows and three sets of wooden bunks. It overlooks the craterlike formation of Burke's Garden, also known as "God's Thumbprint." The deep, mountain-ringed bowl is 10 miles in diameter and surrounded by tall ridges on all sides. The AT ridge follows the feature for almost 8 miles. The valley sits at 3,000 feet and is the highest mountain valley in Virginia. James Burke discovered the rare geologic feature in the 1740s while hunting in the area. The name Burke's Garden was given to the valley as a joke in 1748 after Burke planted potato peelings by his campfire and potatoes sprouted the next year. Today, the area is believed to have some of the most fertile farmland in the state.

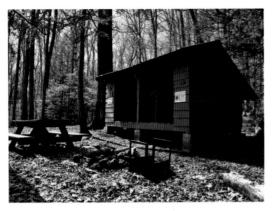

JENKINS SHELTER

#	75	🛏	8
📍	VA	💧	Stream 100 yd north on blue-blazed trail
🏔	2,470 ft	🚻	Y
⟋	580.4	🐻	N
📍	On AT	👥	PATH
📅	1960s		
🔨	1980s		

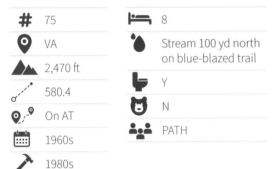

▲ This shelter is located in the Jefferson National Forest, south of Hunting Camp Creek. The original 1960s structure, Monster Rock Shelter, was on Walker Mountain before the trail was rerouted. The shelter was moved to its current location in the 1980s.

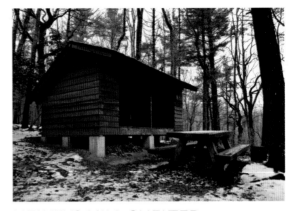

HELVEYS MILL SHELTER

#	76	🛏	6
📍	VA	💧	Source 0.1 mi down switchbacked trail in front of shelter
🏔	3,090 ft	🚻	Y
⟋	593.9	🐻	N
📍	0.1 mi E	👥	OCVT
📅	1960s		
🔨	N/A		

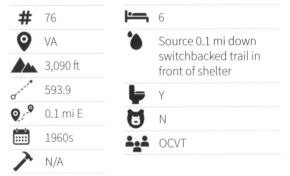

▲ Located north of the I-77 overpass, this shelter is a wooden-plank design. Its picnic table has a plaque for a 2006 Eagle Scout project by Ted Born. It is the first shelter maintained by the Outdoor Club at Virginia Tech (OCVT). Established in 1970, the club maintains three shelters, 8.8 miles, and two sections of the AT divided between Bland and VA-611, and 18.9 miles between US 460 and Pine Swamp Branch Shelter.

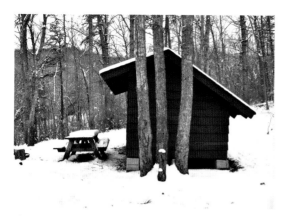

JENNY KNOB SHELTER

77

📍 VA

⛰ 2,800 ft

⤴ 603.6

📍 On AT

📅 1960s

🔨 2000

🛏 6

💧 Source on blue-blazed trail to left of shelter, past privy

🚽 Y

🐻 N

👥 RATC

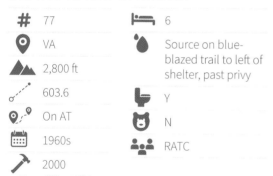

▲ Located north of Brushy Mountain (2,680 feet) between VA-611 and VA-608, this wooden-plank shelter with a picnic table is the first shelter maintained by the Roanoke Appalachian Trail Club (RATC). Established in 1932, the club maintains 15 shelters, 36.9 miles of the AT between VA-611 and US 460, and 87 miles between Pine Swamp Branch Shelter and Black Horse Gap.

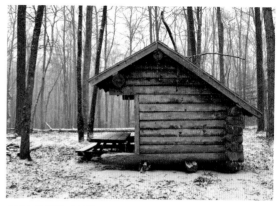

WAPITI SHELTER

78

📍 VA

⛰ 2,600 ft

⤴ 618.1

📍 0.1 mi E

📅 1980

🔨 N/A

🛏 8

💧 Reliable Dismal Creek nearby

🚽 Y

🐻 N

👥 RATC

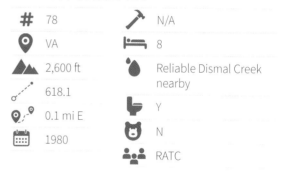

▲ A prefab log cabin, this is one of the only Adirondack-style structures in Virginia. There is a large pond nearby. In May 1981, 27-year-old social workers Laura Susan Ramsay and Robert Mountford Jr. were slain at this shelter in Giles County.

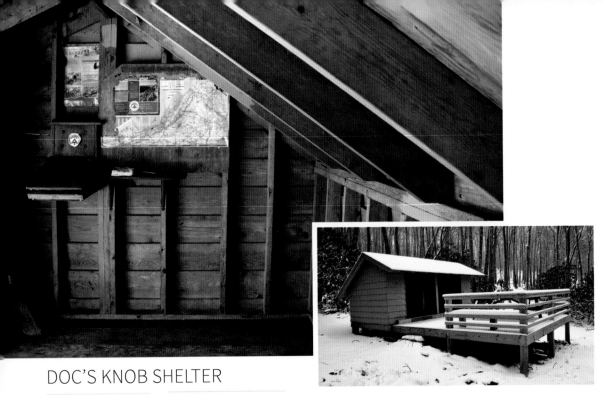

DOC'S KNOB SHELTER

#	79	🛏	8
📍	VA	💧	Reliable spring near shelter; often goes dry by June
⛰	3,555 ft		
⌁	627.6	🚻	Y
📍↗	On AT	🐻	N
📅	1971	👥	RATC
🔨	Deck added in 2017		

▲▲ The last shelter before entering the Central Virginia section of the AT, this wooden-plank design has a large front deck and a picnic table.

RICE FIELD SHELTER

#	80	🛏	7
📍	VA	💧	Source 0.5 mi south of shelter on AT; may dry up during drought
⛰	3,400 ft		
⌁	643.7	🚻	Y
📍↗	< 0.1 mi	🐻	N
📅	1995	👥	OCVT
🔨	2000		

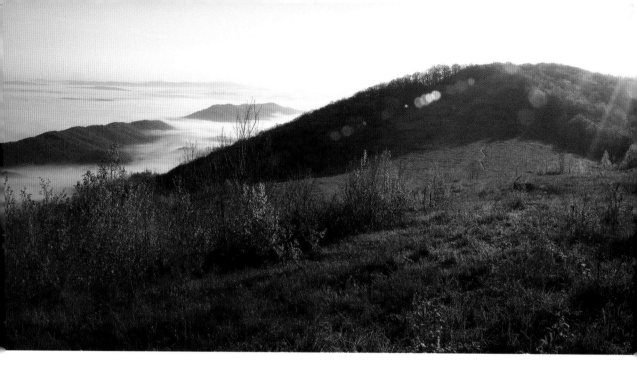

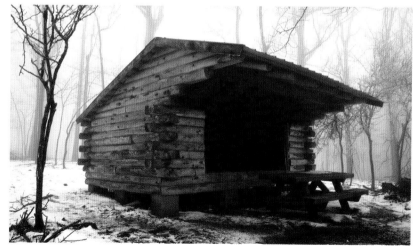

▶ This log shelter is located in the woods at the edge of a field. Hikers must climb over a stile and fence to get to it. Located south of the Peters Mountain traverse along the Virginia-West Virginia border, it is a great location for sunset watching and has views into West Virginia.

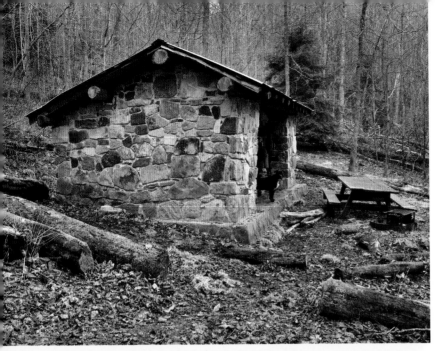

PINE SWAMP BRANCH SHELTER

#	81
📍	VA
⛰	2,530 ft
⟋	656.3
📍	On AT
📅	1980s
🔨	2008
🛏	8
💧	Reliable stream 75 yd down blue-blazed trail near shelter
🚽	Y
🐻	N
👥	OCVT

▲ ◀ Unique for this area, this stone shelter is designed with two bunks on each side and a fireplace in the middle, similar to the design of Trimpi Shelter to the south. It is also dedicated in memory of Robert William Trimpi (1951–1969).

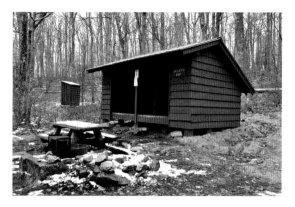

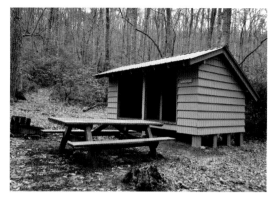

BAILEY GAP SHELTER

82

📍 VA

⛰ 3,525 ft

⚲ 660.2

📍 On AT

📅 1965

🔨 N/A

🛏 6

💧 Tiny spring about 0.1 mi from shelter, but goes dry in early summer; spring 0.2 mi south of shelter more reliable, but can also go dry in drought periods

🚻 Y

🐻 N

👥 RATC

WAR SPUR SHELTER

83

📍 VA

⛰ 2,340 ft

⚲ 669

📍 On AT

📅 1965

🔨 N/A

🛏 6

💧 Reliable stream north on AT

🚻 Y

🐻 N

👥 RATC

▲ Located north of Wind Rock (4,121 feet) and south of Johns Creek Valley (2,102 feet), this shelter is a wooden-plank design with a picnic table.

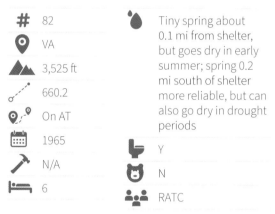

▲ This shelter is a wooden-plank design with a picnic table. The area around the shelter is rocky and there is not a lot of camping.

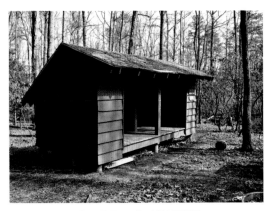

LAUREL CREEK SHELTER

#	84	🛏	8
📍	VA	💧	West on AT at shelter turnoff
⛰	2,720 ft	🚽	Y
⟋	674.8	🐻	N
📍	< 0.1 mi	👥	RATC
📅	1988		
🔨	N/A		

▲ Named for Laurel Creek nearby, this shelter is a wooden-plank design with a picnic table. It was originally located near the top of Kelly Knob and was called Big Pond Shelter. In 1988, United States Marine Corps and RATC volunteers moved it to its current location—south of the famous Keffer Oak. At 300 years old and with a girth of 18 feet, 3 inches, it is the largest oak tree on the southern half of the AT. It is second only to the Dover Oak in New York.

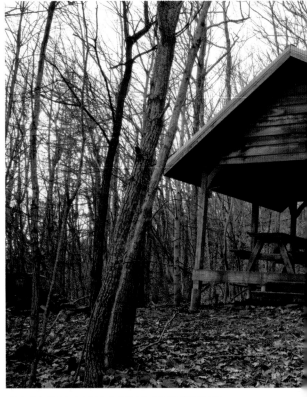

SARVER HOLLOW SHELTER

#	85	🔨	N/A
📍	VA	🛏	12
⛰	3,000 ft	💧	Spring on blue-blazed trail near shelter
⟋	681.2	🚽	Y
📍	0.4 mi E downhill	🐻	N
📅	2002	👥	RATC

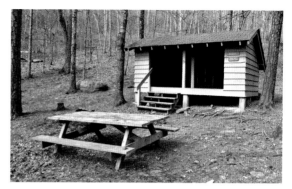

NIDAY SHELTER

#	86	📅	1960s	🚽	Y
📍	VA	🔨	2000	🐻	N
⛰️	1,800 ft	🛏️	6	👥	RATC
⋯	687.2	💧	Source 75 yd down blue-blazed trail		
📍	On AT				

▲ This shelter was built in the 1960s by the USFS and then moved to its current location in 1980 by the Marine Corps Reserve. It is located south of Brushy Mountain (2,600 feet) and the Audie Murphy Monument on a blue-blazed trail that also leads to a view. Murphy was a local and national hero, becoming the most decorated World War II soldier. He became a movie star after the war and was in countless films, mostly westerns, but also starred in a movie about his life titled *To Hell and Back*. He died in a plane crash in 1971 near the monument site.

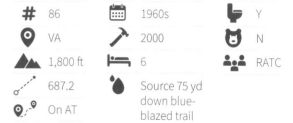

▲▲ This shelter was built by volunteers from the RATC, with help from the USFS, to fill in a 22-mile gap for northbound thru-hikers between Roanoke and Blacksburg. A memorial to Scott Marshall Riddick, it has a large covered eating area and skylights. It is located near remnants of the old Henry Sarver homestead from the 1850s. The Sarver family lived in the area for more than 70 years, from the Civil War to the Great Depression, before leaving and abandoning the homestead intact. Today, ghost chimneys, rock walls, a cemetery, and a few structures remain below the brick-lined springhouse that is still the water source for the shelter. According to local legends, the area has been haunted for years; some stories mention a ghost named George.

PICKLE BRANCH SHELTER

#	87	💧	Pickle Branch below shelter and down several flights of stairs; usually reliable, but may need to walk downstream during times of drought
📍	VA		
⛰	1,845 ft		
⟋	697.3		
📍	0.3 mi E	🚽	Y
📅	1960s	🐻	N
🔨	N/A	👥	RATC
🛏	6		

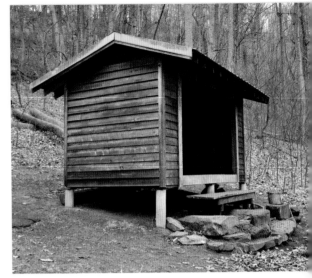

▼ Built in the 1960s by the USFS, this shelter was moved to its present location in 1980 by RATC volunteers and USFS staff. It is located south of Dragon's Tooth, the first of three special geological formations along the AT heading north that make up the Virginia "Triple Crown." The other two are McAfee Knob and Tinker Cliffs.

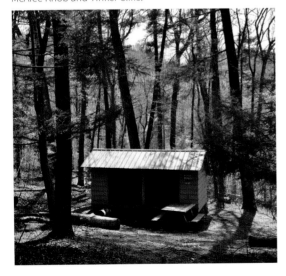

JOHNS SPRING SHELTER

#	88	🛏	6
📍	VA	💧	Source 0.25 mi down blue-blazed trail; unreliable source in front of shelter
⛰	1,980 ft		
⟋	710.9		
📍	On AT	🚽	Y
📅	2003	🐻	N
🔨	N/A	👥	RATC

▲ This is one of the newest shelters in Virginia. It was built as a memorial to John P. Haranzo, an avid AT hiker and RATC member. The plaque inside also dedicates it to his dog, Chester. Formerly known as Boy Scout Shelter, it was built by the RATC as a replacement for the older shelter.

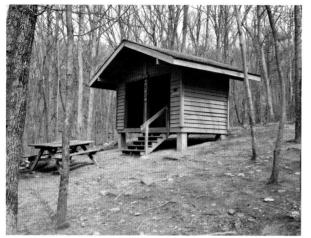

CATAWBA MOUNTAIN SHELTER

#	89	🛏	6
📍	VA	💧	Blue-blazed trail directly in front of shelter
⛰	2,580 ft		
↗	711.9	🚻	Y
📍	On AT	🐻	Bear box
📅	1984	👥	RATC
🔨	N/A		

▲ Located a mile north of Johns Spring Shelter, this structure was built by volunteers from the RATC when the trail was rerouted from North Mountain to Catawba Mountain to include the famous McAfee Knob. Overflow campsites are available just north of the shelter.

CAMPBELL SHELTER

#	90	🛏	6
📍	VA	💧	Down blue-blazed trail to left and behind shelter
⛰	2,580 ft		
↗	714.3	🚻	Y
📍	< 0.1 mi	🐻	Bear box
📅	1989	👥	RATC
🔨	N/A		

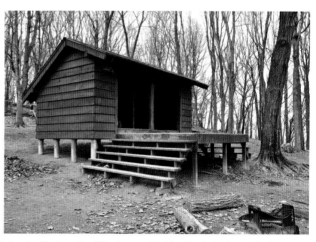

▶ Built by the RATC, this shelter with an attached deck is located just north of the famous McAfee Knob. A plaque dedicates it to RATC pioneers Tom and Charlene Campbell. Camping is forbidden at the lookout because of the fragile environment and heavy traffic impact, but is available at Pig Farm Campsite located south of the shelter and 0.6 miles from the knob.

LAMBERTS MEADOW SHELTER

#	91	🛏	6
📍	VA	💧	Source 50 yd down trail in front of shelter; unreliable in drought years
⛰	2,080 ft		
⟋	720.3	🚽	Y
📍	On AT	🐻	Bear box
📅	1972	👥	RATC
🔨	N/A		

▼ Located north of Tinker Cliffs, a 0.5-mile exposed cliff walk, this is the oldest shelter in this section of the AT. Tentsites are 0.3 miles north. Local lore says the cliffs were named for the "tinkers," Revolutionary War deserters who lived in the area and repaired pots and pans.

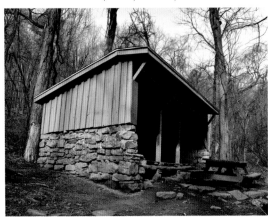

FULLHARDT KNOB SHELTER

#	92	💧	Cistern system; all water should be treated; sometimes unreliable; spring 0.4 mi north on AT, then 350 ft on unblazed trail
📍	VA		
⛰	2,676 ft		
⟋	734.7		
📍	0.1 mi E	🚽	Y
📅	1965	🐻	N
🔨	Roof extended in 2019	👥	RATC
🛏	6		

▼ Located at a former fire-tower site, this shelter is one of the few with no spring or water source nearby. It has the only remaining water-gathering cistern system still in functioning order on the AT. Rainwater is collected from the roof, stored in a large tank, and then accessed from a spigot just behind and below the shelter.

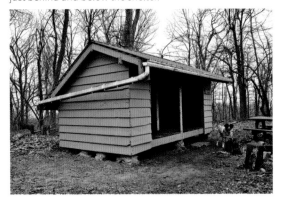

WILSON CREEK SHELTER

93

📍 VA

⛰ 1,830 ft

🔗 740.9

📍 < 0.1 mi

📅 1986

🔨 Roof extended in 2019

🛏 6

💧 Spring 0.3 mi north of shelter; Wilson Creek 0.7 mi south more reliable

🚽 Y

🐻 N

👥 RATC

▼ This shelter is located south of the first encounter with the Blue Ridge Parkway (BRP), a driving road that runs 469 miles from Waynesboro, Virginia, to Cherokee, North Carolina. The AT parallels the BRP and then Skyline Drive in Shenandoah National Park (SNP) for more than 200 miles and crosses it multiple times.

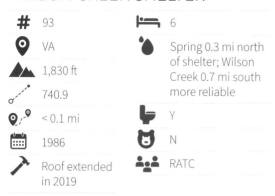

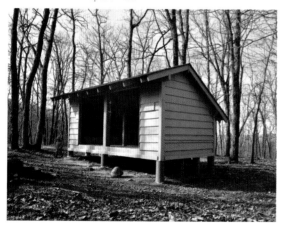

BOBBLETS GAP SHELTER

94

📍 VA

⛰ 1,920 ft

🔗 748.2

📍 0.2 mi W

📅 1961

🔨 N/A

🛏 6

💧 Spring to left of shelter; can dry up in drought years

🚽 Y

🐻 N

👥 NBATC

▼ This shelter was named for Will Bobblet, a local farmer who used to live nearby. It is the first shelter maintained by the Natural Bridge Appalachian Trail Club (NBATC). Established in 1930, the club maintains 12 shelters, 90.6 miles of the AT from Black Horse Gap to Tye River, and other hiking trails in Central Virginia.

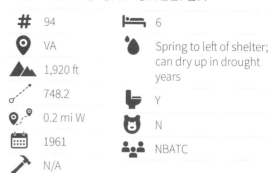

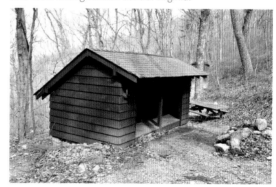

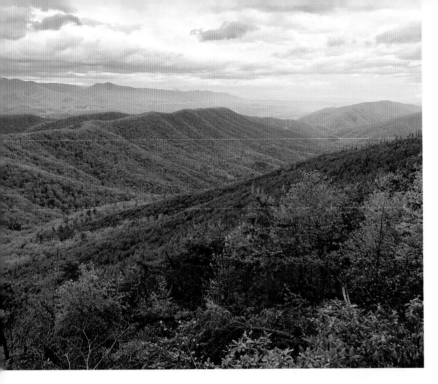

BRYANT RIDGE SHELTER

#	96
📍	VA
⛰	1,330 ft
⸱⸱⸱	761.7
📍	On AT
📅	1992
🔨	N/A
🛏	16
💧	Stream beside shelter
🚻	Y
🐻	N
👪	NBATC

COVE MOUNTAIN SHELTER

#	95	**🔨**	N/A
📍	VA	**🛏**	6
⛰	1,996 ft	**💧**	Steep 0.5 mi downhill, unmarked trail leads to stream
⸱⸱⸱	754.7		
📍	On AT	**🚻**	Y
📅	1981	**🐻**	N
		👪	NBATC

▶ This shelter was built by the USFS and volunteers from the NBATC with materials salvaged from Marble Spring Shelter, which was removed in February 1980.

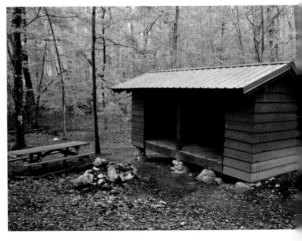

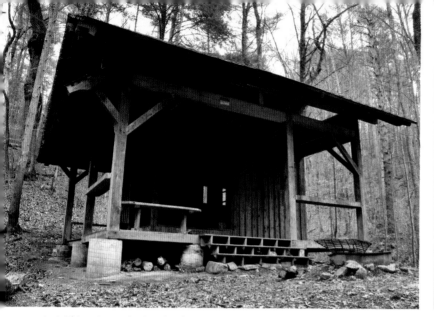
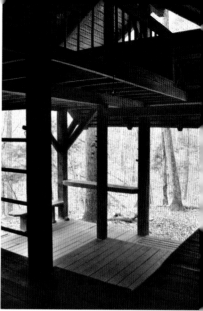

▲ ▲ This unique trilevel timber-frame shelter with an open loft design is dedicated to the memory of Nelson Leavell Garnett Jr. Built from a plan designed by Garnett's architecture school classmates and converted to timber-frame construction, the shelter was a cooperative project of the ATC, NBATC, USFS, Garnett's family, and several area firms. Garnett's parents, in memory of their son who loved hiking on the AT, helped with the costs. A set of logging horses pulled the timbers to the site from the closest road.

CORNELIUS CREEK SHELTER

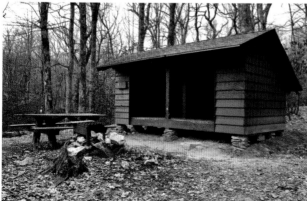

#	97	🔨	N/A
📍	VA	🛏	6
⛰	3,145 ft	💧	Spring on shelter access trail
•	766.6		
📍	0.1 mi E	🚽	Y
📅	1960	🐻	N
		👥	NBATC

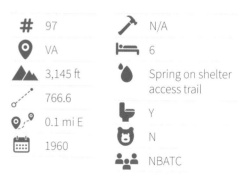

◀ This is one of the older shelters on this stretch of the AT. It is located south of Black Rock (3,420 feet) and the Cornelius Creek Trail. An unmarked trail behind the shelter leads 0.1 miles to a fire road and then left 0.2 miles to the BRP.

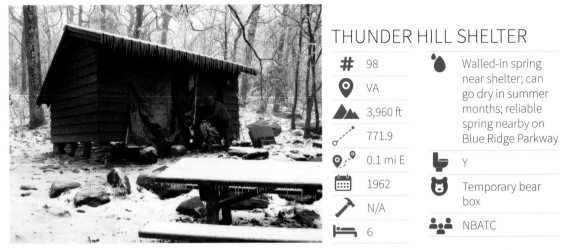

THUNDER HILL SHELTER

#	98	💧	Walled-in spring near shelter; can go dry in summer months; reliable spring nearby on Blue Ridge Parkway
📍	VA		
🏔	3,960 ft		
📏	771.9		
📍📍	0.1 mi E	🚽	Y
📅	1962	🐻	Temporary bear box
🔨	N/A		
🛏	6	👥	NBATC

▲ This shelter is located on the northern slope of Apple Orchard Mountain (4,225 feet), the tallest point on the AT between Chestnut Knob in Virginia and Mount Moosilauke in New Hampshire. There are remnants of an old Air Force Base on the summit. No camping is allowed on the summit.

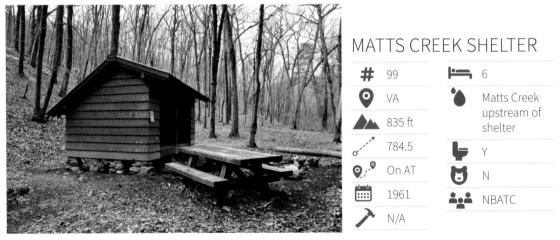

MATTS CREEK SHELTER

#	99	🛏	6
📍	VA	💧	Matts Creek upstream of shelter
🏔	835 ft		
📏	784.5		
📍📍	On AT	🚽	Y
📅	1961	🐻	N
🔨	N/A	👥	NBATC

▲ The lowest-elevation shelter in Virginia is located in the James River Face Wilderness of the Jefferson National Forest. Swimming holes are located nearby.

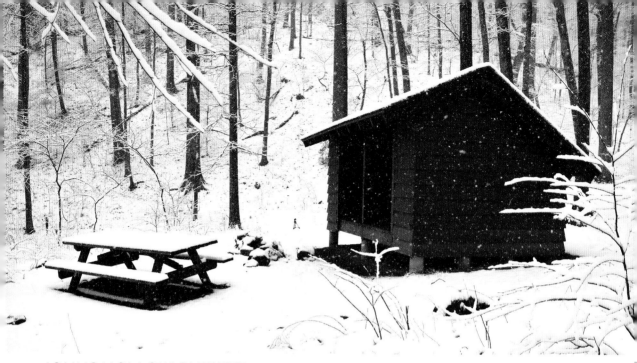

JOHNS HOLLOW SHELTER

#	100	🔨	N/A
📍	VA	🛏	6
⛰	1,020 ft	💧	Spring and stream on both sides of shelter
⸜	788.4	🚽	Y
📍	0.1 mi E	🐻	N
📅	1961	👥	NBATC

▲ ▶ This is the first shelter northbound hikers encounter after crossing the James River Foot Bridge. It is located near the trail town of Glasgow, which is also home to a shelter for AT hikers built in 2010 by local Eagle Scout Parks Talbott.

PUNCHBOWL SHELTER

#	101	🔨	N/A
📍	VA	🛏	6
⛰	2,500 ft	💧	Spring by tree near pond
⟋	797.2	🚽	Y
📍	0.2 mi W	🐻	N
📅	1961	👥	NBATC

▼ This shelter is located in the George Washington National Forest between the James and Tye Rivers. A tentsite is nearby. Local lore says the ghost of a four-year-old boy who wandered away from his school in November 1891 while gathering firewood haunts the shelter. The body of Emmett (Ottie) Cline Powell, or "Little Ottie," was found months later—several miles from the schoolhouse, up very difficult terrain, and at the top of nearby Bluff Mountain (3,391 feet). A monument to his passing is located south on the trail and is said to have some conflicting information, including the date when he got lost. Some NBATC members erected a permanent gravestone for his final resting place, 7 miles from the monument.

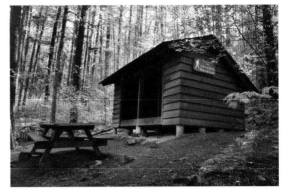

BROWN MOUNTAIN CREEK SHELTER

#	102	🛏	6
📍	VA	💧	Spring near shelter; Brown Mountain Creek south of shelter also an option
⛰	1,395 ft		
⟋	806.7		
📍	On AT	🚽	Y
📅	1961	🐻	N
🔨	N/A	👥	NBATC

▲ This shelter is located north of Brown Mountain Creek and near the site of the former Brown Mountain Creek community, which existed before the national forest and the AT. It was started by descendants of freed slaves who moved here after the Civil War and made a living growing corn and tobacco until about 1918. They created a small but thriving community of houses, barns, and outbuildings near the stream that gives the hollow its name, and some stonework remains.

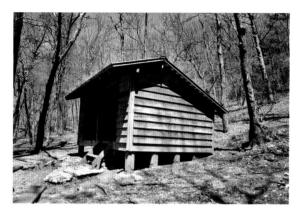

COW CAMP GAP SHELTER

#	103	🔨	N/A
📍	VA	🛏	8
⛰	3,200 ft	💧	Spring on blue-blazed trail near shelter
⸞	812.3	🚻	Y
📍	0.6 mi E	🐻	N
📅	1986	👥	NBATC

▲ The side trail that leads to this shelter, the Old Hotel Trail, is located between the wooded summit of Bald Knob (4,059 feet) and Cole Mountain (4,022 feet). The NBATC and USFS mow the Cole Mountain bald to maintain views and animal habitats.

SEELEY-WOODWORTH SHELTER

#	104	🛏	6
📍	VA	💧	Piped spring 0.1 mi beyond shelter
⛰	3,770 ft	🚻	Y
⸞	822.5	🐻	N
📍	< 0.1 mi E	👥	NBATC
📅	1984		
🔨	N/A		

▼ Built by volunteers from the NBATC, this shelter is named in honor of Harold Seeley and Jack Woodworth, two longtime club members. It was constructed as part of a relocation of several shelters in this section of the trail, either to eliminate structures too close to roads or remove others from wilderness areas.

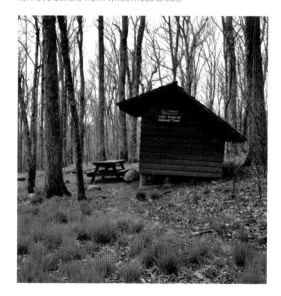

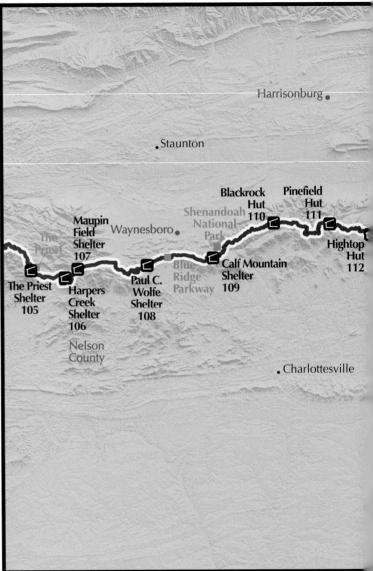

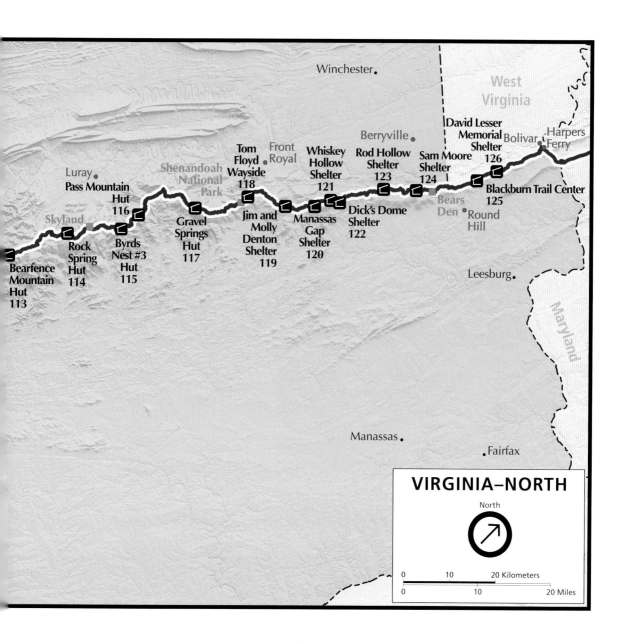

Winchester.

West Virginia

David Lesser Memorial Shelter 126

Bolivar. Harpers Ferry

Berryville.

Luray.
Pass Mountain Hut 116

Skyland

Shenandoah National Park

Tom Floyd Wayside 118

Front Royal

Whiskey Hollow Shelter 121

Rod Hollow Shelter 123

Sam Moore Shelter 124

Blackburn Trail Center 125

Rock Spring Hut 114

Byrds Nest #3 Hut 115

Gravel Springs Hut 117

Jim and Molly Denton Shelter 119

Manassas Gap Shelter 120

Dick's Dome Shelter 122

Bears Den

Round Hill

Bearfence Mountain Hut 113

Leesburg.

Maryland

Manassas.

.Fairfax

VIRGINIA–NORTH

North

| 0 | 10 | 20 Kilometers |
| 0 | 10 | 20 Miles |

THE PRIEST SHELTER

#	105	🔨	N/A
📍	VA	🛏	6
⛰	3,840 ft	💧	Spring near shelter
↗	829.1	🚻	Y
📍	0.1 mi E	🐻	N
📅	1960	👥	NBATC

◀ It is traditional for hikers to confess their sins to "the Priest" in this shelter's logbook. It is named for the nearby mountain, The Priest (4,063 feet). Heading north, after the summit, hikers descend 3,000 feet to the Tye River.

HARPERS CREEK SHELTER

#	106	🛏	6
📍	VA	💧	Harpers Creek in front of shelter
⛰	1,800 ft	🚻	Y
↗	836.7	🐻	N
📍	On AT	👥	TATC
📅	1960		
🔨	N/A		

▲ The only shelter within the Three Ridges Wilderness, this is the first one maintained by the Tidewater Appalachian Trail Club (TATC). Established in 1972, the TATC maintains two shelters and 10.6 miles of the AT from the Tye River to Reeds Gap. The club also maintains many state park trails in the Tidewater area and 23 miles in the Blue Ridge Mountains, including the White Rock Falls Trail, the Mau-Har Trail off the AT, and select trails in St. Mary's Wilderness. Designated low-impact tentsites are located near the shelter.

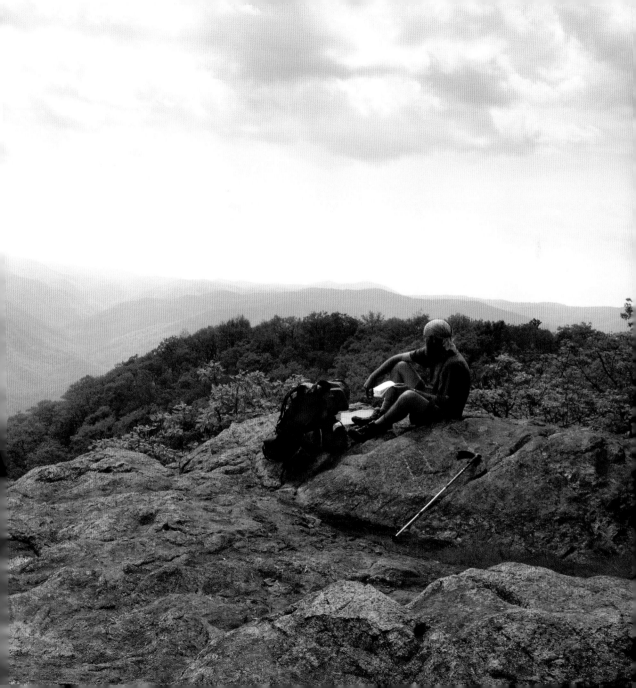

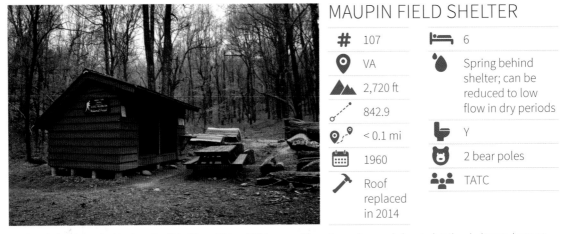

MAUPIN FIELD SHELTER

#	107	🛏	6
📍	VA	💧	Spring behind shelter; can be reduced to low flow in dry periods
⛰	2,720 ft		
⟋	842.9	🚽	Y
📍⟋	< 0.1 mi	🐻	2 bear poles
📅	1960	👥	TATC
🔨	Roof replaced in 2014		

▲ This shelter is located just north of the Three Ridges Wilderness. There is one bear pole located at the shelter and one at designated low-impact tentsites near the AT.

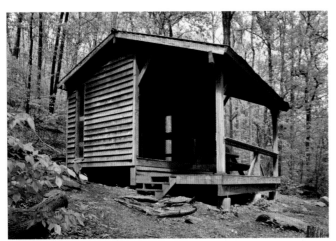

PAUL C. WOLFE SHELTER

#	108	🔨	N/A
📍	VA	🛏	10
⛰	1,700 ft	💧	Mill Creek in front of shelter
⟋	858.7		
📍⟋	On AT	🚽	Y
📅	1991	🐻	Bear pole
		👥	ODATC

◀ This two-story shelter, built by volunteers from the Old Dominion Appalachian Trail Club (ODATC), is the only one maintained by the club. Established in 1969, the ODATC maintains 19.1 miles of the AT from Reeds Gap to Rockfish Gap. The shelter is original construction with a few repairs along the way, including a floor replacement from a fire and a roof replacement early on. Located north of Humpback Rocks, it is the last shelter northbound before entering SNP. Free permits are required for overnight hikers staying in the park. There are also tentsites nearby.

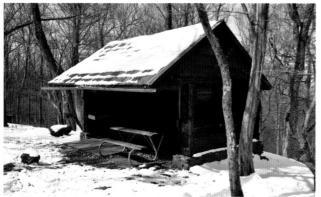

CALF MOUNTAIN SHELTER

#	109	🔨	N/A
📍	VA	🛏	6
⛰	2,700 ft	💧	Piped spring on access trail
⟋	871.4		
📍⟋	0.1 mi W	🚽	Y
📅	1984	🐻	N
		👥	PATC

◀ Not part of the SNP hut system or park rules, this is the first shelter maintained by the Potomac Appalachian Trail Club (PATC). Established in 1927, the club maintains a locked cabin system and 30 shelters, the Blackburn Trail Center, and 240.5 miles of the AT from Rockfish Gap, Virginia, to Pine Grove Furnace State Park, Pennsylvania. This shelter was built, in part, out of remains of Riprap and Sawmill Run Shelters, both of which were dismantled due to overuse. Water is scarce between this shelter and Blackrock Hut.

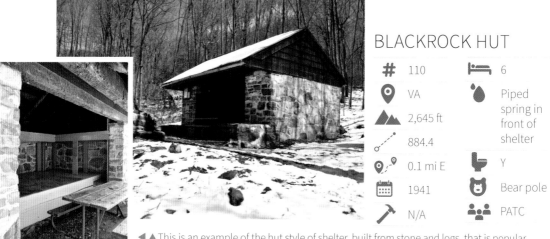

BLACKROCK HUT

#	110	🛏	6
📍	VA	💧	Piped spring in front of shelter
⛰	2,645 ft		
⟋	884.4		
📍⟋	0.1 mi E	🚽	Y
📅	1941	🐻	Bear pole
🔨	N/A	👥	PATC

◀▲This is an example of the hut style of shelter, built from stone and logs, that is popular in this section of the trail in SNP. The current shelter is the original structure from 1941. Designated tentsites are also available. Overnight camping at or within sight of shelters in SNP was once prohibited because the park superintendent was concerned AT shelters had become party locations for visitors. The ban was eventually relaxed after much contention between the PATC and SNP in the 1970s.

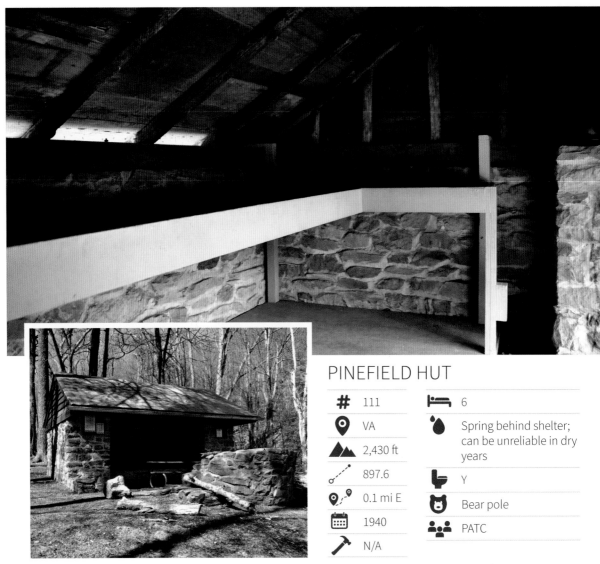

PINEFIELD HUT

#	111	🛏	6
📍	VA	💧	Spring behind shelter; can be unreliable in dry years
⛰	2,430 ft		
	897.6	🚽	Y
	0.1 mi E	🐻	Bear pole
📅	1940	👥	PATC
🔨	N/A		

▲ ▲ Located near Pinefield Gap (2,590 feet), this shelter was built in the style typical to SNP at the time of its construction—a stone base with a wooden roof and a semicircle firepit. Designated tentsites are also nearby.

HIGHTOP HUT

#	112
📍	VA
⛰	3,175 ft
⤴	905.8
📍	0.1 mi W
📅	1939
🔨	N/A

🛏	6
💧	Reliable piped spring 0.1 mi on nearby side trail
🚽	Y
🐻	Bear pole
👥	PATC

▼ Located south of Hightop Mountain (3,587 feet), this is one of the oldest shelters on the AT in SNP. Designated tentsites are also nearby.

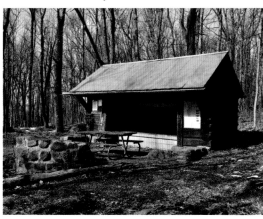

BEARFENCE MOUNTAIN HUT

#	113
📍	VA
⛰	3,110 ft
⤴	918.2
📍	0.1 mi E
📅	1940
🔨	N/A

🛏	6
💧	Piped spring in front of shelter; unreliable in dry periods
🚽	Y
🐻	Bear pole
👥	PATC

▼ Built by the Civilian Conservation Corps (CCC), this shelter is off a blue-blazed fire road. It is named for the nearby summit of Bearfence Mountain (3,640 feet). The origin of the Bearfence name came from a nearby pasture, which was fenced in to keep bears out. Designated tentsites are also nearby.

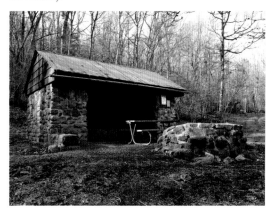

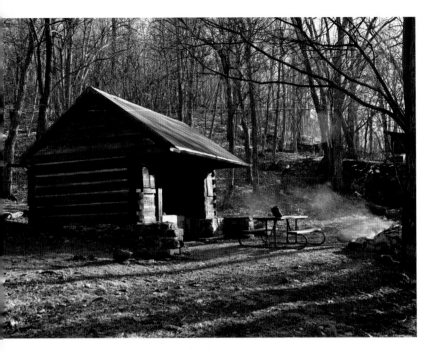

ROCK SPRING HUT

#	114	🛏	8
📍	VA	💧	Spring down steep trail in front of shelter; flows from under rock
🏔	3,465 ft		
⚬	929.7		
📍	0.1 mi W	🚻	Y
📅	1940s	🐻	Bear pole
🔨	1977	👥	PATC

▲ Originally named Elkwallow Shelter, this chestnut log structure was located too close to the parking lot of Elkwallow. An original shelter to the park, it was dismantled and moved to its current location. There is a locked PATC cabin in front of the shelter and designated tentsites are nearby.

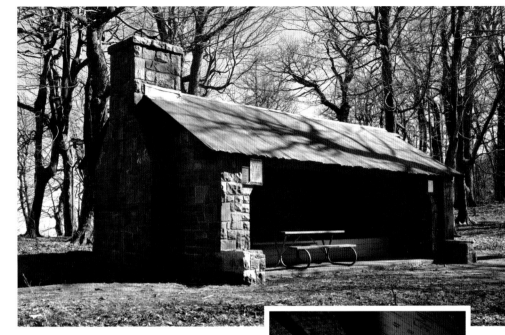

BYRDS NEST #3 HUT

 115

 VA

3,290 ft

940.6

 On AT

1964

2008

 8

 Spring 0.3 mi down fire road

 Y (moldering)

 Bear pole

 PATC

▲ ▶ This former SNP day-use picnic shelter was converted to an overnight shelter in 2008. It is a large stone structure with wraparound bunks and a fireplace.

PASS MOUNTAIN HUT

#	116	🛏	8
📍	VA	💧	Piped spring behind shelter
⛰	2,690 ft	🚽	N
∕	945	🐻	Bear pole
📍	0.1 mi E	👥	PATC
📅	1939		
🔨	N/A		

▼ Constructed largely out of stone by the PATC, this is one of the oldest shelters on the AT in SNP. Designated campsites are also nearby. Today the area around the shelter is heavily wooded, but when it was first built hikers had views up to Mary's Rock above Thornton Gap and into the foothills of Rappahannock County.

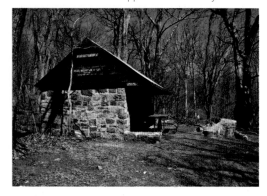

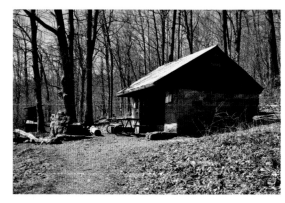

GRAVEL SPRINGS HUT

#	117	🔨	N/A
📍	VA	🛏	8
⛰	2,480 ft	💧	Box spring on side trail
∕	958.1	🚽	Y (moldering)
📍	0.1 mi E	🐻	Bear pole
📅	1940	👥	PATC

▲ Located near Gravel Springs Gap (2,666 feet), this shelter closed in 1974 and reopened in 1979. Designated tentsites are also nearby.

TOM FLOYD WAYSIDE

#	118	🛏	6
📍	VA	💧	Unreliable source 0.2 mi down blue-blazed trail
🏔	1,900 ft		
⟋	968.6	🚻	Y
📍	On AT	🐻	Bear pole
📅	1976	👥	PATC
🔨	N/A		

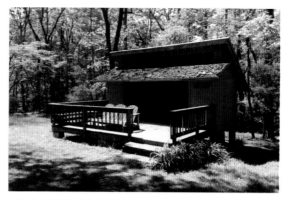

▼ This shelter is located outside SNP and is not actually a "wayside" like the small stores and restaurants inside the park. It has a large overhanging front deck with storage space. Built by longtime PATC volunteer Tom Floyd during the years when one couldn't stay overnight at the shelters in the park, it was later named for him. Floyd originally owned the land on which the shelter was built, which he purchased to secure the corridor before the National Trails System Act provided federal protection.

JIM AND MOLLY DENTON SHELTER

#	119	📍	On AT	🚻	Y
📍	VA	📅	1991	🐻	N
🏔	1,310 ft	🔨	N/A	👥	PATC
⟋	976.7	🛏	8		
		💧	Spring on AT		

▲ Located north of the Smithsonian Conservation Biology Institute—where hikers can get a glimpse of exotic animals through the fences—this shelter has a large front porch with bench seating, a pavilion, and an unreliable solar shower. Jim and Molly Denton originally came from Roanoke, where Jim was president of the RATC. They moved to Front Royal, joined the PATC, and he became the first person to scout the route of the Tuscarora Trail south of the Potomac River. In the days before the federal government protected the AT, the PATC and ATC feared the trail would be fragmented by second-home development in northern Virginia. The Tuscarora Trail was designed as a reroute for the AT, moving it west of its present location in SNP in Virginia and reconnecting with the AT near Darlington Shelter in Pennsylvania. After the government began acquiring private lands for the AT in 1978, the reroute was unnecessary, but the PATC decided to keep it as a separate trail. The shelter was named for the couple after Jim's death.

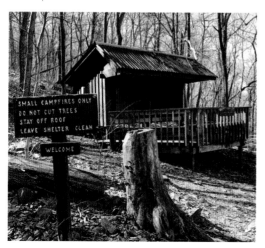

MANASSAS GAP SHELTER

#	120
📍	VA
🏔️	1,655 ft
⋯	982.2
📍	On AT
📅	1939
🔨	2002

🛏️	6
💧	Reliable spring near shelter
🚽	Y
🐻	Bear pole
👥	PATC

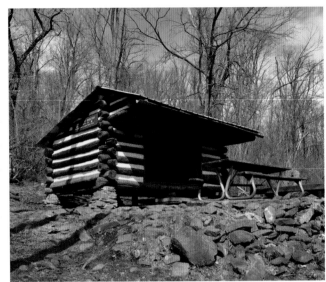

▶ Constructed by the CCC with chestnut logs, this is one of the oldest shelters in Virginia. Like many of the shelters along the AT, this one resided on private land for many decades. There were also bunks across the back of the structure until they were removed for a restoration project in the 1980s.

WHISKEY HOLLOW SHELTER

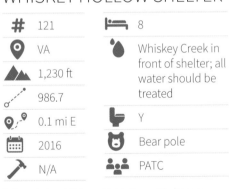

#	121
📍	VA
🏔️	1,230 ft
⋯	986.7
📍	0.1 mi E
📅	2016
🔨	N/A

🛏️	8
💧	Whiskey Creek in front of shelter; all water should be treated
🚽	Y
🐻	Bear pole
👥	PATC

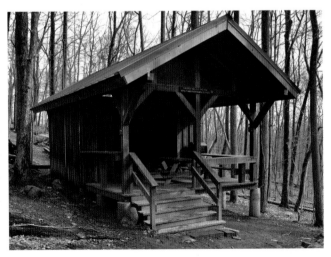

▶ Located uphill from Dick's Dome Shelter on National Park Service (NPS) land between two sections of the G. Richard Thompson Wildlife Management Area, this is the newest shelter in Virginia and one of the newest on the AT.

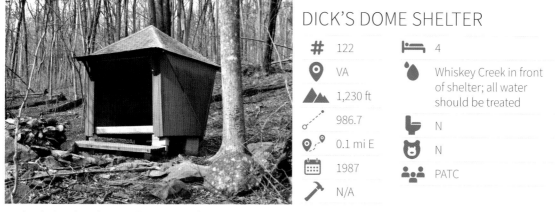

DICK'S DOME SHELTER

#	122	🛏	4
📍	VA	💧	Whiskey Creek in front of shelter; all water should be treated
⛰	1,230 ft		
⟋	986.7	🚽	N
📍	0.1 mi E	🐻	N
📅	1987	👥	PATC
🔨	N/A		

▲ This shelter closed in 2019, but there are future plans to remove and rebuild it on the Tuscarora Trail. One of the smallest shelters on the entire AT, it slept only four (small) people. The one-of-a-kind shelter was built on land owned by PATC member Dick George and then transferred to NPS ownership. It was a small wooden geodesic dome along the bank of Whiskey Creek below the newer Whiskey Hollow Shelter.

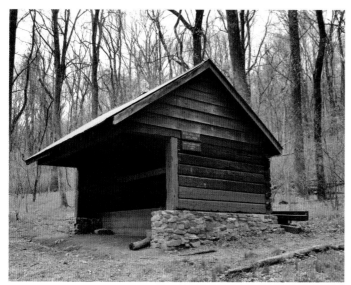

ROD HOLLOW SHELTER

#	123	🛏	8
📍	VA	💧	Spring or streams south of shelter
⛰	840 ft		
⟋	995.1	🚽	Y
📍	0.1 mi W	🐻	Bear pole
📅	1985	👥	PATC
🔨	N/A		

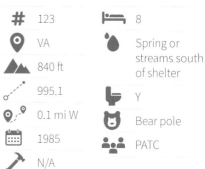

◀ Constructed by volunteers from the PATC, this shelter is located in a marshy bottomland just south of the "Roller Coaster," a 13.5-mile section of trail that climbs up and down 10 viewless and rocky ridges.

SAM MOORE SHELTER

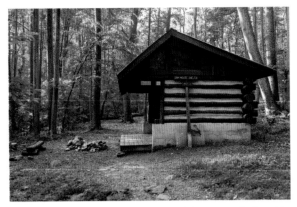

#	124	🛏	6
📍	VA	💧	Sawmill Spring in front of shelter
⛰	990 ft	🚽	Y
⚬⋯	1,002	🐻	Bear pole
📍	On AT	👥	PATC
📅	1993		
🔨	N/A		

▲ Constructed with materials from the old Keys Gap Shelter, this one was named for volunteer Sam Moore, who gave 55 years of service to the AT. It is located on the "Roller Coaster" and south of Bears Den Hostel, a historic 1933 stone mansion that is located 150 yards from the AT and operated by the PATC.

BLACKBURN TRAIL CENTER

#	125	🔨	1980s
📍	VA	🛏	8
⛰	1,650 ft	💧	Outside spigot at center; solar shower
⚬⋯	1,013	🚽	Y
📍	0.2 mi E	🐻	N
📅	1979	👥	PATC

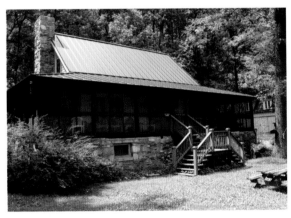

▲ This is a hiker cabin with four double bunks, a picnic pavilion, six tentsites, and a tent platform. A group campsite is also available on a blue-blazed trail. With donations from the Appalachian Long Distance Hikers Association, the pavilion was built by two Eagle Scouts and dedicated to the late Ed Garvey, a longtime hiker and big supporter of the center. Ed Garvey Shelter north on the trail is also named for him. In 1978, the PATC made a deal with a local landowner that allowed a right-of-way over the west side of the mountain for a new reroute away from the road. In return, the old stone shelter built in 1940, Wilson Gap Shelter, was also removed. The land and dilapidated buildings were purchased in 1979, renovated, and eventually dedicated to Fred and Ruth Blackburn for their many years of dedicated service to the PATC and AT. In the late 1980s, Chris Brunton and Sandi Marra (later CEO of the ATC) took over renovations, assisted by a large crew of volunteers. The center also hosts events and houses, supports, and trains trail crews. Donations are appreciated.

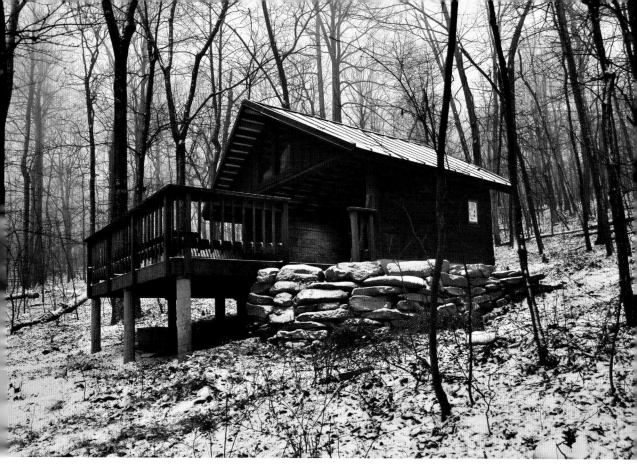

DAVID LESSER MEMORIAL SHELTER

#	126	📅	1994	🚽	Y
📍	VA	🔨	N/A	🐻	Bear pole
⛰	1,430 ft	🛏	6	👥	PATC
⟋	1,016.2	💧	Spring 0.4 mi downhill from shelter		
📍	0.1 mi E				

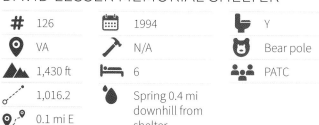 With a large front deck and a picnic pavilion with a fire pit, this shelter is named for David Lesser, a longtime volunteer of the PATC. Tentsites are also available. It is the last shelter on the AT before northbound hikers reach the historic town of Harpers Ferry, West Virginia, the psychological halfway point of the AT. North of Harpers Ferry, Jefferson Rock (425 feet) overlooks the confluence of the Shenandoah and Potomac Rivers. It was named for Thomas Jefferson, who enjoyed the view in 1783.

WEST VIRGINIA

West Virginia is the only state on the AT that does not have any shelters. Four miles of the trail pass through historic Harpers Ferry, the psychological halfway point of the AT (the real halfway point is in Pennsylvania). Harpers Ferry has a rich history and is the home of the Appalachian Trail Conservancy (ATC)—the trail's headquarters. Formerly the Appalachian Trail Conference, the organization was founded in 1925 to coordinate the building of the trail. In 2005, the leadership changed its name to the Appalachian Trail Conservancy to reflect the organization's evolving role in preserving the trail corridor and its natural and cultural resources. Now with more than 42,000 members and 600,000 supporters, the ATC continues to protect, promote, and manage the world's longest hiking-only footpath in a unique partnership with local, state, and federal partners, including the National Park Service, United States Forest Service, dozens of state agencies, and 31 local trail-maintaining clubs.

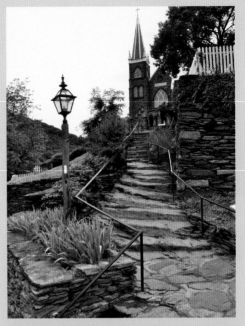

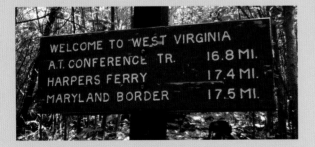

WELCOME TO WEST VIRGINIA
A.T. CONFERENCE TR. 16.8 MI.
HARPERS FERRY 17.4 MI.
MARYLAND BORDER 17.5 MI.

LEFT: Virginia-West Virginia border
TOP: AT through Harpers Ferry
ABOVE: Hiking packs at the ATC headquarters
RIGHT: AT crossing the Potomac River over the Goodloe E. Byron Memorial Footbridge (left)

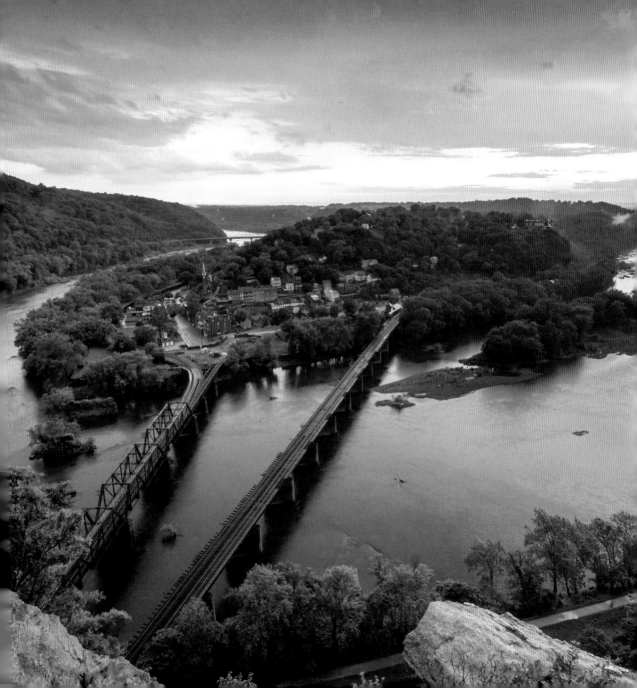

MARYLAND

TOP: AT across I-70 footbridge; **ABOVE:** Washington Monument State Park;
RIGHT: Annapolis Rock

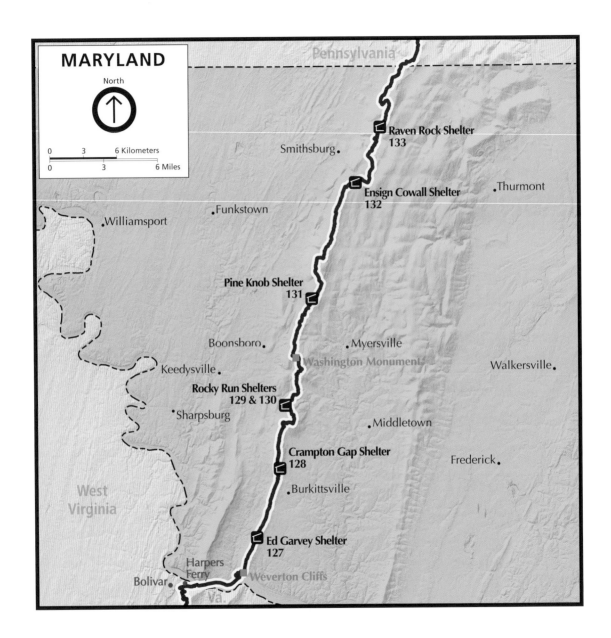

MARYLAND

North

0 3 6 Kilometers

0 3 6 Miles

Pennsylvania

Smithsburg.

Raven Rock Shelter
133

Ensign Cowall Shelter
132

.Thurmont

.Funkstown

.Williamsport

Pine Knob Shelter
131

Boonsboro.

.Myersville

Washington Monument

.Walkersville

Keedysville.

Rocky Run Shelters
129 & 130

.Sharpsburg

.Middletown

Crampton Gap Shelter
128

.Burkittsville

Frederick.

Ed Garvey Shelter
127

**West
Virginia**

Harpers
Ferry

Weverton Cliffs

Bolivar.

Va.

ED GARVEY SHELTER

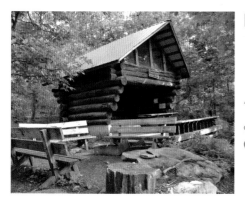

#	127	📅	2001	🚽	Y (composting)	
📍	MD	🔨	N/A	🐻	N	
⛰️	1,100 ft	🛏️	12	👥	PATC	
	1,031.8	💧	0.5 mi down steep side trail in front of shelter			
📍	0.1 mi E					

▲ ▶ The first shelter in Maryland is named for Ed Garvey, former president of the Potomac Appalachian Trail Club (PATC) and a legendary hiker whose groundbreaking 1971 book *Appalachian Hiker: Adventure of a Lifetime* popularized the external-frame pack and thru-hiking the AT. His support was also instrumental in passing the amendment to the National Trails System Act in 1978. There are tentsites to the north and south of the shelter. It is also the first shelter north of Harpers Ferry, West Virginia, and the C&O Canal.

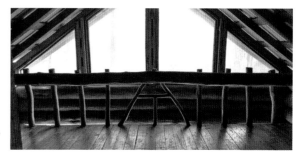

CRAMPTON GAP SHELTER

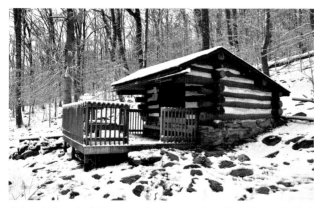

#	128	🛏️	6	
📍	MD	💧	Intermittent spring 0.1 mi south on AT; can go dry by summer	
⛰️	1,000 ft			
	1,035.9			
📍	0.3 mi E	🚽	Y	
📅	1939	🐻	N	
🔨	N/A	👥	PATC	

▲ Located north of Crampton Gap and Gathland State Park, this shelter—one of the original log lean-tos built by the Civilian Conservation Corps (CCC) in 1939—has a front deck and a cooking table.

ROCKY RUN SHELTER (OLD)

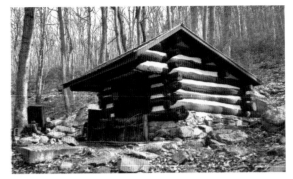

#	129	🛏	6
📍	MD	💧	Piped spring on blue-blazed trail
⛰	970 ft	🚽	Y (pit)
	1,040.9	🐻	N
	0.2 mi W	👥	PATC
📅	1941		
🔨	2005–06		

▲ The lowest-elevation shelter in Maryland, this Adirondack-style log lean-to was built by the CCC and is eligible for the National Register of Historic Places. The small shelter was considered for demolition by the PATC when Pam Underhill—then heading the National Park Service office managing the AT—donated the funds to save and restore it. The shelter is on a blue-blazed trail to the water source for the newer shelter. Tent and hammock sites are also available. The shelter has an inscription inside by legendary trail pioneer Myron Avery. Avery is considered largely responsible for the completion of the AT in the 1930s and was one of its biggest supporters. He was the chair of the Appalachian Trail Conference (now the Appalachian Trail Conservancy) from 1931 until just before his death in 1952. He also co-founded the PATC in 1927 and is considered the first section hiker to complete the entire trail.

ROCKY RUN SHELTER (NEW)

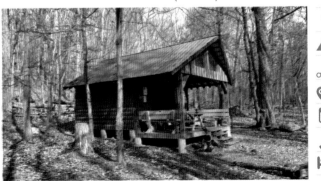

#	130	💧	Piped spring on blue-blazed trail
📍	MD	🚽	Y (composting)
⛰	970 ft	🐻	N
	1,040.9	👥	PATC
	0.2 mi W		
📅	2008		
🔨	N/A		
🛏	16		

▲ ▶ This newer two-story shelter was built by the PATC shortly after the renovation of the historic shelter. Tent and hammock sites are also available, and there are additional tent platforms and benches on the ridgeline.

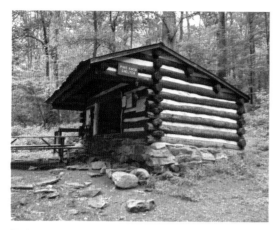

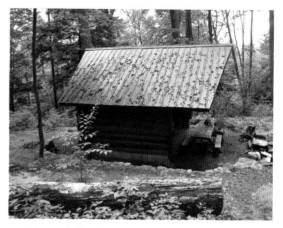

PINE KNOB SHELTER

131

◎ MD

▲ 1,360 ft

⟋ 1,048.4

◎ 0.1 mi W

▦ 1939–40

⚒ N/A

🛏 5

💧 Piped spring north of shelter

🚽 Y

🐻 N

👥 PATC

▲ Built by the CCC, this is one of the oldest shelters in Maryland and on the AT. It is a good example of the traditional lean-to design common at that time. It is located off a blue-blazed trail and sits just north of the footbridge over I-70. Tent and hammock sites are also available.

ENSIGN COWALL SHELTER

132

◎ MD

▲ 1,430 ft

⟋ 1,056.6

◎ On AT

▦ 1999

⚒ N/A

🛏 8

💧 Boxed spring south 0.2 mi down AT

🚽 Y

🐻 Bear pole

👥 PATC

▲ This shelter replaced Hemlock Hill Shelter, which was located close to a road and constantly vandalized. It is not far from the original shelter, but is farther from the road. Five tent pads and hammock sites are also available. The shelter is dedicated to the memory of Ensign Phillip Cowall. It was funded by the PATC and his parents, David and Cindy Cowall, in memory of their son, who loved the AT.

RAVEN ROCK SHELTER

#	133
📍	MD
⛰	1,480 ft
⟋	1,061.5
📍	0.2 mi W
📅	2010
🔨	N/A
🛏	16

💧	Source on opposite side of AT 0.3 mi east on steep side trail
🚻	Y (composting)
🐻	Bear cables
👥	PATC

▲ ▼ This shelter was built by the PATC in 2010 as a replacement for Devils Racecourse Shelter, which was one of the shelters constructed by the CCC in 1940. It is the newest and highest-elevation shelter in Maryland. It is farther uphill and farther away from the road than the original shelter and is located south of the Mason-Dixon Line.

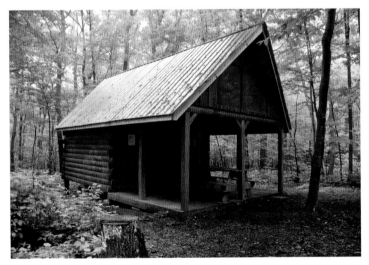

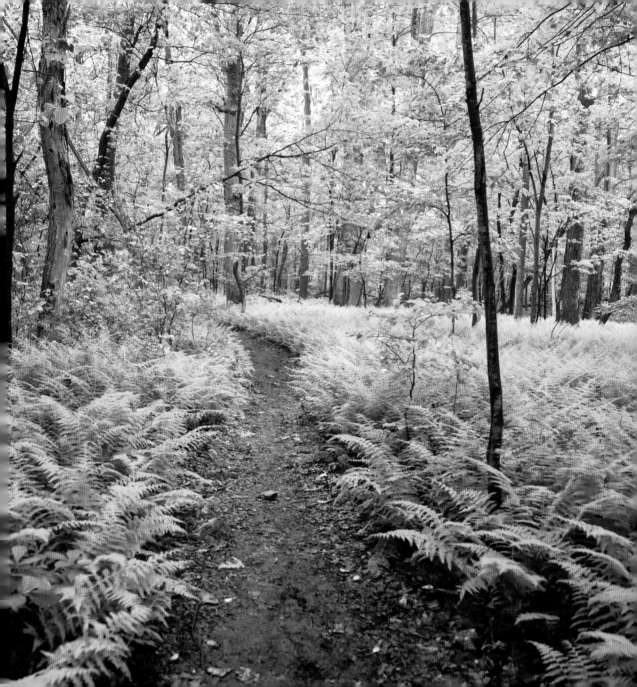

WATER

Gathering water is a daily chore on the trail. Most, but not all, shelters are built near a reliable, natural source. Sometimes the water is located directly at the shelter, while other times the sources are marked by a blue-blazed trail nearby. Cold-flowing streams, creeks, and springs are frequently found along the trail, but many can go dry in drought years or the heat of summer, sometimes lasting through fall. To help hikers plan accordingly, water sources can be found in guidebooks and apps and on trail signs and maps.

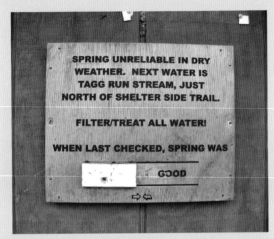

Spring status sign, James Fry Shelter at Tagg Run, Pennsylvania

Some shelters use ponds or lakes. Others, like RPH and Wiley Shelters in New York, have spigots located nearby, though these are not common. Partnership Shelter in Virginia has cold showers built inside the structure, while Eckville and 501 Shelters in Pennsylvania and Jim and Molly Denton Shelter in Virginia have (sometimes unreliable) solar showers. Fullhardt Knob Shelter in Virginia has the last functioning water-gathering cistern system on the trail. Rainwater is collected from the roof, stored in a large tank, and accessed from a spigot just behind and below the shelter.

As with any backcountry water source, it is advised to treat or filter water before drinking. There are different treatment options. Boiling water, using a pump or filter, and

Reliable spring overflowing into a metal trough, Rausch Gap Shelter, Pennsylvania

applying chemical treatments are all options for water safety. Parasites and bacteria can be found in all water sources, including piped, clear, cold, and flowing ones. Water sources may be contaminated for numerous reasons. Microorganisms, like the parasite *Giardia lamblia* that causes giardiasis, can be found in water and can cause major gastrointestinal distress that will derail any hiker's trip.

ABOVE: Solar-heated shower warm only on sunny days, Jim and Molly Denton Shelter, Virginia

BELOW: Johns Spring Shelter, Virginia

Piped spring, Rock Gap Shelter, North Carolina

THE APPALACHIAN TRAIL

CLOCKWISE FROM THE LEFT: Cheoah Bald, North Carolina; George W. Outerbridge Shelter, Pennsylvania; Little Laurel Shelter, North Carolina; Glen Brook Shelter, Massachusetts; Spring Mountain Shelter, Tennessee

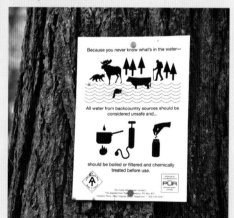

Because you never know what's in the water—

All water from backcountry sources should be considered unsafe and...

should be boiled or filtered and chemically treated before use.

PENNSYLVANIA

TOP: Green tunnel, Quarry Gap Shelters; **MIDDLE:** Midpoint marker created by Chuck "Woodchuck" Wood, near Pine Grove Furnace State Park; **RIGHT:** Bethany "Naps" Rooks hiking through a cornfield

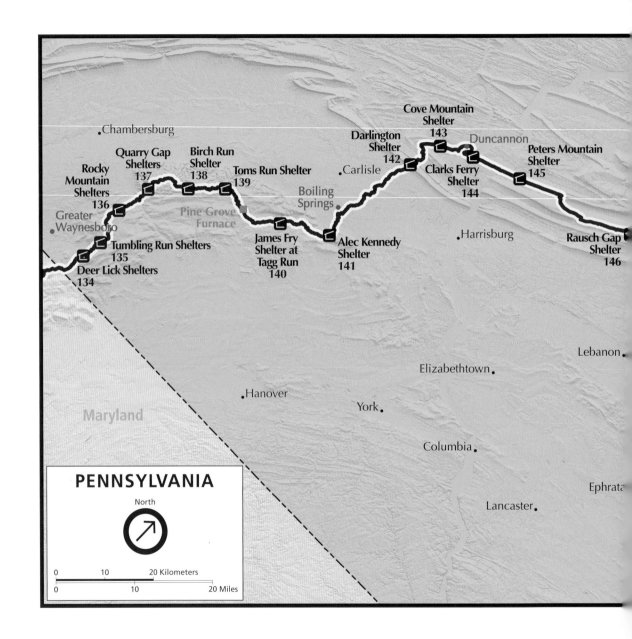

Chambersburg

Cove Mountain
Shelter
143

Darlington
Shelter
142

Duncannon

Quarry Gap
Shelters
137

Birch Run
Shelter
138

Toms Run Shelter
139

Peters Mountain
Shelter
145

Rocky
Mountain
Shelters
136

Carlisle

Clarks Ferry
Shelter
144

Greater
Waynesboro

Pine Grove
Furnace

Boiling
Springs

Tumbling Run Shelters
135

James Fry
Shelter at
Tagg Run
140

Alec Kennedy
Shelter
141

Harrisburg

Rausch Gap
Shelter
146

Deer Lick Shelters
134

Lebanon

Maryland

Hanover

Elizabethtown

York

Columbia

Ephrata

Lancaster

PENNSYLVANIA

North

0 10 20 Kilometers
0 10 20 Miles

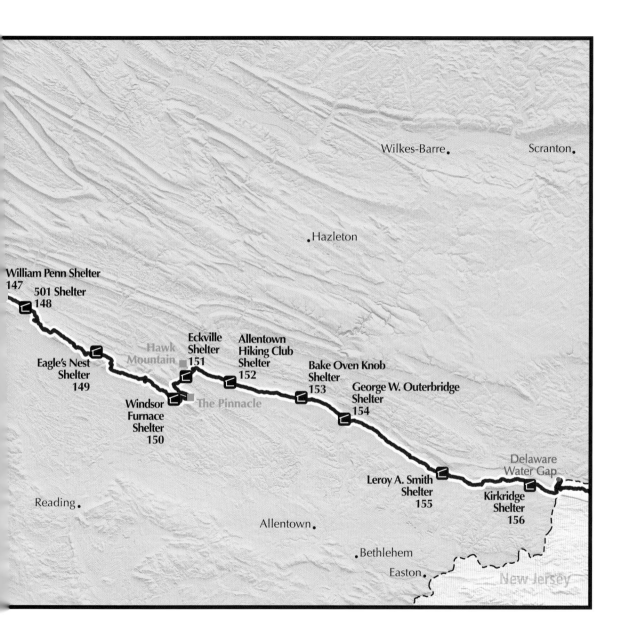

Wilkes-Barre.

Scranton.

.Hazleton

William Penn Shelter
147
 501 Shelter
 148

Eckville
Shelter
151

Allentown
Hiking Club
Shelter
152

Hawk
Mountain

Eagle's Nest
Shelter
149

Bake Oven Knob
Shelter
153

Windsor
Furnace
Shelter
150

The Pinnacle

George W. Outerbridge
Shelter
154

Delaware
Water Gap

Leroy A. Smith
Shelter
155

Kirkridge
Shelter
156

Reading.

Allentown.

.Bethlehem

Easton.

New Jersey

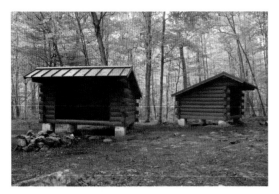

DEER LICK SHELTERS

#	134	🛏	4 each
📍	PA	💧	Seasonal spring 0.2 mi on blue-blazed trail or stream near shelter
⛰	1,420 ft	🚻	Y
⤴	1,071.1	🐻	N
📍	On AT	👥	PATC
📅	1980s		
🔨	N/A		

▲ The first shelters in Pennsylvania, these are also the first of the double shelters common in this section of the state. They are some of the smallest shelters on the trail, sleeping only four each. Although they are newer structures, they are built in the same paired-shelter style of many of the original lean-tos on this stretch of the AT. The shelters were built in the early 1980s in the Michaux State Forest after the removal of Mackie Run Shelter, a single structure built in 1939. Mackie Run was one of many shelters removed or relocated because it was too close to a road. Southern Pennsylvania was the only place on the AT where double shelters were used, and they were a creation of Michaux State Forest rangers.

TUMBLING RUN SHELTERS

#	135	⤴	1,074.7
📍	PA	📍	On AT
⛰	1,120 ft	📅	1980s

▲▲▶ The Civilian Conservation Corps (CCC) built the original shelter at this location in 1935. There are discrepancies in some sources on the shelter's build date, completion, and dedication; it is sometimes listed as built in 1936. It burned down and was rebuilt by the Potomac Appalachian Trail Club (PATC) in the 1980s as a pair of shelters. One shelter is designated for snoring hikers and the other for non-snoring. George, Curt, and Tawnya Finney and their family have been caretakers for these shelters since 1991.

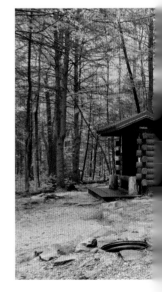

SNORING

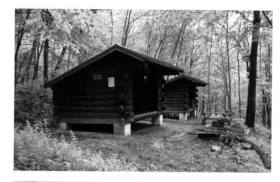

🔨	N/A	🚽	Y
🛏	4 each	🐻	N
💧	Located west of shelter	👥	PATC

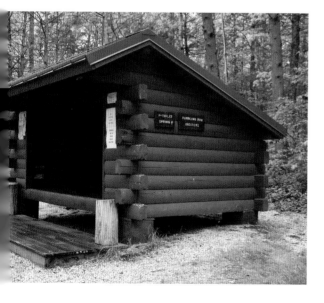

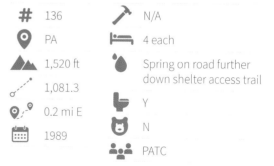

ROCKY MOUNTAIN SHELTERS

#	136	🔨	N/A
📍	PA	🛏	4 each
⛰	1,520 ft	💧	Spring on road further down shelter access trail
⸱⸱⸱	1,081.3		
📍	0.2 mi E	🚽	Y
📅	1989	🐻	N
		👥	PATC

▲▲ These are two of the smallest shelters on the AT and the last double shelters until Maine. A side trail to the shelters is 0.2 miles steep downhill. They were built to replace the old Raccoon Run Shelters that were torn down after a relocation of the trail away from PA-233 during the late 1980s.

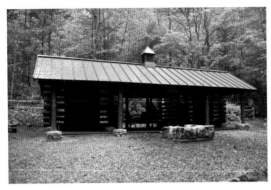

QUARRY GAP SHELTERS

#	137	🔨	N/A
📍	PA	🛏	4 each
⛰	1,455 ft	💧	Source in front of shelter
✦	1,086.9	🚽	Y
📍	On AT	🐻	N
📅	1934	👥	PATC

▲ Located in Caledonia State Park and built by the CCC, these are the oldest shelters in Pennsylvania on the AT. Originally built as two separate structures, the shelters were renovated with a single, continuous roof, providing shelter and a covered area for a picnic table between the two structures. They are unique compared to the other double shelters in the state. They are also known for being some of the best maintained on the trail, and even have hanging flower baskets for hikers to enjoy. A sign that reads "Jim Stauch, Innkeeper" hangs proudly in between the two shelters.

BIRCH RUN SHELTER

#	138	🔨	N/A
📍	PA	🛏	8
⛰	1,795 ft	💧	Spring in front of shelter
✦	1,094.3	🚽	Y
📍	On AT	🐻	N
📅	2003	👥	PATC

▶▶ The CCC built the original double lean-tos here in 1934. They were small, low-to-the-ground structures that slept four people each. Those shelters stood until they were replaced with a single, larger shelter in 2003. It is the highest-elevation shelter in Pennsylvania and is located south of the ever-changing halfway point on the AT.

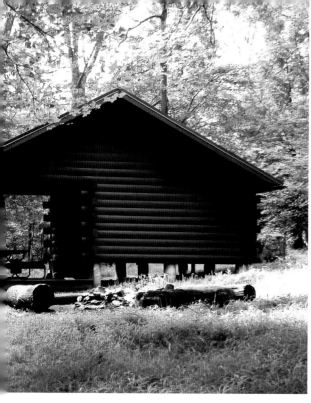

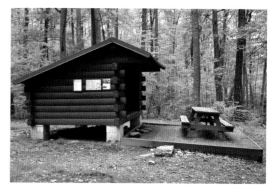

TOMS RUN SHELTER

#	139	🔨	N/A
📍	PA	🛏	4
🏔	1,300 ft	💧	Spring near old chimney
⤴	1,100.5	🚻	Y
📍	On AT	🐻	N
📅	1936	👥	PATC

▲ This was once a double shelter, but one structure burned down in 2013. A unique fire pit in front of the remaining shelter was part of an Eagle Scout project by Mason Banner, BSA Troop 793, in 2016. A plaque reads, "Keep Finding Truth North." The shelter is located south of Pine Grove Furnace State Park, the Ironmaster's Mansion, and the Appalachian Trail Museum. The Pine Grove Furnace General Store is home to the famous "half-gallon challenge," where hikers can have a half gallon of ice cream all to themselves to celebrate crossing the halfway point of the trail.

JAMES FRY SHELTER
AT TAGG RUN

#	140	🛏	10
📍	PA	💧	Source off blue-blazed trail 0.4 mi east on AT; can run dry in drought years
⛰	805 ft		
⟋	1,111.4	🚽	Y (composting)
📍	0.2 mi E	🐻	Bear box
📅	1998	👥	MCM
🔨	N/A		

▼ This shelter is named for James H. Fry, a longtime Maryland resident and an avid outdoorsman who hiked most of the AT. After his death in 1994, the Mountain Club of Maryland (MCM) received many donations in his name. The club used the donations to fund the construction of the new shelter, which has bunks. It was built directly on top of the location of the two old, small shelters (Tagg Run) built in the 1930s by the CCC. It is the first shelter maintained by the MCM. Established in 1934, the club maintains four shelters, 16.2 miles of the AT from Pine Grove Furnace State Park to Center Point Knob, and 12.6 miles from the Darlington/Tuscarora Trail Junction to the Susquehanna River. There are also 10 tentsites nearby.

ALEC KENNEDY SHELTER

141
⚲ PA
⛰ 850 ft
⟋ 1,119.5
⚲⚲ 0.2 mi E
📅 1991
⚒ N/A
🛏 9

💧 Spring on trail behind shelter, but can go dry in summer; nearby stream is alternative source
🚽 Y
🐻 Bear box
👥 MCM

◀▶ This shelter with bunks was built by the Tressler Wilderness School and MCM in memory of Alexander "Alec" Kennedy, who was one of the founders of the club in 1934. He served as president and continued to hike with the club until his death in 1989 at the age of 88. The privy at this shelter was replaced in 2017.

DARLINGTON SHELTER

142
⚲ PA
⛰ 1,250 ft
⟋ 1,137.7
⚲⚲ 0.1 mi E
📅 2005
⚒ N/A
🛏 8

💧 Intermittent spring down blue-blazed side trail beginning in front of shelter; regularly dries up in spring; hikers should get water before stopping here
🚽 Y (composting)
🐻 Bear box
👥 MCM

◀▲ The original Darlington Shelter was built by Earl Shaffer in 1956, and then the MCM built a replacement shelter in 1977. The 1977 shelter was built off-site in small pieces, carried into the site, and bolted together. The shelter was torn down in 2004, and a completely new shelter was built in its place the following year. It is named for Bishop James Henry Darlington, an early advocate of the AT. He was also active in the Pennsylvania Alpine Club, an early club in the Harrisburg area. The nearby Darlington Trail is also named after him. The shelter is also home to the "Taj Mahal" double-seater privy.

COVE MOUNTAIN SHELTER

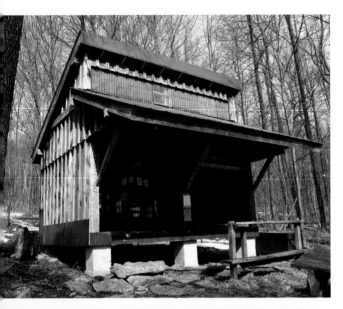

#	143
📍	PA
⛰	1,200 ft
⸱⸱⸱	1,145
📍	0.2 mi E
📅	2000
🔨	N/A
🛏	10

💧	Spring down steeply graded trail near shelter
🚽	Y (composting)
🐻	Bear box
👥	MCM

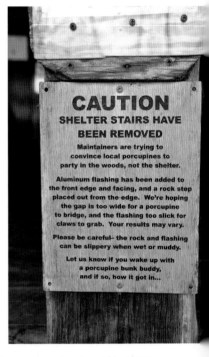

CAUTION
SHELTER STAIRS HAVE
BEEN REMOVED
Maintainers are trying to convince local porcupines to party in the woods, not the shelter.

Aluminum flashing has been added to the front edge and facing, and a rock step placed out from the edge. We're hoping the gap is too wide for a porcupine to bridge, and the flashing too slick for claws to grab. Your results may vary.

Please be careful– the rock and flashing can be slippery when wet or muddy.

Let us know if you wake up with a porcupine bunk buddy, and if so, how it got in...

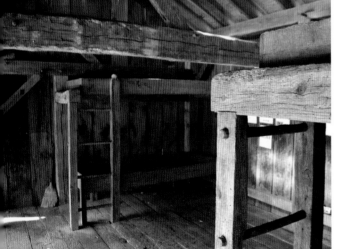

◄◄► This shelter was built with timbers salvaged from a barn with help from the Timber Framers Guild. Some beams date to more than 100 years old. Porcupines are active in the area; the steps of the shelter have been removed and metal has been nailed around the base to deter their chewing. Located just south of Duncannon and the Susquehanna River, the shelter was built near the site of the former Thelma Marks Shelter, which was torn down following the murders of Molly LaRue and Geoffrey Hood in September 1990.

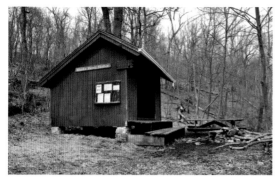

CLARKS FERRY SHELTER

#	144	⚒	N/A
📍	PA	🛏	8
⛰	1,260 ft	💧	Reliable piped spring down access trail past shelter
⤺	1,153.3	🚽	Y
📍	0.1 mi E	🐻	Bear box
📅	1993	👥	YHC

▲ This shelter was built by volunteers from the York Hiking Club (YHC), one of the member clubs of the Keystone Trails Association, and is the only shelter maintained by the club. Established in 1932, it maintains 6.9 miles of the AT from the Susquehanna River to the top of Peters Mountain at PA-225.

PETERS MOUNTAIN SHELTER

#	145	📍	On AT	💧	Weak spring 0.3 mi from shelter, down 300 rock steps
📍	PA	📅	1994	🚽	Y
⛰	970 ft	⚒	N/A	🐻	Bear boxes
⤺	1,160	🛏	20	👥	SATC

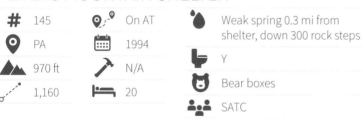

◄► Built in memory of Steven W. Barber, from his parents Monica and Don and his sister Karen, this is the only shelter maintained by the Susquehanna Appalachian Trail Club (SATC). Cofounded in 1954 by Earl Shaffer, the club maintains 20.8 miles of the AT from PA-225 to Rausch Creek. The club also maintains the Darlington Trail and several side trails to the AT. The SATC built the new shelter near the small original one built by Shaffer, the first person to hike the entire AT in 1948. The original structure was dismantled in 2008 and reassembled inside the Appalachian Trail Museum in nearby Pine Grove Furnace State Park. The new shelter is one of only four (non-hut) shelters on the trail that sleeps more than 20 people.

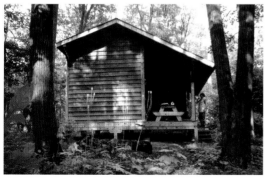

RAUSCH GAP SHELTER

#	146
📍	PA
⛰	980 ft
⟋	1,178
📍⟋📍	0.3 mi E
📅	2012
🔨	N/A
🛏	12
💧	Reliable spring near shelter
🚻	Y
🐻	N
👥	BMECC

▼ This shelter replaced a 1972 structure here in 2012. A new privy was built in 2005. Tenting is available on a side trail. A sign nearby states, "The village of Rausch Gap stood here from 1828 to 1910. Peak population of 1000+ people. Industries were coal mining and railroad equipment repair. The mines were not productive and the railroad moved its operations in 1872." It is the first shelter maintained by the Blue Mountain Eagle Climbing Club (BMECC). Established in 1916, the club maintains 7 shelters, 62.5 miles of the AT from Rausch Creek to Tri-County Corner, and 3 miles from Bake Oven Knob to Lehigh Furnace Gap.

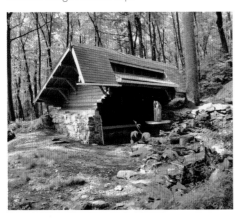

WILLIAM PENN SHELTER

#	147
📍	PA
⛰	1,300 ft
⟋	1,191.4
📍⟋📍	0.1 mi E
📅	1993
🔨	N/A
🛏	16
💧	Source 200 yd down blue-blazed trail
🚻	Y
🐻	N
👥	BMECC

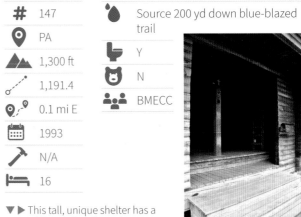

▼▶ This tall, unique shelter has a second-floor loft with windows.
The Blue Mountain campsite is nearby, and a waste-management structure is uphill from the shelter.

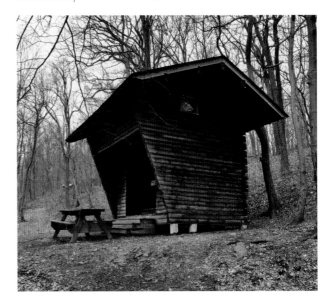

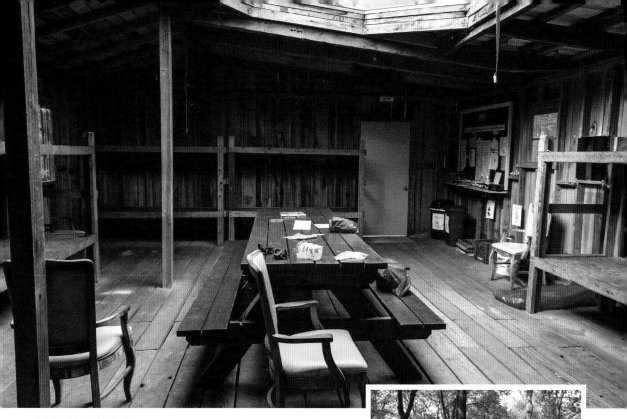

501 SHELTER

#	148		12	🐻	N	
📍	PA	💧	Available from faucet at BMECC caretaker house next door	👥	BMECC	
⛰️	1,460 ft					
⟋	1,195.5		Y			
📍	0.1 mi W					
📅	1975					
🔨	N/A					

▲▶ Retained by special arrangement with the National Park Service (NPS) and Appalachian Trail Conservancy (ATC), this fully enclosed shelter with a skylight is located right near PA-501. (There used to be a potter's wheel under the skylight.) It is always open and free, and it has 12 bunks and a solar shower. Some local restaurants deliver food. No smoking or alcoholic beverages are allowed inside, and pets are allowed on a leash only. It is located north of Kimmel Lookout (1,330 feet).

EAGLE'S NEST SHELTER

#	149	💧	Yeich Spring to west of shelter; primary source is small intermittent stream fed by several small seeps near ridgetop
📍	PA		
⛰	1,510 ft		
⟋	1,210.6		
📍	0.2 mi W	🚽	Y (composting)
📅	1988	🐻	N
🔨	N/A	👥	BMECC
🛏	8		

▼ This shelter has a raised sleeping area inside and a mounted birdhouse made by Chuck Wood. Campsites are also available. The area is on state forest land, but is adjacent to land managed by the Pennsylvania Game Commission, where camping is prohibited at any site that is more than 200 feet from the trail or less than 500 feet from trailheads, road crossings, parking areas, or water sources. Restrictions should be observed to avoid hefty fines.

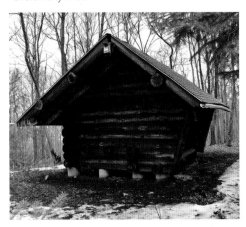

WINDSOR FURNACE SHELTER

#	150	🔨	N/A
📍	PA	🛏	6
⛰	940 ft	💧	Creek south of shelter
⟋	1,225.3	🚽	Y
📍	0.1 mi W	🐻	N
📅	1972	👥	BMECC

▶▼ This shelter is the only legal camping in the Hamburg Watershed area. It is located south of The Pinnacle (1,615 feet), which is listed as one of the best views in Pennsylvania. Tentsites are also available. Fires are prohibited except at the shelter, and swimming is prohibited in streams and the nearby reservoir.

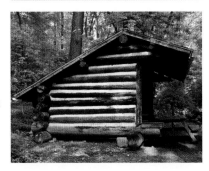

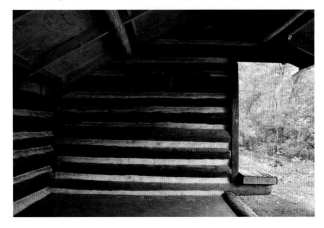

ECKVILLE SHELTER

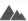 151

 PA

 600 ft

 1,234.4

 0.2 mi E

 1930s

 N/A

 6

 Spigot at nearby caretaker's house

 Y

N

BMECC

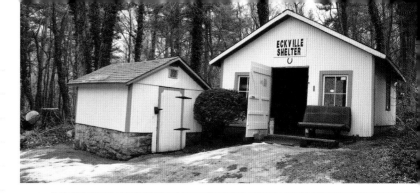

▶ This enclosed shelter with bunks has no fee and is open year-round. It has a solar shower (winterized), flush toilets, and tent platforms. Built in the early 20th century as a farmhouse outbuilding, it is retained by special arrangement with the NPS and ATC. The Eckville Facility was received into ownership by the NPS in 1985 and the BMECC became managers of the caretaker facility. Cindy Ross and Todd Gladfelter were the first caretakers, and the present caretaker is Mick Charowsky. Located just south of Hawk Mountain Sanctuary, it is the lowest-elevation shelter in Pennsylvania.

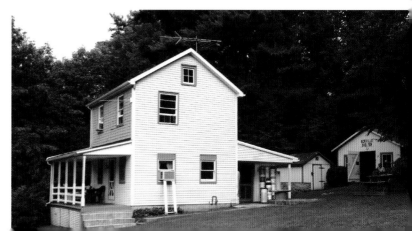

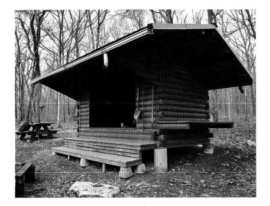

ALLENTOWN HIKING CLUB SHELTER

#	152	🛏	8
📍	PA	💧	Two springs downhill, 0.2 and 0.3 mi from shelter
⛰	1,350 ft		
⤴	1,241.8	🚻	Y
📍↗	< 0.1 mi E	🐻	N
📅	1997	👥	AHC
🔨	N/A		

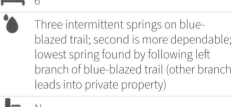

▲▶ This is the first shelter maintained by the Allentown Hiking Club (AHC), a member of the Keystone Trails Association. Established in 1931, the club maintains two shelters and 10.3 miles of the AT from Tri-County Corner to Bake Oven Road. The original 1935 shelter was built by the AHC and lasted 62 years. In 1961, four wire bunks replaced the dirt floor where hikers slept, and, in 1973, a work crew built a wooden floor. In 1996, the AHC built a privy near the shelter, and, in 1997, volunteers dismantled the old shelter and prepared the site for the new structure. The crew cut the logs and prebuilt the new milled-log shelter at an off-site location. Every piece was numbered and driven to the shelter site. In all, more than 1,000 hours of labor were contributed. On National Trails Day in 1997, the AHC formally dedicated the shelter, concluding a very active decade of volunteer effort on behalf of the AT. Tentsites are also available.

BAKE OVEN KNOB SHELTER

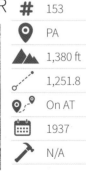

#	153	🛏	6
📍	PA	💧	Three intermittent springs on blue-blazed trail; second is more dependable; lowest spring found by following left branch of blue-blazed trail (other branch leads into private property)
⛰	1,380 ft		
⤴	1,251.8		
📍↗	On AT		
📅	1937	🚻	N
🔨	N/A	🐻	N
		👥	BMECC

▲ The current shelter is the original structure built in 1937 and one of the only remaining original shelters in the state. It is typical of the log-sided Adirondack lean-to design recommended by the ATC during the original construction of the shelter chain. Located just a mile north of Bake Oven Road and a large parking lot, it is south of Lehigh Gap on Pennsylvania Game Commission lands. Strict camping regulations are in place.

GEORGE W. OUTERBRIDGE SHELTER

#	154	🔨	N/A
📍	PA	🛏	6
⛰	1,000 ft	💧	Piped spring < 0.1 mi north on AT
⟋	1,258.6	🚽	N
📍	On AT	🐻	N
📅	1965	👪	AHC

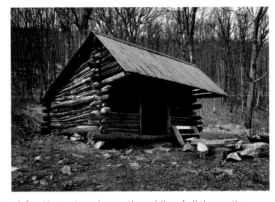

▶ This shelter is named for George Outerbridge, the second person (after Myron Avery) reporting a hike of all the sections of the AT. Outerbridge began his section hikes on October 30, 1932, and completed his final section on June 22, 1939. The shelter, which has a unique, partially enclosed fourth wall, is located on the first section that Outerbridge hiked. It was constructed in 1965 by the Philadelphia Trail Club (PTC). Outerbridge, who died in 1967, was a PTC member. In 1978, the PTC relinquished its responsibility for the shelter, and the AHC agreed to take over all maintenance and repairs.

LEROY A. SMITH SHELTER

#	155	📍	0.3 mi E	💧 Three reliable sources: one 0.2 mi down blue-blazed trail, second 0.2 mi farther on yellow-blazed trail, and third even farther down trail	🚽 Y (composting)
📍	PA	📅	1973		🐻 N
⛰	1,410 ft	🔨	N/A		👪 AMC-DVC
⟋	1,275.3	🛏	8		

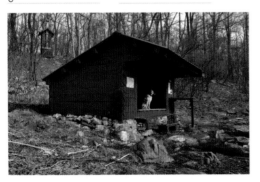

◀ This shelter, built by members of the PTC, was constructed to replace Smith Gap Shelter. The original 1948 shelter was built on private land, and, in the 1960s, the landowner turned the shelter into a shed for his vacation home at the site. In 1973, the Delaware Valley Chapter of the Appalachian Mountain Club (AMC-DVC) built a new shelter closer to the trail. They dedicated it to their long-serving volunteer Leroy Smith, who passed away shortly after the completion of the current structure. It was "discovered" on a privately owned site adjacent to Pennsylvania Game Commission lands. The owner willingly entered into a friendly exchange with the AMC-DVC, and the paperwork was initiated and slowly traveled through the Pennsylvania bureaucracy to confirm the transfer. This is the only shelter maintained by the AMC-DVC, one of 12 regional AMC chapters. The club maintains 15.4 miles of the AT from Little Gap to Wind Gap.

KIRKRIDGE SHELTER

156

📍 PA

⛰ 1,500 ft

⸰—⸰ 1,289

📍 On blue-blazed trail about 100 ft above AT

📅 1948

🔨 1997; 2006

🛏 8

💧 Outside tap near shelter before Kirkridge Retreat facility parking lot; not winterized

🚻 Y

🐻 N

👥 WTC

▼ Great views are available from the blue-blazed trail to this shelter. It is the only shelter maintained by the Wilmington Trail Club (WTC). Established in 1939, the club maintains 7.2 miles of the AT from Fox Gap to Delaware River Bridge. The construction of the latest shelter was under the direction of Ed Twaddell, Ben Woodland, and Tom Wheatley, and it was created by volunteers and WTC members.

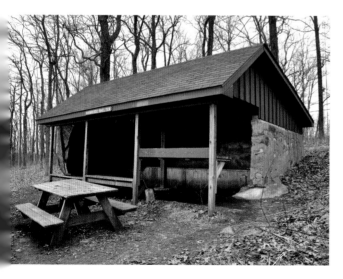

CARETAKERS

In 1968, the National Trails System Act desig-
nated the AT as the first national scenic trail.
This act created the framework that would
eventually lead to the most extensive land-
acquisition program in the history of the
National Park Service (NPS). As a result, the AT
and a corridor of land averaging a thousand
feet in width is now in public ownership.

In a subsequent formal delegation agree-
ment signed in 1984, the federal government
recognized the work that volunteers had been
doing since the trail's inception. It assigned for-
mal responsibility for sections of NPS trail and
associated lands and features, including shel-
ters, to trail clubs and their volunteers.

Today, the trail corridor is managed coop-
eratively by the Appalachian Trail Conservancy
(ATC), 31 trail clubs, and more than 60
land-managing agencies, with about 75 per-
cent of the land owned by either the NPS or
United States Forest Service and the rest mostly
on state lands. The trail is under the overall
administration of the NPS.

The AT was built and continues to be
maintained by ordinary people. Trail volun-
teers—more than 6,000 people of all ages and
backgrounds—are essential to keeping the AT
vision alive by building, repairing, restoring,

and reshaping
the trail. Club
volunteers and
ATC-led or club-
led crews per-
form activities
from working in
visitor centers
to monitoring
rare plants.

Horns Pond Lean-tos, Maine

More than 200,000 volunteer hours are
typically recorded each year along the trail.
The keepers of the trail take on many names:
boundary monitor, caretaker, "croo," overseer,

Sign for the NBATC, which maintains shelters in Virginia

GATC's Ginny Smith, Darleen Jarman, and Brent Binion (left to right) preparing for the upcoming thru-hiker season, Gooch Mountain Shelter, Georgia

The popularity of the AT continues to soar. With more interest comes more hikers and more impact. Trail maintainers continue to keep the footpath free of obstructions and cleared of vegetation; they also keep it well marked by painting the famous white blazes along the trail. Downed trees, erosion, waste management, and human impact all play a role in the trail's long-term needs.

Trail clubs agree to maintain their section and shelters to the ATC's standards for marking, clearing, and treadway care. Some trail clubs have only a few shelters along their section, while others have 10 to 20 structures to service and maintain. The Cumberland Valley Appalachian Trail Club and Batona Hiking Club do not maintain any shelters for their section of Pennsylvania; the Old

ranger, ridgerunner, sawyer, section maintainer, shelter adopter, shelter maintainer, trail crew, trail club volunteer, trail maintainer, or trail ambassador. The success and longevity of the AT relies on the shared love and commitment of these dedicated people who work to preserve it. These workers and volunteers are the heart and soul of this beloved footpath.

The ATC supports six trail crews from May to October every year—the Konnarock, Rocky Top, S.W.E.A.T., Mid-Atlantic, Maine, and Volunteer Long Trail Patrol—as well as other youth crews along the trail. Crews work in all weather conditions and put in long, physical days of construction, often with just hand tools. Without their hard work, along with the work of trail stewards, the AT would not be able to sustain itself.

Members of the Harlem Valley AT Community, AMC-CT, Sierra Club Military Outdoors, NPCA, and Girl Gotta Hike doing trail maintenance on National Public Lands Day, New York/Connecticut

Dominion Appalachian Trail Club in Virginia and the Wilmington Trail Club, Appalachian Mountain Club-Delaware Valley Chapter (AMC-DVC), and York Hiking Club in Pennsylvania each maintain only one shelter along their routes. The Potomac Appalachian Trail Club (PATC) has 31 shelters in three states—Virginia, Maryland, and Pennsylvania. The Maine Appalachian Trail Club maintains 30 shelters through the rugged mountains of Maine, and the Appalachian Mountain Club (and its chapters) maintains 37 shelters in five states.

Maintainers typically care for a one- to five-mile section of the trail, visiting several times a year. Severe weather and possible blowdowns may have maintainers out more.

Shelter adopters have similar duties, except they take care of a particular shelter instead of

PATC member repairing Rod Hollow Shelter, Virginia

a trail section. Section maintainers become the "eyes and ears" for each club by finding and reporting the need for maintenance along their sections.

The AMC-DVC created a "shelter watch program" for the Leroy A. Smith Shelter it maintains in Pennsylvania. According to club guidelines, the watchers "check the condition of the shelter, composting privy, the adjacent camping site, three lower springs, and the Katellen Trail; remove debris; and report their findings on postcards preaddressed to the shelter chair." The Summer Watch is scheduled from April 15 to November 1, with volunteers visiting once a week. The Winter Watch runs from November 1 to April 1, with a volunteer visiting twice a month, weather permitting. In 2018, watchers logged 275 hours for the program.

Some maintainers live right near the trail, while many volunteers live hours away and have to hike in miles to maintain their areas. George, Curt, and Tawnya Finney and their family have been PATC caretakers for the Tumbling Run Shelters in Pennsylvania since 1991. George, Curt's father, usually heads out every morning during peak season to make sure the privy is clean and stocked with toilet paper and hand sanitizer. Curt and Tawnya also live nearby and check in on the shelter almost every day.

Curt describes their role as caretakers as an honor. "We are to look after the shelters and

Curt and Tawnya Finney, caretakers since 1991 of Tumbling Run Shelters, Pennsylvania

CMC members building fencing, Max Patch, North Carolina

keep them maintained and clean," he said. "Due to the fact that we live so close to our shelters, we take a more personal approach to maintenance. We hope that when backpackers arrive at Tumbling Run they feel comfortable and can rest and relax in order to be ready for the next day's hike. We have had the opportunity to meet great people from all over the world and have fostered friendships from some of our acquaintances. It's a very rewarding opportunity to be able to give back to the trail and the trail community. We hope to be the caretakers for many more years to come."

Trail caretakers do more than just maintain their sections and shelters. They also inform and educate hikers on how to lessen their impact, and often they are the ones carrying out trash other people leave behind. Hired caretakers, or

ridgerunners, hit their sections each year to help maintain the trail and educate hikers on Leave No Trace ethics in hopes of curbing unsustainable practices. The ridgerunner program, started in the 1980s, now has more than 50 positions along the trail that continue to be an integral part of trail conservation and influencing user impact. In 2017, Georgia ridgerunners interacted with more than 10,000 people, dismantled 245 fire rings, and packed out 486 pounds of trash. The Smoky Mountains Hiking Club hired its first ridgerunner in 1990, and the position continues to play an important role in hikers' experience in the heavily used Great Smoky Mountains National Park. Since 1995, the ridgerunner season in the park has run for 34 weeks, from early March through October.

Croo packboards, Zealand Falls Hut, New Hampshire

The Appalachian Mountain Club (AMC) employs lodge and hut crews (referred to as "croos") that have provided high-mountain hospitality at its hut system in the White Mountains for more than a century. Croo members help serve food, prepare facilities, and offer trail information to the thousands of visitors who travel to AMC lodges every year. They also carry vintage packboards of supplies—weighing anywhere from 40 to 80 pounds—to resupply and support the remote huts throughout the area.

The AMC also created the White Mountain Campsite and Caretaker Program, which ensures the continuing sustainability of backcountry areas in the White and Mahoosuc Mountains in New Hampshire and Maine. Created in 1970, the program currently maintains 15 campsites, with nine staffed by caretakers, along the AT. The campsites, available for a $10 per person fee, are staffed in the summer months, but open year-round for use. The caretakers maintain trails and campsites, manage composting waste, educate hikers, promote Leave No Trace principles, assist in search-and-rescue operations, and collect fees to cover part of the program. These areas see an estimated 15,000 to 18,000 visitors a year and more than 2,000 gallons of composted human waste. The seasonal caretakers monitor and help minimize human impact, protecting the fragile environment in the area.

The Georgia Appalachian Trail Club created a trail ambassador program to patrol its popular section. The 38 ambassadors are similar to ridgerunners, but are all volunteers. Many other trail clubs along the AT have adopted the ambassador program in recent years, including the Nantahala Hiking Club, Roanoke Appalachian Trail Club, PATC, and AMC.

In areas where a corridor of land has been acquired by the NPS to provide buffer lands around the footpath, volunteers and ATC staff members monitor the boundary lines. In all, about 1,400 miles of rugged boundary are walked each year by boundary monitors. This special breed of caretaker usually works in winter or late spring, when vegetation is dormant

(except in the conifer forests of northern New England) and walking through trail areas is easiest. These volunteers look for encroachments and report them to law enforcement; they also refresh the yellow blazes originally painted by surveyors that mark boundary lines and replace any missing signs marking government property.

Regardless of the title of the person caring for the trail, the purpose is the same: protect and maintain these natural resources for future generations. The love and dedication of the maintainers and trail enthusiasts involved in the trail's care are impressive. The thousands of volunteer hours logged every year are essential to the success of a wild, continuous trail through the densely populated eastern United States.

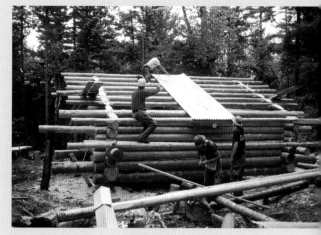

Volunteers building Sabbath Day Pond Lean-to, Maine

Sign for the PATC, which maintains shelters in Virginia, Maryland, and Pennsylvania

NEW JERSEY

TOP LEFT: Boardwalk over Pochuck Creek; **TOP RIGHT:** High Point Monument, High Point State Park; **ABOVE:** New York-New Jersey border; **RIGHT:** Sunfish Pond, one of seven protected natural areas in New Jersey

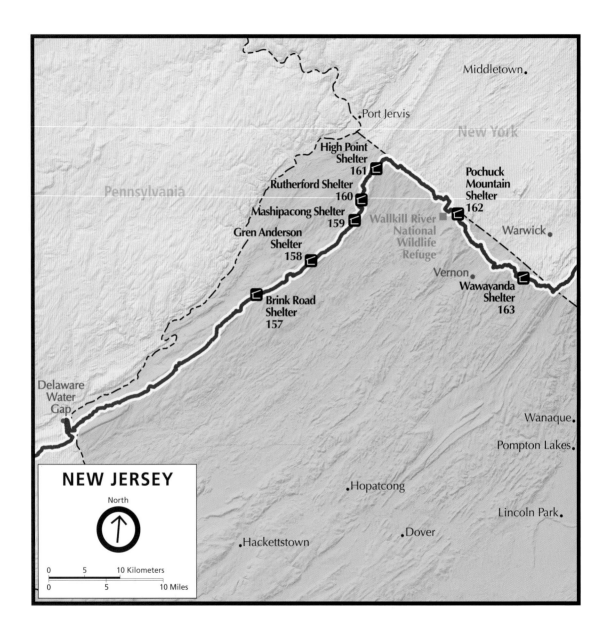

NEW JERSEY

North

0 5 10 Kilometers

0 5 10 Miles

Delaware
Water
Gap

Brink Road
Shelter
157

Gren Anderson
Shelter
158

Mashipacong Shelter
159

Rutherford Shelter
160

High Point
Shelter
161

Port Jervis

Middletown

New York

Pennsylvania

Pochuck
Mountain
Shelter
162

Warwick

Wallkill River
National
Wildlife
Refuge

Vernon

Wawayanda
Shelter
163

Wanaque

Pompton Lakes

Hopatcong

Lincoln Park

Dover

Hackettstown

BRINK ROAD SHELTER

- **#** 157
- **📍** NJ
- **⛰** 1,110 ft
- **⤢** 1,320.2
- **📍↗** 0.2 mi W
- **📅** 2013
- **🔨** N/A
- **🛏** 8
- **💧** Spring 100 yd northeast of shelter
- **🚽** Y (composting)
- **🐻** N
- **👥** NYNJTC

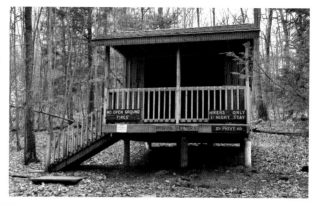

▶ Built by New York-New Jersey Trail Conference (NYNJTC) volunteers and Stokes State Forest staff, this is the newest shelter in New Jersey by more than 23 years. It was constructed from trees downed by Hurricane Irene. A shelter built in 1937 was once located near this site, which is an active bear and rattlesnake area. It is located north of the Delaware Water Gap National Recreation Area and 4 miles from the Buttermilk Falls Trail, a steep 1.5-mile side trail to the state's highest waterfall. It is the first shelter maintained by the NYNJTC. Established in 1920, the conference maintains 15 shelters and 162.2 miles of the AT from the Delaware Water Gap to the New York-Connecticut border. It also coordinates the maintenance of 2,000 miles of foot trails throughout New York and New Jersey, including around the New York metropolitan area.

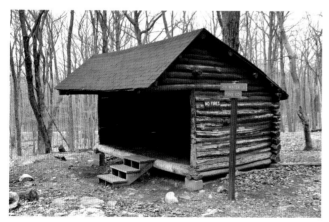

GREN ANDERSON SHELTER

- **#** 158
- **📍** NJ
- **⛰** 1,320 ft
- **⤢** 1,326.8
- **📍↗** 0.1 mi W
- **📅** 1958
- **🔨** N/A
- **🛏** 8
- **💧** Piped spring near shelter
- **🚽** Y
- **🐻** N
- **👥** NYNJTC

▲ Built by the now-disbanded New York section of the Green Mountain Club, this shelter is located between Culver Fire Tower (1,550 feet) and Sunrise Mountain (1,653 feet). It was rededicated in 1994. The Civilian Conservation Corps (CCC) built the Sunrise Mountain Picnic Shelter, a stone pavilion, in the 1930s. There is no camping at the pavilion.

MASHIPACONG SHELTER

#	159	🔨	N/A
📍	NJ	🛏	8
⛰	1,425 ft	💧	None at shelter
∘–∘	1,332.6	🚻	Y
📍	On AT	🐻	N
📅	1936	👥	NYNJTC

◄◄ This historic stone shelter has a wooden floor. Located near the southern boundary of High Point State Park, it is only 0.2 miles from a paved road. There is known bear activity in the area. The origin of the word "Mashipacong" is lost to history, and many places in the area carry the name, including Mashipacong Island on the Delaware River, located 11 miles away by car.

RUTHERFORD SHELTER

#	160	🛏	6
📍	NJ	💧	Small stream behind shelter
⛰	1,345 ft	🚻	Y
∘–∘	1,335.2	🐻	N
📍	0.4 mi E	👥	NYNJTC
📅	1967		
🔨	N/A		

▲ Lake Rutherford is within sight of this shelter, which has a nonfunctioning satellite dish mounted on its roof. The access trail has been rerouted 0.5 miles south to avoid a steep rock scramble. There is high bear activity in the area.

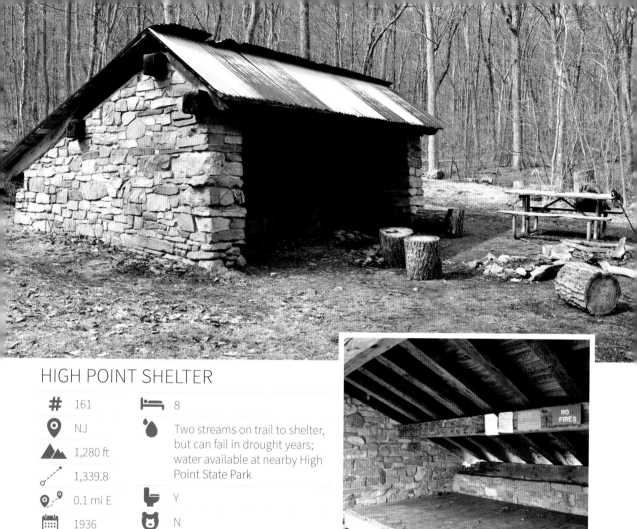

HIGH POINT SHELTER

#	161	🛏	8
📍	NJ	💧	Two streams on trail to shelter, but can fail in drought years; water available at nearby High Point State Park
⛰	1,280 ft		
⟋	1,339.8		
📍⟋	0.1 mi E	🚻	Y
📅	1936	🐻	N
🔨	N/A	👥	NYNJTC

▲ ▶ Located north of High Point State Park, this stone shelter with a wooden floor was built by the CCC. High Point Monument, built from 1928 to 1930, marks the highest elevation in the state—1,803 feet—and is a memorial to New Jersey veterans. The 220-foot structure, located on the peak in the state park, offers views of the Pocono Mountains to the west, the Catskill Mountains to the north, and the Wallkill River Valley to the southeast.

POCHUCK MOUNTAIN SHELTER

#	162	💧	Spigot 0.6 mi down steep hill south of shelter on vacant house owned by New Jersey Department of Environmental Protection; no camping allowed at house
📍	NJ		
⛰	840 ft		
⟋	1,352.2		
📍	0.1 mi W		
📅	1989	🚻	Y
⚒	N/A	🐻	N
🛏	6	👥	NYNJTC

▲ Located south of Pochuck Mountain (1,200 feet), this is the lowest-elevation shelter in New Jersey. A plaque states that it was built in loving memory of Jim Quinlan (1953–2015): "As you come to this place for a long or short rest, think of the journey you're on. Think of the people you hold in your heart, especially those that are gone. Think of this man who took time from his life to help build this shelter for you. With hope all its guests should find comfort and peace, a hope we all have for him too."

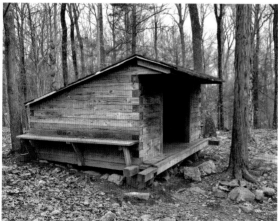

WAWAYANDA SHELTER

#	163	💧	Bathroom faucet or seasonal spigot on maintenance building at park office 0.1 mi north on AT; southbounders should get water before going to shelter
📍	NJ		
⛰	1,200 ft		
⟋	1,363.7		
📍	0.1 mi W		
📅	1990	🚻	Y
⚒	N/A	🐻	N
🛏	6	👥	NYNJTC

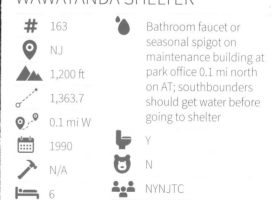

▲ This shelter replaced an older three-sided log-and-beam lean-to that was located here. A sign on the side calls it the "Wawayanda Hilton." A blue-blazed trail near the summit of Wawayanda Mountain leads to Pinwheel Vista, which has views of Pochuck Mountain and High Point Monument.

SIGNS

Signage on the trail can vary from club to club, and land-managing agencies may also have their particular styles. While most backcountry signs are made of wood, Shenandoah National Park, for example, uses concrete posts with metal bands.

Signs in federally designated wilderness areas have to follow certain guidelines, like being made with rough-hewn wood that is carved and created without the use of paint. Currently, there are about 28 designated wilderness areas along the trail. Chain saws and other motorized equipment cannot be operated in these areas, which affects how signs are built, how trail markings are created, and how trail maintenance is performed.

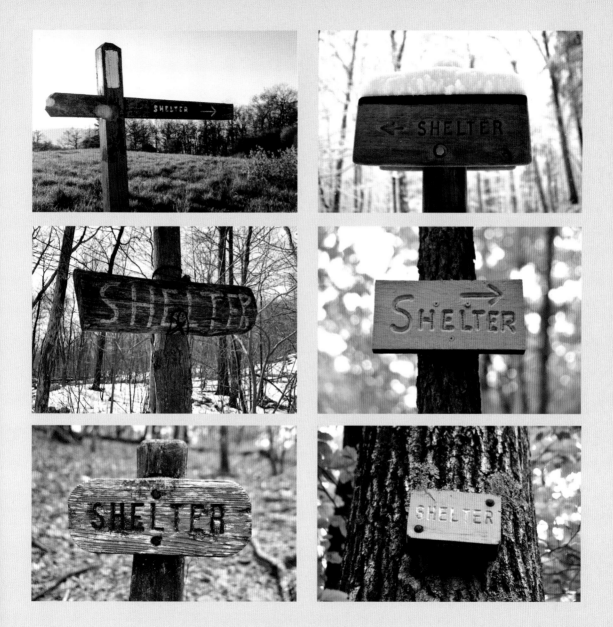

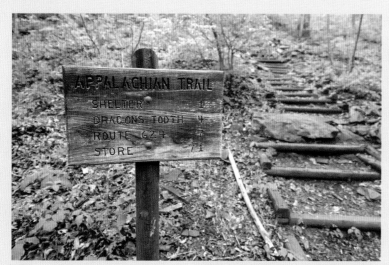

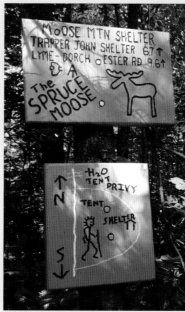

Signs

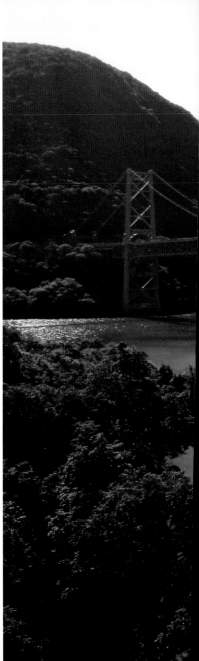

TOP: Appalachian Trail stop, Metro-North Railroad (a New York commuter train); **ABOVE:** Climbing near Wildcat Shelter; **RIGHT:** Bear Mountain Bridge

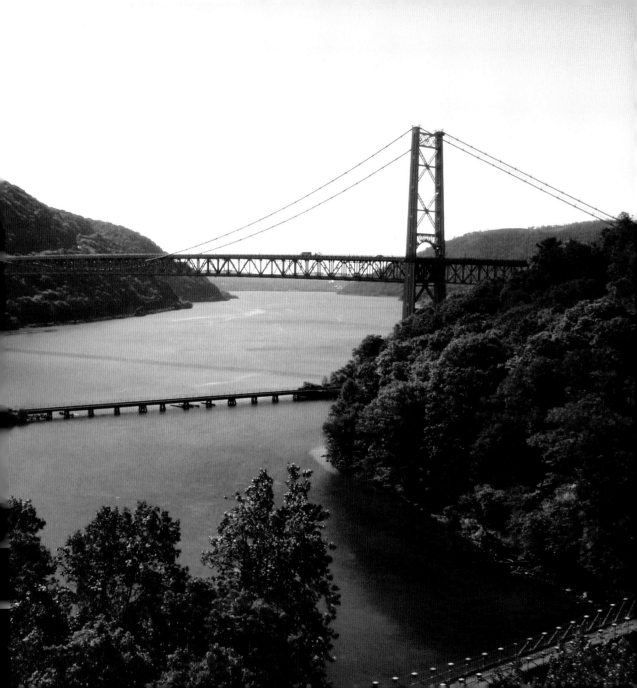

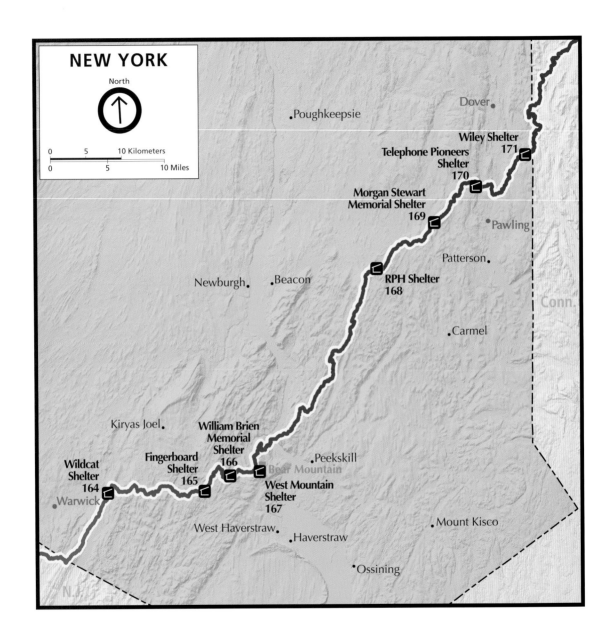

THE APPALACHIAN TRAIL

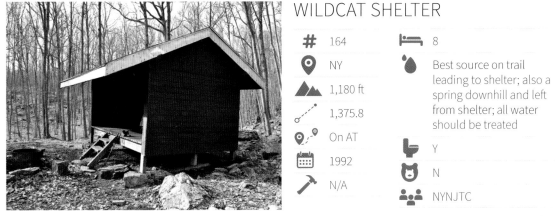

WILDCAT SHELTER

164

⚲ NY

⛰ 1,180 ft

⤢ 1,375.8

⚲ On AT

📅 1992

⚒ N/A

🛏 8

💧 Best source on trail leading to shelter; also a spring downhill and left from shelter; all water should be treated

🚽 Y

🐻 N

👥 NYNJTC

▲ The first shelter in New York, this plank-sided design is very different from other shelters in the area. It is located north of Prospect Rock (1,433 feet), the highest point on the AT in New York, and south of Mombasha High Point (1,280 feet), where hikers can see the New York City skyline on a clear day.

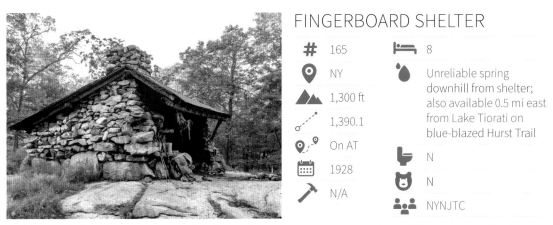

FINGERBOARD SHELTER

165

⚲ NY

⛰ 1,300 ft

⤢ 1,390.1

⚲ On AT

📅 1928

⚒ N/A

🛏 8

💧 Unreliable spring downhill from shelter; also available 0.5 mi east from Lake Tiorati on blue-blazed Hurst Trail

🚽 N

🐻 N

👥 NYNJTC

▲ This stone shelter is located just north of the Lemon Squeezer—a narrow rock crevice that hikers must negotiate in order to continue on the trail. It is the highest-elevation shelter in New York, one of the two oldest shelters in the state, and one of only three (non-hut) shelters built before 1930 that are still in use today. It also shares the title for the oldest (non-hut) shelter on the AT with West Mountain Shelter, just two shelters north. There is known bear activity in the area.

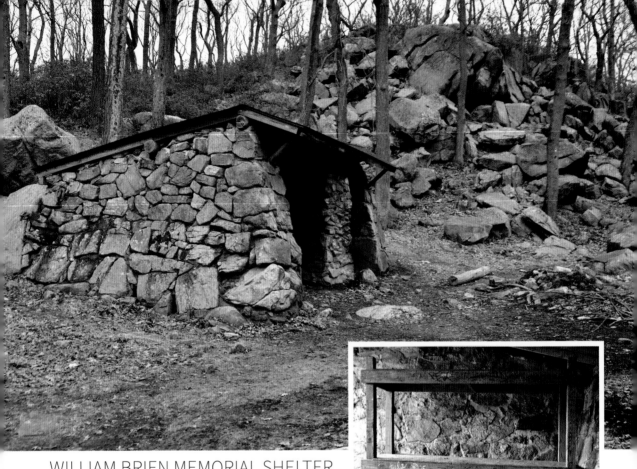

WILLIAM BRIEN MEMORIAL SHELTER

#	166	**📅**	1933
📍	NY	**🔨**	N/A
⛰	1,070 ft	**🛏**	8
⟋	1,395.4	**💧**	Unreliable spring-fed well east on blue-blazed trail; prone to go dry
📍	On AT		

 N

 N

NYNJTC

 This old stone shelter with double bunks and a fireplace was built by the Civilian Conservation Corps (CCC). One of the oldest shelters still in use on the AT, it is located between Goshen Mountain (1,180 feet) and Black Mountain (1,160 feet).

WEST MOUNTAIN SHELTER

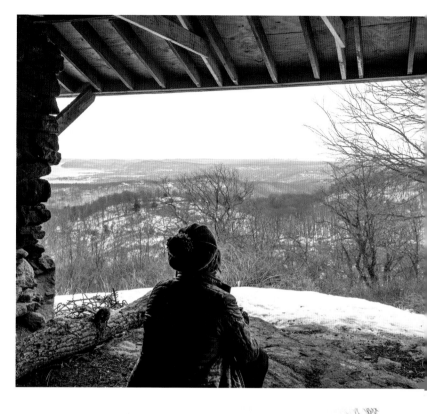

 # 167

 NY

1,240 ft

1,398.6

0.6 mi E

1928

N/A

 8

 Unreliable source 0.7 mi south of side trail junction; seasonal stream 0.2 mi before shelter

N

N

NYNJTC

▲▶ Located 0.5 miles off the AT via the Timp-Torne Trail, this is one of the two oldest shelters in New York and one of only three (non-hut) shelters built before 1930 that are still in use today. It is located south of Bear Mountain (1,350 feet), one of the highest points on the AT in the state, and there are great views from the shelter of the New York City skyline. More than two million people visit the Bear Mountain area every year; it is considered one of the most-visited areas on the trail. The New York-New Jersey Trail Conference and Appalachian Trail Conservancy just completed a massive 14-year reroute project in the area. The trail still travels through the Bear Mountain zoo, an original section from the 1920s, descending to the lowest elevation on the whole trail (124 feet). Hikers don't have to pay the $1 entrance fee.

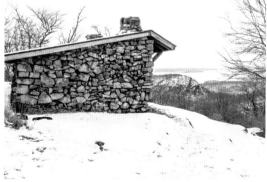

RPH SHELTER (RALPH'S PEAK HIKERS' CABIN)

#	168
◉	NY
⛰	350 ft
⟋	1,430.8
◉	On AT
📅	1982
🔨	1990
🛏	6
💧	Hand pump to left of shelter or stream nearby; all water should be treated
🚻	Y
🐻	N
👥	Ralph's Peak Hikers' Cabin Volunteers

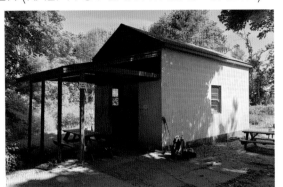

◀ Two structures, a small wooden cabin and a cinderblock building, were located on a parcel of land that was acquired for the AT. The president of the Ralph's Peak Hikers' Club at the time, Ralph Ferrusi, recognized the long-term potential and declared out loud, "This is a shelter." The club dismantled and removed the small cabin, and the cinderblock building became an AT shelter in 1982. In 1990, the frame part of the structure was removed at one end. Today, the shelter has AMC-style bunk beds, a covered porch area, and the Geraldine Messerich Memorial Garden on the side trail leading to it. It is one of the few shelters on the trail where hikers can have food delivered (it is located near a road and has an address), and it is also the only shelter to have mannequin legs wearing hiking boots coming out of a plastered ceiling. The next shelter to the south is located after the farthest stretch between two shelters on the trail—32.2 miles. It is also second only to Ten Mile River Lean-to in Connecticut as the lowest-elevation shelter on the entire trail.

MORGAN STEWART MEMORIAL SHELTER

#	169	📅	1984	🚻	Y
◉	NY	🔨	N/A	🐻	N
⛰	1,285 ft	🛏	6	👥	NYNJTC
⟋	1,439.8	💧	Well with pump located downhill 400 ft in front of shelter		
◉	On AT				

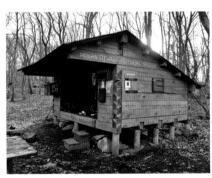

▶ The Ralph's Peak Hikers' Club (now the Ralph's Peak Hikers' Cabin Volunteers) built this shelter in memory of hiker Morgan Stewart with funds from an IBM Community Service Grant. It was built in volunteer Bob Haas's garage, disassembled piece by piece, and then rebuilt in its current location north of Mount Egbert (1,329 feet). Its unique interlocking oak-beam-corner design was chiseled with old-fashioned hand tools.

TELEPHONE PIONEERS SHELTER

#	170	(hammer)	N/A
(location)	NY	(bed)	6
(mountains)	910 ft	(water)	Stream crossed on side trail to shelter
(distance)	1,447.6	(toilet)	Y
(location pin)	0.1 mi E	(bear)	N
(calendar)	1988	(group)	NYNJTC

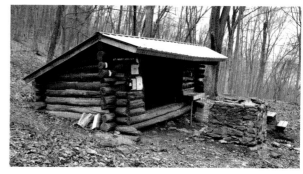

▼ Built with assistance from the White Plains Council of the Telephone Pioneers of America, the materials for this shelter were helicoptered in as pieces, and then built on the mountainside. It is located south of the Dover Oak, the largest oak tree on the AT. The tree is currently 20 feet, 4 inches in girth and estimated to be 300 years old. North on the trail, hikers pass the Appalachian Trail train stop and can catch a ride to New York City on the Metro-North Railroad.

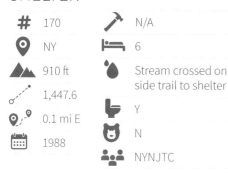

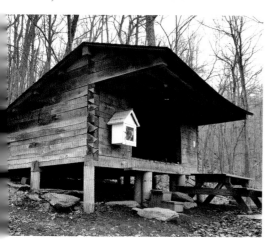

WILEY SHELTER

#	171	(bed)	6
(location)	NY	(water)	Pump 0.1 mi north of shelter; all water should be treated
(mountains)	740 ft	(toilet)	Y
(distance)	1,456.4	(bear)	N
(location pin)	On AT	(group)	NYNJTC
(calendar)	1940		
(hammer)	2014		

▲ ▶ This shelter was named for the New York Tramp and Trail Club's William O. Wiley, who helped the Boy Scouts build it. The land it is on was once Boy Scout Camp Sinoway. The shelter's original wire bunks were replaced with a wooden floor by an all-female trail crew. It was renovated as part of an Eagle Scout project in 2014 by Hunter Esposito, the rest of Pawling Troop 34, and the shelter's caretakers. Tent platforms are also available.

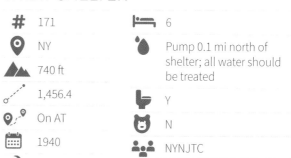

BUILDING MATERIALS

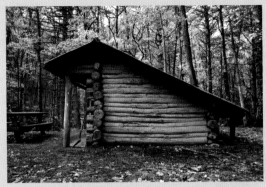

Deer Park Mountain Shelter, North Carolina

The majority of shelters on the AT follow the basic three-walled design with one open side and an overhanging roof, but a few enclosed cabins exist along the trail. Shelter construction varies by state, region, time period, trail club, materials used, and design style. Some are built with stone, some with wooden boards or planks, and others with logs downed nearby or sometimes brought in by helicopter.

The early shelters on the AT were built from stone or a mix of stone and logs. Many shelters, only a few of which still exist today, were built with logs from dead American chestnut trees. While shelters built today are still constructed out of stone and wood, the materials and designs vary more widely.

The Adirondack log style is quintessential in backcountry design and can be found in most states from North Carolina to Maine. The early CCC shelters and most of the shelters in Connecticut and Maine are this classic design. The Nantahala design is a wooden structure common in Georgia and North Carolina. The roof covers the sleeping platform and an open porch area that typically has a picnic table. The Massachusetts-style design is a tall, two-story wooden shelter with bunks, a loft, and skylights.

The United States Forest Service (USFS) plank-wood design is common throughout Virginia and parts of Vermont. The lightweight design became popular because it eased the process of bringing supplies to the shelter site and did not require specialized knowledge of the techniques used to construct log shelters. The USFS concrete-block design is only found on the trail in East Tennessee.

Fewer than 25 stone shelters are sprinkled throughout Georgia, North Carolina, Tennessee, Virginia, New Jersey, New York, and Vermont. Three of the oldest stone shelters on the trail, Fingerboard Shelter and West Mountain Shelter in New York and Governor Clement Shelter in Vermont, are also the only (non-hut) shelters built before 1930 that are still used today. William Brien Memorial Shelter, another stone shelter located between Fingerboard and West Mountain, was built in 1933.

Tri-Corner Knob Shelter, North Carolina

Little Laurel Shelter, North Carolina

Vandeventer Shelter, Tennessee

Carter Gap Shelter, North Carolina

Bryant Ridge Shelter, Virginia

Hurricane Mountain Shelter, Virginia

Quarry Gap Shelters, Pennsylvania

Siler Bald Shelter, North Carolina

Old Job Shelter, Vermont

Matts Creek Shelter, Virginia

Morgan Stewart Memorial Shelter,
New York

TOP: A juvenile red-spotted newt; **MIDDLE:** New York-Connecticut border; **ABOVE:** Pink lady's slipper, a member of the orchid genus; **RIGHT:** Ten Mile River area

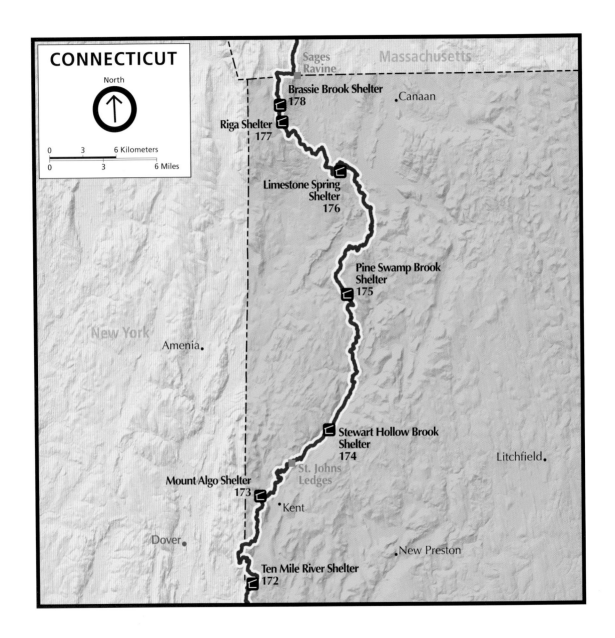

THE APPALACHIAN TRAIL

TEN MILE RIVER SHELTER

172

📍 CT

⛰ 290 ft

↗ 1,460.4

📍 0.1 mi E

📅 1996

🔨 N/A

🛏 6

💧 Hand pump 100 ft to left of shelter

🚻 Y

🐻 Bear box

👥 AMC-CT

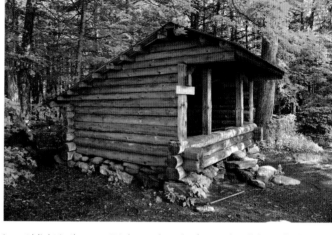

▶ The first shelter heading northbound in Connecticut, this is the lowest-elevation shelter on the entire trail and the newest in the state. It was built from dying pines affected by insect blight in the area. It is located north of Ten Mile Hill (1,000 feet). Tentsites are located at a campsite 0.2 miles north. All shelters in Connecticut are maintained by the Appalachian Mountain Club Connecticut Chapter (AMC-CT). Established in 1921, the club maintains seven shelters and 51.2 miles of the AT from the New York-Connecticut border to Sages Ravine, Massachusetts.

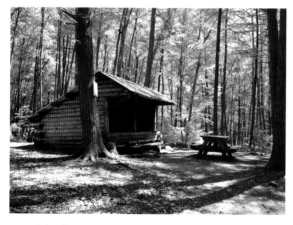

MOUNT ALGO SHELTER

173

📍 CT

⛰ 655 ft

↗ 1,468.8

📍 400 ft W

📅 1986

🔨 Roof replaced in 2019

🛏 6

💧 Rushing brook on blue-blazed trail to shelter

🚻 Y

🐻 Bear box

👥 AMC-CT

▲ Built by the AMC-CT, this shelter is located just south of the trail town of Kent and north of the only place along the entire AT where the trail crosses an Indian reservation.

STEWART HOLLOW BROOK SHELTER

#	174	🔨	N/A
📍	CT	🛏	6
⛰	400 ft	💧	Reliable Stony Brook 0.4 mi north on AT
⤴	1,476.1	🚽	Y
📍	0.1 mi W	🐻	Bear box
📅	1987	👥	AMC-CT

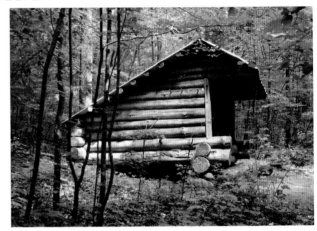

▶ This shelter is located west of the Housatonic River, between two junctions of River Road. Stony Brook Campsite is located 0.4 miles north on the AT.

PINE SWAMP BROOK SHELTER

#	175	🔨	N/A
📍	CT	🛏	6
⛰	1,075 ft	💧	Source on blue-blazed trail
⤴	1,486.1	🚽	Y
📍	0.1 mi E	🐻	Bear box
📅	1989	👥	AMC-CT

▶ Named for nearby Pine Swamp Brook and Pine Swamp Brook Falls, this shelter is located south of Mount Easter (1,350 feet).

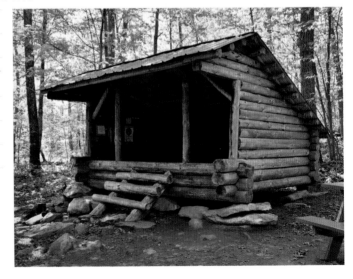

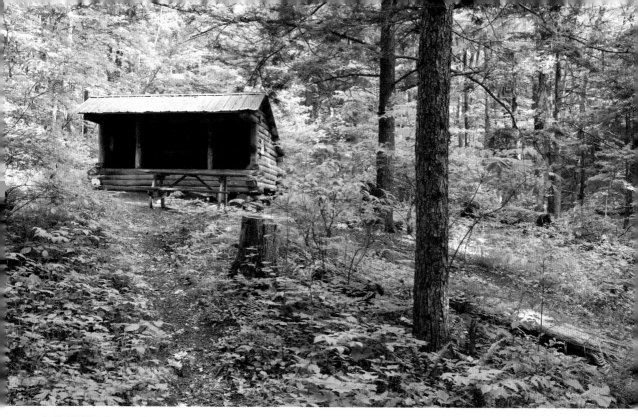

LIMESTONE SPRING SHELTER

#	176	📍	0.5 mi W	💧	Follow stream to spring coming out of small limestone cave
📍	CT	📅	1986	🚻	Y
⛰️	980 ft	🔨	N/A	🐻	Bear box
🥾	1,497.4	🛏️	6	👥	AMC-CT

▲ This shelter is located down a very steep 0.5-mile blue-blazed side trail that was once the main route of the AT. A large tenting area is located near the shelter. A plaque at the shelter reads, "In memory of Stephen Z. Meyers, a generous donation has been made by family and friends toward the protection and maintenance of the Appalachian Trail in this area, April 19, 1997." The shelter is located north of a hydroelectric plant and the Iron Bridge over the Housatonic River. A showerhead at the plant can be seen sticking out of the vine-covered building so hikers can take a cold shower outside. The original bridge was built in 1903 and recently has been renovated.

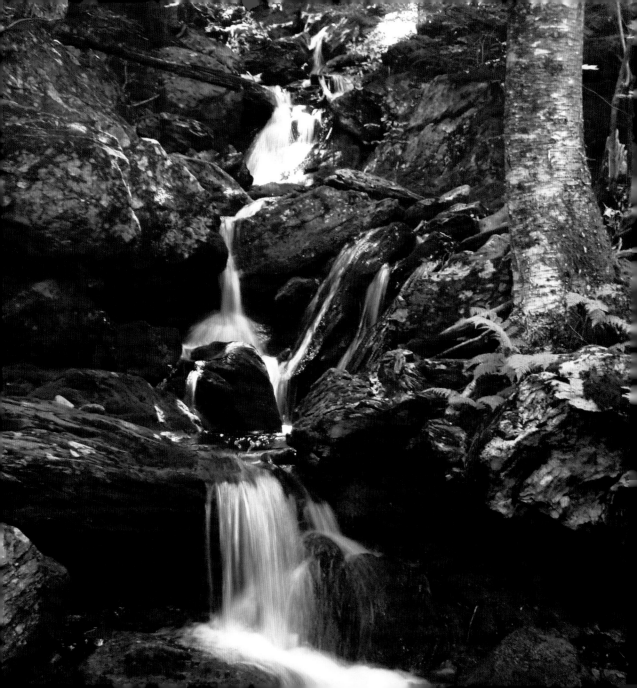

RIGA SHELTER

177 🛏 6

📍 CT 💧 Spring on blue-blazed trail to left of clearing at AT

⛰ 1,610 ft

〰 1,504.8

📍 0.2 mi E 🚻 Y

📅 1990 🐻 Bear box

🔨 N/A 👥 AMC-CT

▶ This is the only shelter in Connecticut with a view (see contents page), which faces east for great sunrises. Tentsites and platforms are also available.

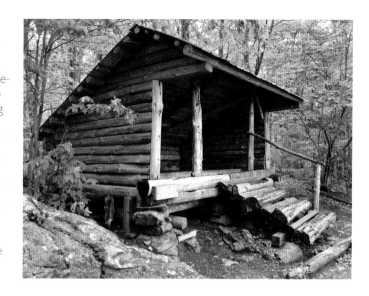

BRASSIE BROOK SHELTER

178 🛏 6

📍 CT 💧 Stream on AT north of side trail to shelter

⛰ 1,705 ft

〰 1,506

📍 0.1 mi E 🚻 Y

📅 1980s 🐻 Bear box

🔨 N/A 👥 AMC-CT

◀ This shelter is located south of Bear Mountain (2,316 feet), the highest peak in Connecticut. It is the highest-elevation shelter in the state. Tentsites are also available.

CAMPSITES

While spending the night on the AT, hikers have many options: staying in a shelter, hanging a hammock, or pitching a tent. Shelters, in addition to being a welcoming gathering place, help localize hiker impact. But shelters are often full, so it is essential that hikers carry a tent or other lightweight portable shelter. In most areas, the limit of stay is generally two nights at any one shelter or campsite unless otherwise posted.

Hikers can help minimize impact along the trail by staying at designated camping sites or shelters, which limits the areas where vegetation is trampled and wildlife habitat disturbed. Backcountry camping is available at more than 100 designated campsites along the trail and is allowed in the immediate vicinity of most shelters. Designated camping areas are typically named, marked, and have obvious flat choices nearby. Campsites that are not at a shelter site typically do not have a privy, but are usually located near a water source.

According to the Appalachian Trail Conservancy, dispersed camping, sometimes referred to as stealth camping, is allowed in some areas, meaning hikers can legally choose their own campsite. Hikers should always pitch tents on durable surfaces like rock, bare soil, or grass, out of sight of the trail and at least 200 feet

(80 steps) from water. But in many areas along the trail—including Great Smoky Mountains National Park in Tennessee and North Carolina, Grayson Highlands State Park in Virginia, and many areas from Harpers Ferry, West Virginia, all the way to Baxter State Park in Maine—dispersed camping is prohibited. In Maryland, New Jersey, New York, Connecticut, and Massachusetts, camping is allowed only at designated overnight sites along the AT.

Some shelters have constructed tent pads that reduce impacts in the camping areas. These pads range in design, size, and materials, but are often raised wooden platforms or gravel pads. Many shelters and designated campsites in New Hampshire have wooden platforms that allow for tenting in steep terrain.

In 2015, the Georgia Appalachian Trail Club documented 202 non-designated, hiker-created sites in the first heavily used 30 miles of the AT. In response, 10 members of the club, along with Army Rangers from nearby Camp Frank D. Merrill, constructed 30 tent pads between Hawk Mountain Shelter and Gooch Mountain Shelter in 2016. The volunteer crew carried three 150-pound bear-resistant food-storage boxes, more than

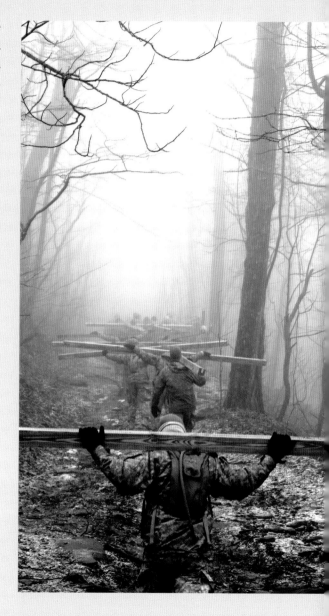

LEFT: Tent platform, Kinsman Pond Shelter and Campsite, New Hampshire

RIGHT: Army Rangers boosting volunteer efforts in 2016 by hand-carrying heavy lumber for new sustainable tent pads on Hawk Mountain, Georgia

100 pieces of lumber, and 10 sheets of plywood for new campsites and a moldering privy. The new sustainable camping area was built to help with the increasing traffic in the area, especially during peak season when thousands of hikers—up to 200 a day—pass through the section.

In some areas maintained by the Green Mountain Club and Appalachian Mountain Club, there are heavily used campsites that require a small fee for overnight campers due to the need for increased education and management of human waste in ecologically sensitive areas. Baxter State Park in Maine has its own unique permits, requirements, and fees for AT hikers, overnight hikers, and day hikers. Overnight permits are required in Shenandoah National Park in Virginia and Great Smoky Mountains National Park in North Carolina and Tennessee. The latter requires permits of all backcountry campers and operates on a reservation system due to high demand and limited space in the shelters. Tenting is not allowed, except by thru-hikers when the shelter is full; folks with reservations have the first spots inside. Long-distance hikers obtain a thru-hiker permit from the park that replaces the standard backcountry permit. Almost all shelters continue to be available on a first-come, first-served basis along the entire AT.

BELOW, LEFT: Pine Knob Shelter, Maryland
BELOW, RIGHT: Tent pad with mulched floor, Ensign Cowall Shelter, Maryland

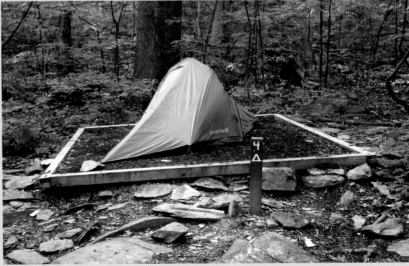

Regardless of how hikers spend the night on the trail—either at a shelter, designated campsite, or dispersed camping—they should minimize their impact and know the local camping regulations, including restrictions or prohibitions on the building of campfires, which should be kept small.

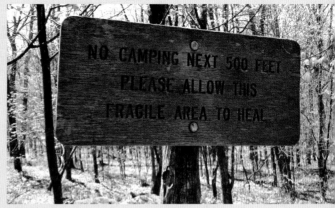

Near Mount Rogers, Virginia

Tumbling Run Shelters, Pennsylvania

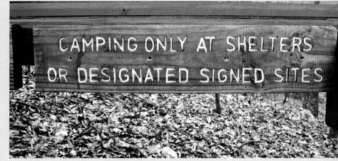

Near Johns Spring Shelter, Virginia

Campbell Shelter, Virginia

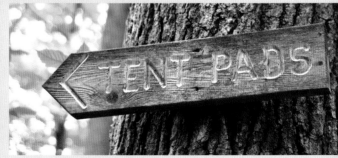

Ensign Cowall Shelter, Maryland

MASSACHUSETTS

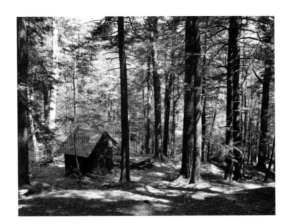

TOP: Glen Brook Shelter; **ABOVE:** Veterans War Memorial Tower on Mount Greylock, the tallest peak in Massachusetts; **RIGHT:** Open ledges of Mount Race

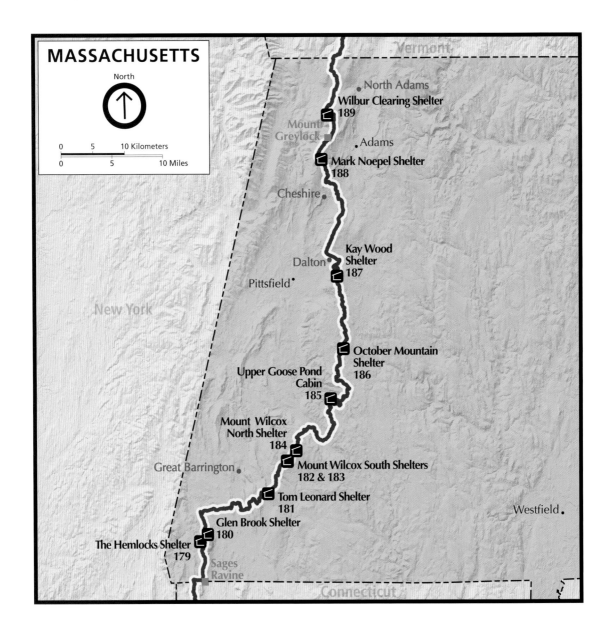

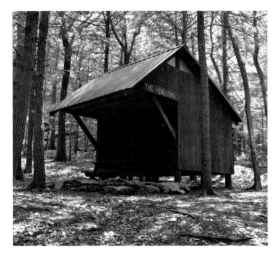

THE HEMLOCKS SHELTER

#	179	🔨	N/A
📍	MA	🛏	10
⛰	1,880 ft	💧	Source on AT just north of shelter
⊶	1,514.8	🚽	Y (moldering)
📍	0.1 mi E	🐻	Bear box
📅	1999	👥	AMC-BK

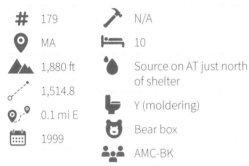

▲ The first shelter located in Massachusetts was built by volunteers from the Appalachian Mountain Club Berkshire Chapter (AMC-BK). It is located in a hemlock grove north of Mount Everett (2,602 feet), the second-highest range in Massachusetts. The shortest distance between shelters on the whole AT is between this one and the next, Glen Brook, just 0.1 miles north. It is a Massachusetts-style shelter—a two-story design with bunks, a loft, and skylights. It is maintained by volunteers of the AMC-BK. Established in 1979, the club maintains 11 shelters and 89.7 miles of the AT from Sages Ravine to the Massachusetts-Vermont border.

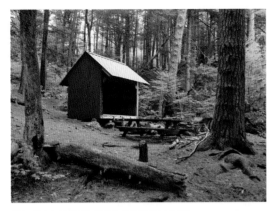

GLEN BROOK SHELTER

#	180
📍	MA
⛰	1,885 ft
↗	1,514.9
📍	0.1 mi E
📅	1986
🔨	N/A
🛏	6

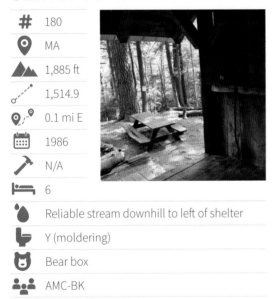

💧	Reliable stream downhill to left of shelter
🚽	Y (moldering)
🐻	Bear box
👥	AMC-BK

▲▲ This small shelter—the first built by the AMC-BK—has two tent platforms and a large tenting area on the plateau above. The shelter sign reads, "Built by volunteers June 14, 1986. Enjoy. Please remember others."

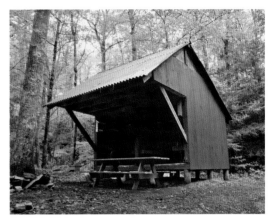

TOM LEONARD SHELTER

#	181	🛏	10
📍	MA	💧	Very cold stream 0.2 mi down ravine on blue-blazed trail
⛰	1,540 ft		
↗	1,529.2	🚽	Y (moldering)
📍	0.1 mi E	🐻	Bear box
📅	1988	👥	AMC-BK
🔨	N/A		

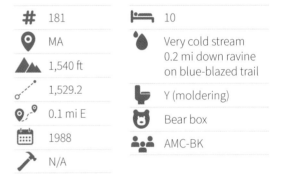

▲ Located near Ice Gulch, this two-story design has bunks, a loft, and skylights. Tent pads and tent platforms are also available, and there is a nice view to the south from the tent platform. The shelter sign reads, "Built by volunteers June 11, 1988. Funded by AMC, DEM, Anonymous Donor. Enjoy. Please remember others."

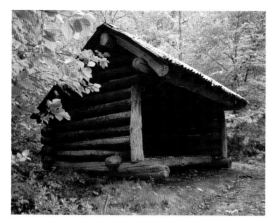

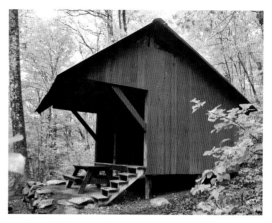

MOUNT WILCOX SOUTH SHELTER (OLD)

182

◉ MA

🏔 1,720 ft

⌇ 1,534.5

📍 0.1 mi E

📅 1939

⚒ N/A

🛏 6

💧 Spring in rocks on side trail west of old shelter

🚽 Y (pit)

🐻 Bear box on blue-blazed trail west of old shelter

👥 AMC-BK

▲ This small log shelter, built by the Civilian Conservation Corps, is located just before a large new shelter. It is one of the oldest shelters in Massachusetts and on the entire trail. Both shelters are located on the same blue-blazed trail. Five tent pads are also available.

MOUNT WILCOX SOUTH SHELTER (NEW)

183

◉ MA

🏔 1,720 ft

⌇ 1,534.5

📍 0.15 mi E

📅 2007

⚒ N/A

🛏 10

💧 Spring in rocks on side trail west of old shelter

🚽 Y (pit)

🐻 Bear box

👥 AMC-BK

▲ The newest shelter in Massachusetts is a two-story design with bunks, a loft, and skylights. Tent pads are located behind the old shelter.

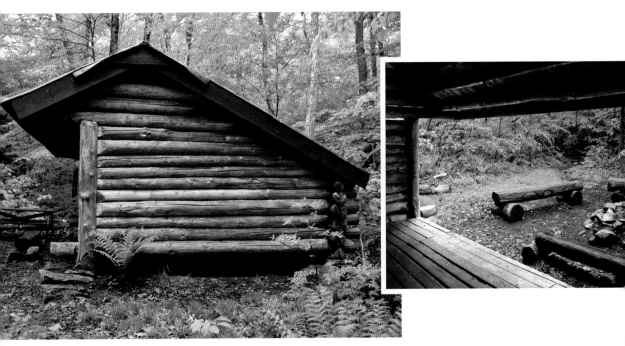

MOUNT WILCOX NORTH SHELTER

#	184	🛏	8
📍	MA	💧	Unreliable brook near shelter; may go dry in summer
⛰	2,100 ft		
🔗	1,536.3	🚻	Y (pit)
📍	0.3 mi E	🐻	Bear box
📅	1977	👥	AMC-BK
🔨	N/A		

▲▲ This older log shelter is located on an early route of the AT, now the blue-blazed access trail. It is north of Benedict Pond in Beartown State Forest.

UPPER GOOSE POND CABIN

#	185	🛏	16
📍	MA	💧	During summer, resident caretaker brings water from spring across pond; otherwise, pond is source
⛰	1,480 ft		
🔗	1,550.5		
📍	0.5 mi W		
📅	Early 1900s	🚻	Y
🔨	Acquired by NPS in 1984	🐻	Bear box
		👥	AMC-BK

OCTOBER MOUNTAIN SHELTER

 186

 MA

 1,950 ft

 1,559.3

 On AT

 1990

 N/A

 8

 Stream south on AT

 Y (moldering)

 Bear box

AMC-BK

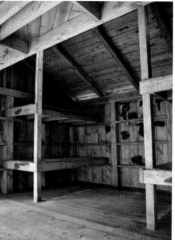

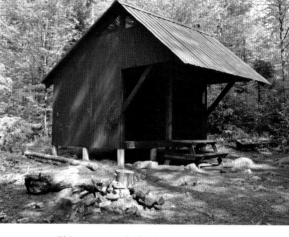

▲▲ This two-story shelter has bunks, a loft, and skylights, and the loft overhangs the picnic table. Tentsites are in an open area behind and to the right of the shelter.

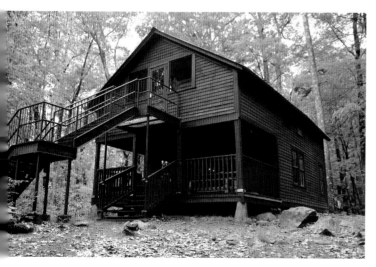

◀ Located on one of the last undeveloped ponds in Massachusetts, this enclosed cabin—the lowest-elevation shelter in the state—is owned by the National Park Service and maintained by the AMC-BK. It has bunks, a fireplace, a covered porch, and an outdoor food prep area. Tent platforms are also available. Swimming is allowed in the pond. It is free to stay, but donations are accepted. A volunteer caretaker is on duty 24 hours a day, seven days a week, from mid-May to mid-October. The cabin is closed when no caretaker is present, but hikers may use the campsites on the approach trail and behind the cabin year-round. The shelter has two moldering privies and one regular privy.

KAY WOOD SHELTER

| # | 187 | 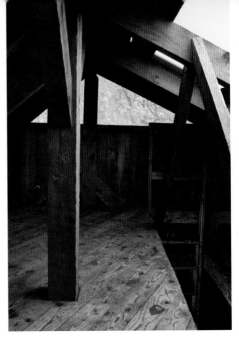 |
|---|-----|
| 📍 | MA |
| ⛰️ | 1,860 ft |
| 〰️ | 1,568.1 |
| 📍 | 0.2 mi E |
| 📅 | 1987 |
| 🔨 | N/A |

🛏️	10
💧	Stream on blue-blazed trail to left of shelter
🚽	Y (moldering)
🐻	Bear box
👥	AMC-BK

▼ Named for the AMC-BK's first chair—Dalton resident, long-time trail maintainer, and thru-hiker Kay Wood—this shelter was funded by the Appalachian Trail Conservancy. A shelter sign reads, "Enjoy—Please Remember Others." A two-story design with bunks, a loft, and skylights, the shelter sits at the top of a small cliff overlooking the forest. Six tent pads are also available.

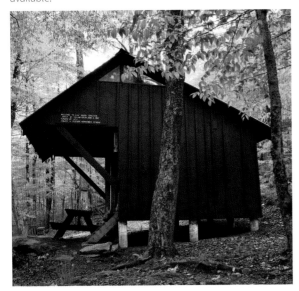

MARK NOEPEL SHELTER

| # | 188 | 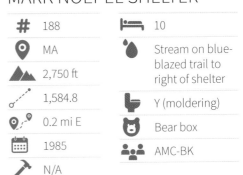 |
|---|-----|
| 📍 | MA |
| ⛰️ | 2,750 ft |
| 〰️ | 1,584.8 |
| 📍 | 0.2 mi E |
| 📅 | 1985 |
| 🔨 | N/A |

🛏️	10
💧	Stream on blue-blazed trail to right of shelter
🚽	Y (moldering)
🐻	Bear box
👥	AMC-BK

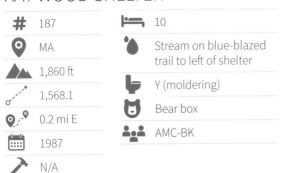

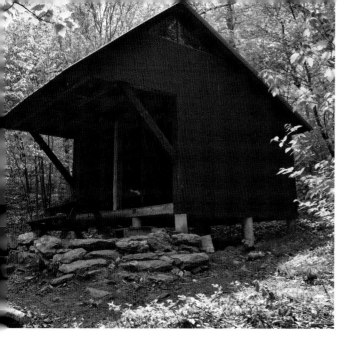

WILBUR CLEARING SHELTER

 189 8

 MA Stream to right of shelter; occasionally can go dry in late summer

 2,310 ft

1,591.4

 0.3 mi W on blue-blazed Money Brook Trail Y (moldering)

 Bear box

1970 AMC-BK

 N/A

▼ This smaller shelter overlooks the head of the Money Brook drainage. It is located 0.3 miles west on Money Brook Trail and 0.7 miles from Notch Road. Tentsites, four tent platforms, and four tent pads are also available. It is popular with groups and can be busy during summer weekends.

▲▲ Named for naturalist, AT volunteer, and ridgerunner Mark Noepel, this two-story shelter has bunks, a loft, and skylights. Two tent pads, two tent platforms, and a group camping area with a picnic table are also available. The highest-elevation shelter in Massachusetts, it is located south of Mount Greylock (the tallest peak in the state at 3,491 feet) and Saddle Ball Mountain (at 3,238 feet, the first peak higher than 3,000 feet north of Shenandoah National Park).

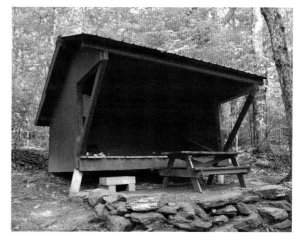

FIRES

The familiar smell, the instant camaraderie, and the warm glow of a gathering around a campfire have existed as long as there have been people camping outdoors. Varying campfire regulations exist along the AT. Campfires are not permitted on some parts of the trail, and most sections restrict fires to designated sites only. Check the local guidelines and fire bans in guidebooks, and read the signs located along the trail.

Use only existing fire rings at officially designated sites and don't build new ones. Hikers must always build and extinguish campfires responsibly. Collect only downed and dead wood that can be broken with your hands—no larger than the diameter of an adult wrist. Do not burn trash, garbage, or leftover food, and always leave the fire ring clean and cold. Burning trash can put toxic chemicals into the soil and air or leave food residue for animals to forage. Put out fires with water. Scattering unused wood, cold coals, and ashes 200 feet away from camp after the fire is cold and completely out is courteous. To reduce impacts to forest ecosystems, hikers should use stoves for cooking. If there's any doubt that a fire may be legal, don't build one.

Overmountain Shelter, North Carolina

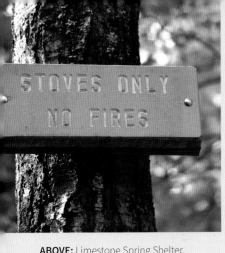

ABOVE: Limestone Spring Shelter, Connecticut

RIGHT: Toms Run Shelter, Pennsylvania

BELOW: The Priest Shelter, Virginia

VERMONT

TOP: Bromley Mountain ski lift; **ABOVE:** Glastenbury Mountain observation tower;
RIGHT: Melissa "Click!" Goodwin enjoying a break at Churchill Scott Shelter

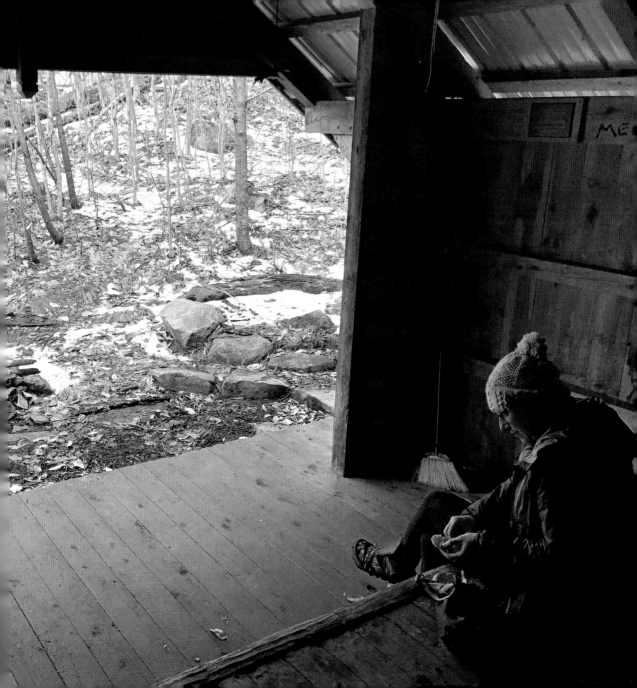

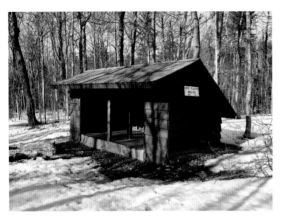

SETH WARNER SHELTER

#	190	🛏	8
📍	VT	💧	Unreliable brook 150 yd to left of shelter; prone to fail in dry years
⛰	2,180 ft		
⸜	1,601.3		
📍	0.2 mi W	🚽	Y
📅	1965	🐻	Bear box
🔨	N/A	👥	GMC

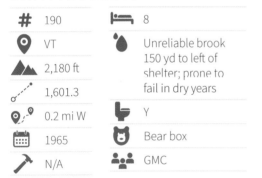

▲ This frame lean-to was built by carpenter trainees of the Manpower Development Training Act in 1965. It is the first shelter in Vermont and the first maintained by the Green Mountain Club (GMC). Established in 1910, the club maintains 27 shelters and 150.8 miles of the AT from the Massachusetts-Vermont border to the Vermont-New Hampshire border. The club is also the founder and maintainer of the Long Trail (LT), the oldest long-distance hiking trail in America. The 272-mile LT runs the length of the state from the Massachusetts border to the Canada border. It coincides with the AT for 100 miles. From here until Churchill Scott Shelter, all shelters are on both the AT and LT. The two trails split at the Maine Junction near Killington.

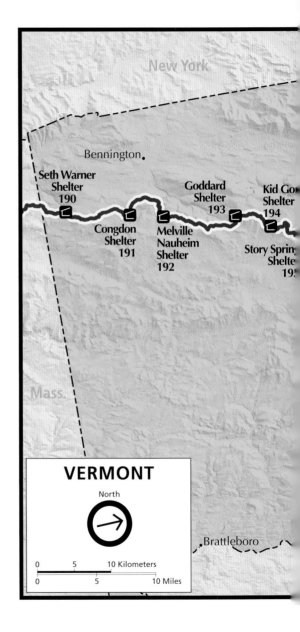

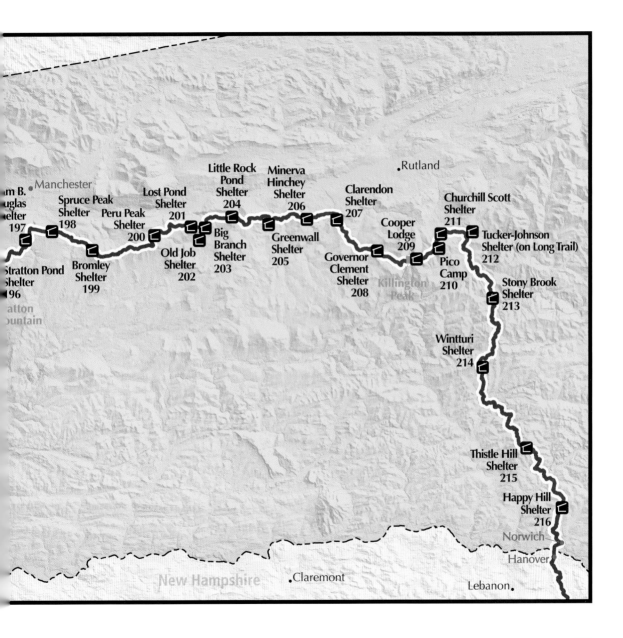

m B.
uglas
elter
197

Manchester

Spruce Peak
Shelter
198

Peru Peak
Shelter
200

Lost Pond
Shelter
201

Little Rock
Pond
Shelter
204

Minerva
Hinchey
Shelter
206

Rutland

Clarendon
Shelter
207

Churchill Scott
Shelter
211

Cooper
Lodge
209

Tucker-Johnson
Shelter (on Long Trail)
212

Big
Branch
Shelter
203

Old Job
Shelter
202

Greenwall
Shelter
205

Governor
Clement
Shelter
208

Pico
Camp
210

Stony Brook
Shelter
213

Stratton Pond
Shelter
196

Bromley
Shelter
199

Killington
Peak

atton
ountain

Wintturi
Shelter
214

Thistle Hill
Shelter
215

Happy Hill
Shelter
216

Norwich

Hanover

New Hampshire

Claremont

Lebanon

CONGDON SHELTER

#	191	🔨	1994	🚽	Y
📍	VT	🛏	8	🐻	N
⛰	2,060 ft	💧	Small brook east of shelter; second source downhill from shelter at larger Stamford Stream	👥	GMC
⚬	1,608.5				
📍	On AT				
📅	1967				

▲ Built by the Long Trail Patrol in 1967 and modified by Pioneer Valley Volunteers in 1994, this open-front frame cabin was named for Herbert Wheaton Congdon—an LT pioneer, trail builder, cartographer, and guidebook editor—as a gift from his family. The shelter has bunks and a small interior table, and tentsites are located on the ridge. It is located south of Marmon Hill (2,325 feet), with views of the trail town of Bennington.

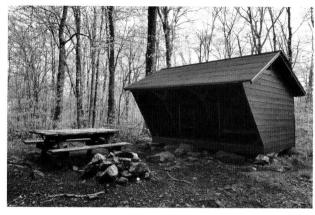

MELVILLE NAUHEIM SHELTER

#	192	🛏	8
📍	VT	💧	Stream crosses trail north of spur junction
🏔	2,330 ft		
⟋	1,614.4	🚽	Y
📍	< 0.1 mi E	🐻	N
📅	1977	👥	GMC
🔨	N/A		

▲ Built with funds contributed by Mrs. Melville Nauheim of New York City in memory of her husband, this shelter is located south of Little Pond Lookout (3,060 feet) and just north of Bennington. It has bunks, a small interior table, and tentsites.

GODDARD SHELTER

#	193	🔨	N/A
📍	VT	🛏	12
🏔	3,540 ft	💧	Piped spring 50 yd south on AT
⟋	1,622.9	🚽	Y
📍	On AT	🐻	Bear box
📅	2005	👥	GMC

▶ This shelter was built by Erik and Laurel Tobiason with GMC volunteers, friends, and the United States Forest Service (USFS), with funds contributed by the family of local hiker Shaun P. Keenan. It is the fourth on this site, with the newest structure replacing a log shelter built by the GMC Bennington Section in 1985. The name honors Ted Goddard, former president and treasurer of the GMC and former president of the Bennington Section. Tenting is allowed above the shelter west of the AT, but no tenting is allowed east of the trail due to the location of the water source. Views to the south are available from the front porch. The shelter is located south of Glastenbury Mountain (3,748 feet), and its summit observation tower, originally built in 1927 and renovated in 2005, has views in all directions.

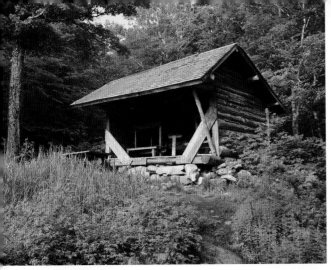

KID GORE SHELTER

#	194	🛏	8
📍	VT	💧	Unreliable spring north of shelter; reliable brook near Caughnawaga Tentsites
⛰	2,795 ft		
⊶	1,627.2		
📍⊶	0.1 mi via loop trail	🚻	Y
📅	1971	🐻	Bear box
🔨	N/A	👥	GMC

◀◀ This log lean-to with a small interior table was built by GMC Connecticut Section volunteers and Camp Najerog alumni in memory of Harold M. (Kid) Gore, who ran the camp. The surrounding area is ecologically fragile. Tentsites are located to the north at the site of the former Caughnawaga Shelter (built in the 1930s and torn down in 2008).

STORY SPRING SHELTER

#	195	📍⊶	On AT	💧	Spring 50 yd north on AT
📍	VT	📅	1963	🚻	Y
⛰	2,810 ft	🔨	Roof replaced in 2015	🐻	Bear box
⊶	1,631.8	🛏	8	👥	GMC

▶ This frame lean-to shelter was built by the USFS and named in honor of George F. Story, an active trail worker in the Worcester section for many years. Tentsites are also available.

STRATTON POND SHELTER

#	196	📍 0.1 mi W via Stratton Pond Trail	
📍	VT		
⛰	2,565 ft	📅 1999	
⟋	1,642.2	🔨 N/A	

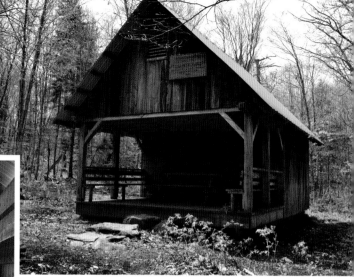

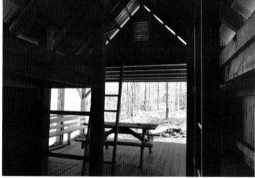

 20

 Intermittent Willis Ross Spring at Stratton Pond or piped Bigelow Spring at Stratton Pond 0.1 mi down Lye Brook Falls Trail

🚽 Y (composting)

 Bear box

 GMC

▲▲ Dedicated in memory of Robert Humes, a longtime volunteer and past GMC president, this post-and-beam structure with an open first floor, bunks, and an enclosed loft was built by Erik and Laurel Tobiason and GMC Worcester Section volunteers. Future maintenance of the shelter has been endowed by Lee and Sunny Allen. There is an overnight fee. No tenting or fires are allowed at the shelter, but camping is allowed at the Stratton View Tenting Area and designated sites. One of only four (non-hut) shelters on the trail that sleep more than 20 people, it is located north of Stratton Mountain (3,936 feet). Many believe it was in a tree atop Stratton Mountain where Benton MacKaye first dreamed of the continuous footpath that eventually became the AT. A fire tower at the summit is open to hikers.

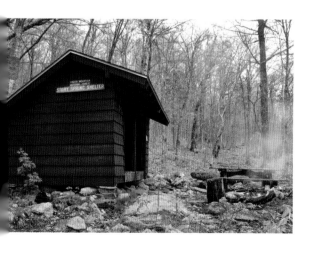

WILLIAM B. DOUGLAS SHELTER

#	197	🔨	2004–05
📍	VT	🛏	10
⛰	2,210 ft	💧	Spring south of shelter on Branch Pond Trail
⟋	1,647.1		
📍	0.5 mi W via Branch Pond Trail	🚻	Y
		🐻	N
📅	1956	👥	GMC

▲ ▶ Renovated by the GMC Brattleboro Section, this shelter is located south of Prospect Rock (2,079 feet), which has views of Manchester and Mount Equinox (3,855 feet), the second-highest peak in southern Vermont after Stratton Mountain. Tentsites are also available.

SPRUCE PEAK SHELTER

#	198	📅	1983
📍	VT	🔨	2015
⛰	2,180 ft	🛏	16
⟋	1,650.1	💧	Reliable piped spring 100 ft beyond shelter
📍	0.1 mi W	🚻	Y (composting)
		🐻	N
		👥	GMC

▲ This enclosed log structure with a covered front porch was built by the GMC Brattleboro Section, a Rutland Corrections Crew, and the USFS. Constructed with logs cut and provided by the USFS, it is located south of Spruce Peak (2,040 feet) and Manchester Center. Tentsites are also available.

BROMLEY SHELTER

199

📍 VT

⛰ 2,560 ft

↗ 1,654.9

📍 < 0.1 mi E

📅 2003

🔨 N/A

🛏 12

💧 Unreliable spring at end of spur trail; no water for next 8 mi

🚽 Y (composting)

🐻 N

👥 GMC

▼ This post-and-beam structure with benches and a small interior table was built by Erik and Laurel Tobiason and the GMC Worcester Section. Funding was provided by the family of Debby Edelstein, and future maintenance has been endowed by Marge and Bob Fish. Four tent platforms are also available. The shelter is located south of Bromley Mountain (3,260 feet), where a Ski Patrol hut is unlocked and available for use. A former observation tower was removed. There is a privy at the summit, but no water.

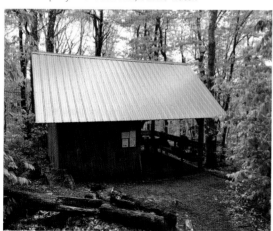

PERU PEAK SHELTER

200

📍 VT

⛰ 2,605 ft

↗ 1,663

📍 On AT

📅 2000

🔨 2011

🛏 10

💧 Nearby brook or pond

🚽 Y (composting)

🐻 N

👥 GMC

▼ The original structure of this shelter was built by the Civilian Conservation Corps (CCC) in 1935, rebuilt by the USFS in 1979, and then rebuilt again in 2000 by the Long Trail Patrol (LTP) with help from the USFS. It was renovated by the LTP in 2011. Future maintenance has been endowed by family and friends in loving memory of Bernard Godfrey. There is an overnight fee. Camping is permitted only at tent platforms within 0.5 miles of Griffith Lake.

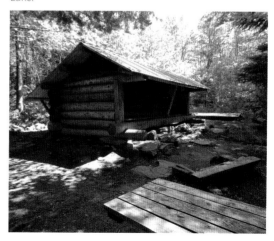

LOST POND SHELTER

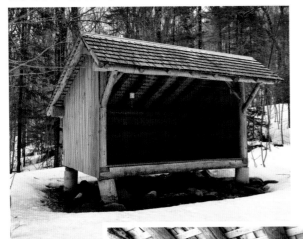

#	201
📍	VT
⛰️	2,150 ft
	1,667.7
	100 ft W
📅	2009
🔨	N/A
🛏️	8
💧	Nearby stream west of shelter
🚽	Y
🐻	N
👥	GMC

▲▲ This is one of the newest shelters in Vermont. The original shelter, built by Louis (Sandy) Stare Jr. in 1965, burned in 2001. It was rebuilt in 2002 by Tom Abbott and GMC volunteers coordinated by Margaret Fish, but it burned down again in 2006. It was rebuilt a third time by John Ogden and GMC volunteers in 2009. It has bunks and there are tentsites nearby. It is located north of Baker Peak (2,850 feet).

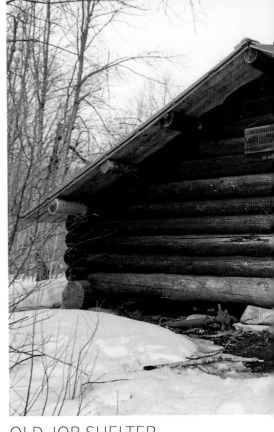

OLD JOB SHELTER

#	202	🔨	2009
📍	VT	🛏️	8
⛰️	1,525 ft	💧	Lake Brook in front of shelter
	1,669.2	🚽	Y
	1.3 mi E via Old Job Trail	🐻	N
📅	1935	👥	GMC

BIG BRANCH SHELTER

#	203	🔨	N/A
📍	VT	🛏	8
⛰	1,460 ft	💧	Big Branch River in front of shelter
⤍	1,669.4		
📍	On AT	🚽	Y
📅	1963	🐻	N
		👥	GMC

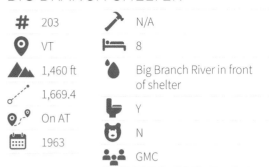

▼ This frame lean-to was built by the USFS. Tentsites are located north of the shelter, and there are good soaking pools nearby. Future maintenance of the shelter has been endowed by Marge and Bob Fish. It is close to USFS Road 10 and can receive heavy traffic.

▲▲ This log shelter was built by the CCC and renovated by the LTP. It is located at the former site of Silas Griffith's 19th-century mill village, which was originally known as Mill Glen (1869), then as Griffith, and then as Old Job (after Griffith's death in the early 1900s). The village once consisted of a large mill, school, cabins, boarding house, offices, homes, and several brick charcoal kilns. The village was largely abandoned by 1910, and, after World War II, the Bellows Falls Ice Company logged the area and created the large sawdust pile still located along the trail. The Old Job Trail, an old woods road that is one of the longest side trails to reach an AT shelter, was a former LT route. It links Griffith Lake and Big Branch. Tentsites are also available.

LITTLE ROCK POND SHELTER

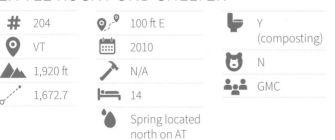

#	204	📍	100 ft E	🚽	Y (composting)
📍	VT	📅	2010	🐻	N
⛰	1,920 ft	🔨	N/A	👥	GMC
⟋	1,672.7	🛏	14		
		💧	Spring located north on AT		

▲ The newest shelter on the AT in Vermont, this timber-frame structure with benches was built by GMC volunteers led by Erik and Laurel Tobiason, with friends and family of John Kidder, and future maintenance of the shelter has been endowed in memory of Kidder. There is an overnight fee, and a GMC caretaker is in residence. Tent platforms are also available. The popular pond is one of the most-visited sites on the LT. Camping at the pond is limited to designated sites.

GREENWALL SHELTER

205 🛏 8

📍 VT

🌧 Seasonal stream near shelter, but prone to fail in dry weather; all water should be treated

⛰ 2,025 ft

⟋ 1,677.5

📍⟋ 0.2 mi E 🚽 Y

📅 1962 🐻 N

🔨 2009 👥 GMC

▶ This frame lean-to, which offers views of the surrounding area, was built by the USFS. It is located outside the northern boundary of the White Rocks National Recreation Area and north of the side trail to White Rocks Cliffs. Tentsites are also available. The privy at this location is an accessible site that complies with Americans with Disabilities Act (ADA) standards.

MINERVA HINCHEY SHELTER

206 🚽 Y

📍 VT 🐻 N

⛰ 1,605 ft 👥 GMC

⟋ 1,682.6

📍⟋ < 0.1 mi E

📅 1969

🔨 2006

🛏 8

🌧 Spring 150 ft south of shelter; follow "Wada" signs

▼▼ This frame structure with bunks and a small interior table was constructed by Sandy Stare and members of the GMC Killington Section and renovated by volunteers led by Gerry Parker. It was named for Minerva Hinchey as a tribute to her 22 years of service as GMC corresponding secretary (1955–1977). Future maintenance of the shelter has been endowed by Scott and Debbie Livingston. It is located north of Bear Mountain (2,240 feet) and south of the Clarendon Gorge Wildlife Management Area and Mill River Suspension Bridge (800 feet). There is also a tenting area.

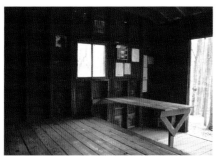

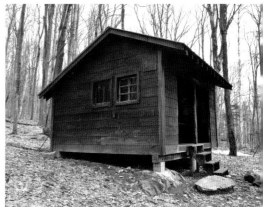

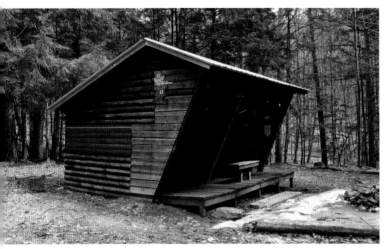

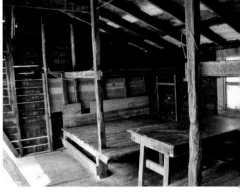

CLARENDON SHELTER

#	207		< 0.1 mi E		Stream east of shelter
	VT		1952		Y (moldering)
	1,190 ft		2012		N
	1,686.3		12		GMC

▲▲ This frame building with double bunks was constructed and renovated by the GMC Killington Section. There are no fees, and tentsites are also available. There is a caretaker in the area from this shelter to Churchill Scott Shelter. The original structure at this location was called Clarendon Lodge Shelter. It was converted from an enclosed camp to an open-front shelter. It is the lowest-elevation shelter in Vermont.

GOVERNOR CLEMENT SHELTER

#	208		1,692.4		Roof and sleeping deck replaced in 2010		Y (moldering)
	VT		On AT		10		N
	1,900 ft		1929		Brook 200 ft east		GMC

▶▶ The oldest shelter on the AT/LT in Vermont, this is one of only three (non-hut) shelters built before 1930 that is still used on the AT today. The stone structure was built by the family of William H. Field of Mendon and named for Percival W. Clement, former governor of Vermont (1919–1921). Renovated by GMC Killington Section volunteers, it has a wooden sleeping platform and a fireplace. Tentsites are nearby. Some guides don't recommend it as a good place to stay overnight due to its proximity to the Forest Service road.

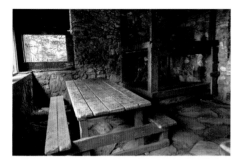

COOPER LODGE

 209

 VT

 3,900 ft

1,696.7

 100 ft W on LT

 1939

 N/A

 12

 Spring 100 ft north on AT

 Y (composting)

 N

GMC

▲▲ This enclosed stone-and-wood cabin with bunks was built by the CCC and Vermont Forest Service. It is the highest-elevation shelter in Vermont, the highest shelter on the LT, and one of the oldest on the AT. There are tent platforms at a spur junction clearing, the former site of a steel camp. Home of the "Cooper Pooper" privy, the shelter is located on land given to the state by Mortimer R. Proctor, GMC president (1916–1917) and later governor of Vermont. It was named in honor of Charles P. Cooper, GMC president (1917–1925). A steep 0.2-mile side trail behind the shelter leads to Killington Peak (4,241 feet), the second-highest peak in the state. Views of the White Mountains are visible from the rocky summit on clear days. A GMC ridgerunner may be present, and an overnight fee may be charged.

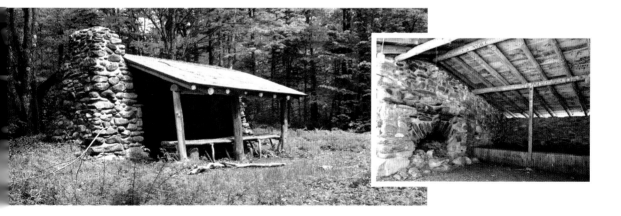

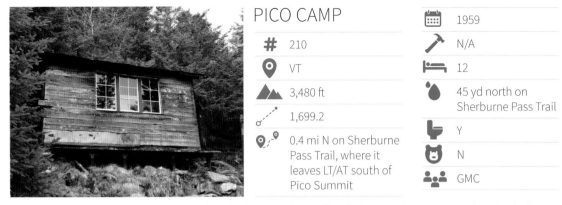

PICO CAMP

#	210	📅	1959
📍	VT	🔨	N/A
⛰	3,480 ft	🛏	12
⦿	1,699.2	💧	45 yd north on Sherburne Pass Trail
⦿	0.4 mi N on Sherburne Pass Trail, where it leaves LT/AT south of Pico Summit	🚽	Y
		🐻	N
		👥	GMC

▲ This enclosed-frame cabin with bunks was built by the LTP and originally called Pico Peak Camp. Located on the Sherburne Pass Trail, the former route of the LT, it offers views of Killington Peak directly to the south and Mount Ascutney (3,144 feet) to the southeast. A GMC ridgerunner may be present, and an overnight fee may be charged.

CHURCHILL SCOTT SHELTER

#	211	⦿	0.1 mi W	💧	Spring 450 ft south of shelter
📍	VT	📅	2002		
⛰	2,560 ft	🔨	N/A	🚽	Y (composting)
⦿	1,701.1	🛏	8	🐻	N
				👥	GMC

◀▶ This post-and-beam structure was built by Erik and Laurel Tobiason, the GMC Killington Section, and volunteers. It was named for a long-time leader and trail maintainer for the section and then dedicated in memory of Alice H. Ference, a thru-hiker who drowned crossing the Kennebec River in Maine, with donated funds from her family. A shelter plaque reads, "When I look down from lofty mountain grandeur and hear the brook and feel the gentle breeze; then sings my soul. In memory of one who loved the trail, Alice H. Ference—1923–1985. Dedicated September 2002." A tent platform is also available. A GMC ridgerunner may be present, and an overnight fee may be charged. This is the last shelter before the Maine Junction at Willard Gap.

TUCKER-JOHNSON SHELTER

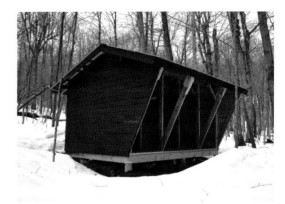

212

📍 VT

⛰ 2,250 ft

⟋ 1,704

📍 0.1 mi W

📅 2018

🔨 N/A

🛏 8

💧 Eagle Square Brook nearby

🚽 Y (moldering)

🐻 N

👥 GMC

◀▶This is one of the newest shelters along the AT. It is located 0.4 miles north on the LT, after the Maine Junction at Willard Gap, where the AT splits off and continues east. The LT continues north another 166.5 miles to the Canadian border. The first shelter at this location was Tucker Lodge, built in 1938 by the LTP and named for longtime GMC member Fred H. Tucker. As the shelter fell into disrepair, the LTP, shelter builder Louis "Sandy" Stare, and members of the GMC Killington Section built a replacement in 1969. That shelter was named for Tucker and Otto Johnson, who bequeathed funds for its construction. The 1969 shelter burned down in 2011 when a hiker started a fire inside of it. It was rebuilt in 2018. There is also a tenting area.

STONY BROOK SHELTER

213

📍 VT

⛰ 1,760 ft

⟋ 1,713

📍 < 0.1 mi E

📅 1997

🔨 N/A

🛏 6

💧 Stony Brook < 0.1 mi north on spur trail

 Y

🐻 Bear box

👥 GMC

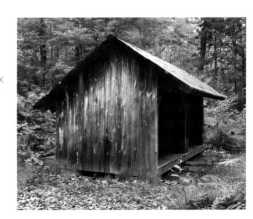

▶ Located north of Quimby Mountain (2,550 feet), this frame lean-to was built by Erik and Laurel Tobiason and friends with GMC Ottauquechee Section volunteers. It was dedicated in honor of the section volunteers who relocated the AT between VT-100 and VT-12 from 1980 to 1990. Tentsites are also available.

WINTTURI SHELTER

# 214	**📍** 0.2 mi N	**💧** Spring 300 ft north of shelter
📍 VT	**📅** 1994	**🚽** Y
⛰ 1,910 ft	**🔨** N/A	**🐻** N
⊶ 1,722.9	**🛏** 6	**👥** GMC

▼▼ Built by Erik and Laurel Tobiason and friends, this frame lean-to with a suspended table in the middle of it replaced an older shelter of the same name. It was named in honor of longtime trail maintainer Mauri Wintturi. A shelter plaque reads, "The trails and the mountains of Vermont stand as a monument to his memory." Tentsites are also available.

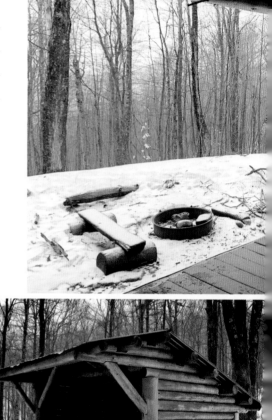

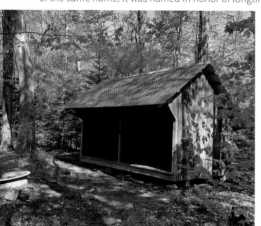

THISTLE HILL SHELTER

#	215	0.1 mi S		Two nearby streams	
	VT	1995		Y	
	1,480 ft	N/A		N	
	1,735.2	8		GMC	

◀◀ This log lean-to was built by the Dartmouth Outing Club (DOC). It replaced the old Cloudland Shelter that is now on private land 0.5 miles west. The owners also run Cloudland Market, and hikers are welcome to stay at the old shelter. The Cloudland Shelter privy was moved to Thistle Hill, partly with help from the Appalachian Long Distance Hikers Association (ALDHA).

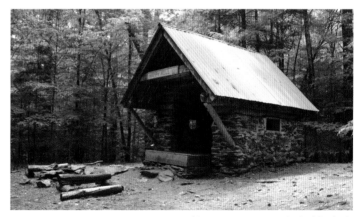

HAPPY HILL SHELTER

#	216	0.1 mi S		Unreliable brook near shelter; may run dry	
	VT	1997–98		Y	
	1,460 ft	N/A		N	
	1,744	8		GMC	

▲ This stone structure with double-deck accommodations was built by the DOC after the 1997 ALDHA Gathering. The original shelter—built in this area in 1918 before the AT existed—was torn down, burned, and removed. The new shelter is located 0.2 miles north of the original and has an ADA accessible privy. It is also called Happy Hill Cabin.

PRIVIES

Privies can be found at most, but not all, shelters along the AT. A privy, from the word *private*, is an outhouse structure available at shelters and some established campsites. A few trail sections, including East Tennessee, do not have privies at every shelter.

The basic outhouse design, an enclosed structure placed over an open hole, was essentially unchanged for decades, but it couldn't keep up with the rising hiker impact of increased use in the 1970s. Advances and research in backcountry waste management by the USFS and GMC in Vermont helped streamline the process.

Composting, moldering, pit, and batch-bin privy designs can all be found on the AT. Privies are built and maintained by trail clubs and maintainers, and often directions for that particular design can be found inside the structure. Proper use—including never throwing trash or wipes into a privy—ensures that the design will function properly and continue to be used by future hikers.

Composting bin privies require coarse bark mulch as a bulking agent to be mixed with human waste. The mulch absorbs water, reduces odors, and provides carbon for composting at high temperatures. Heavy bark sup-

Tray Mountain Shelter, Georgia

plies have to be hauled in, and the outhouses have to be serviced at least twice a year. Users are encouraged to pee outside due to urine absorbing the mulch much quicker, requiring more supplies to be hauled in by maintainers.

The popular moldering privies are elevated up to three feet above ground, and waste accumulates in a screened, ventilated chamber below the toilet seat. The term "moldering" is the slow decomposition of organic material in the presence of air. The design requires lighter-weight bark, wood shavings, or a mix of leaves and dirt, sometimes referred to as "duff," after each use. This design creates an environment where bacteria can break down the waste within the system. Moldering privies need urine moisture to work properly, so peeing is allowed inside. The Green Mountain Club's Dick Andrews designed the low-cost and low-tech moldering

"Your Move" privy with its cribbage board, Piazza Rock Lean-to, Maine

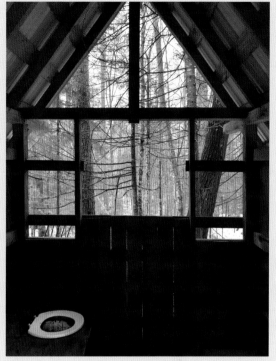

Jeffers Brook Shelter, New Hampshire

privy. The first one was installed in 1997 at the original Little Rock Pond Shelter in Vermont, and the design can now be found in most states along the trail.

There is no standard design for privy structures along the trail. Most privies are enclosed vented structures, and others have few walls or doors, offering very little privacy for their users. Some have the AT symbol on the door, and many have the classic outhouse moon. Some have windows and skylights. It is uncommon to see more than one privy at a shelter site, but Upper Goose Pond Cabin in Massachusetts has two moldering privies and one regular privy.

High Point Shelter in New Jersey has a large plastic Port-a-John style privy with a solar panel on the roof, and Trapper John Shelter in New Hampshire uses an old chair for its privy seat. The "Fort Relief" privy at Antlers Campsite in Maine, the "Your Move" privy at Piazza Rock Lean-to in

Maine (complete with an installed cribbage board for its users), and the large "Taj Mahal" privy at Darlington Shelter in Pennsylvania are some structures that offer hikers a unique two-seater privy experience. Some have names, like the "Cooper Pooper" at Cooper Lodge in Vermont. "Bert's Bath" at Beaver Brook Shelter in New Hampshire includes an additional wooden sign that reads "There is no 'P' in this rivy. (Pee in the woods!)."

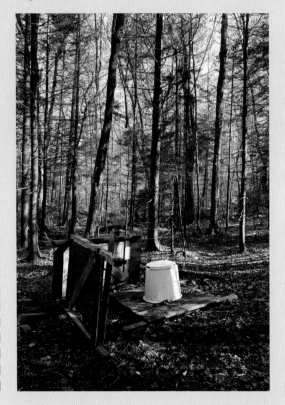

Hikers should always be properly prepared to take care of their business in the woods and follow basic backpacking guidelines to bury waste. That means carrying a lightweight trowel to dig a "cathole" (six to eight inches deep and three to four inches wide) and being prepared to walk 200 feet away from water sources or campsites. Extra plastic resealable bags are essential for carrying out wipes and even used toilet paper for those willing to take the extra step to minimize their impact. In the trail's early years, privies were not a common amenity, but proper disposal of human waste has always been a basic need in the backcountry. With rising hiker numbers and millions of visitors each year, the privy option continues to be essential for minimizing waste, disease, and impact on the trail.

Proper hygiene and sanitation can prevent the spread of disease on the trail. Norovirus outbreaks can occur where large numbers of thru-hikers congregate in close proximity in and around shelters and sanitation is poor. According to the Appalachian Trail Conservancy, proper disposal of human (and pet) waste is not only a courtesy to other hikers, but is a vital Leave No Trace practice for maintaining healthy water supplies in the backcountry and an enjoyable hiking experience for others.

Open-air privy, William B. Douglas Shelter, Vermont

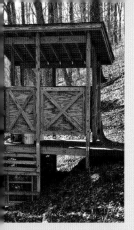
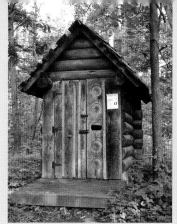
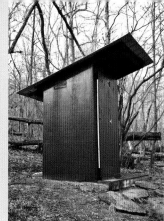

LEFT TO RIGHT:
Cable Gap Shelter, North Carolina; Ed Garvey Shelter, Maryland; Bearfence Mountain Hut, Virginia

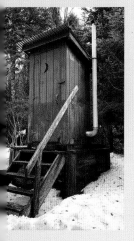

LEFT TO RIGHT:
Baldpate Lean-to, Maine; "Taj Mahal," Darlington Shelter, Pennsylvania; Ten Mile River Shelter, Connecticut

LEFT TO RIGHT:
A. Rufus Morgan Shelter, North Carolina; Bryant Ridge Shelter, Virginia; Thistle Hill Shelter, Vermont

NEW HAMPSHIRE

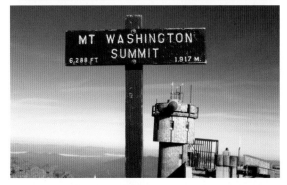

TOP: Above tree line, leaving Madison Spring Hut; **MIDDLE:** Mount Washington summit;
ABOVE: Steep descent from Beaver Brook Shelter; **RIGHT:** Greenleaf Hut

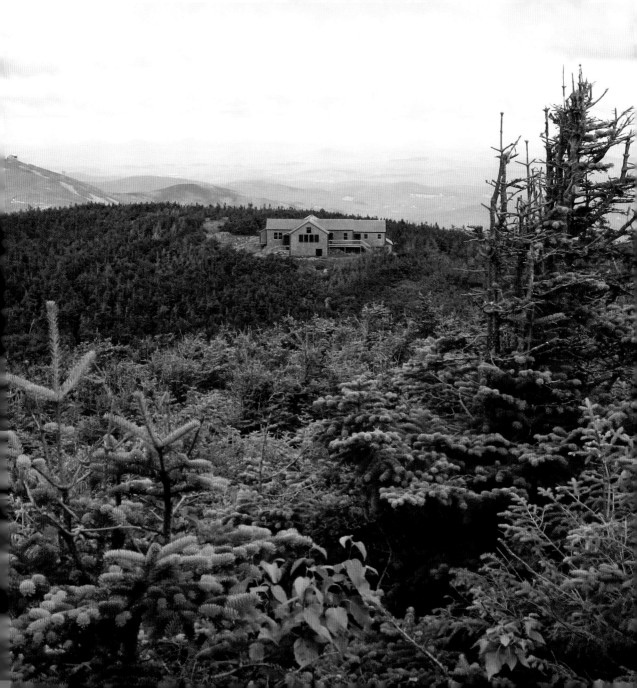

VELVET ROCKS SHELTER

#	217	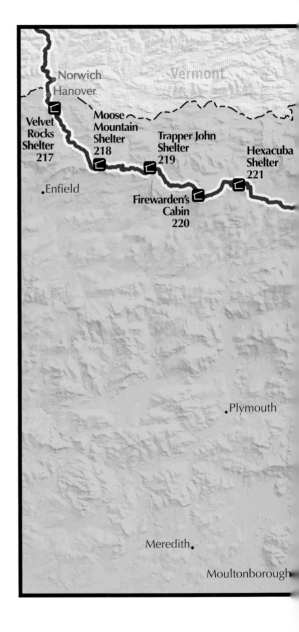 Source is Ledyard Spring, located along northern access to shelter; can fail in dry periods	
📍	NH		
🏔️	1,040 ft		
⚬┄	1,751.3		
📍	0.2 mi W	🚽	Y
📅	1980s	🐻	N
🔨	2006	👥	DOC
🛏️	6		

▲▶ Located on a blue-blazed trail with north and south access, this is the first and lowest-elevation shelter in New Hampshire. A shelter plaque reads, "Dedicated to the

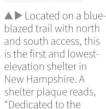

memory of Will Brown, Dartmouth Class of 1937. Builder of the original shelter upon this site in 1936. Lifelong inspiration to the Dartmouth Outing Club, 1915–2005." It is the first shelter maintained by the Dartmouth Outing Club (DOC). Established in 1909, the club maintains seven shelters and 53.3 miles of the AT from the Connecticut River to Kinsman Notch.

Vermont

Littleton

Whitefield

Lancaster

Jeffers Brook
Shelter
222

Mount
Moosilauke

Kinsman
Pond
Shelter
225

er Brook
Shelter
223

Eliza Brook
Shelter
224

Lonesome Lake
Hut
226

Greenleaf Hut
227

Garfield Ridge Shelter
228

Franconia
Ridge

Galehead Hut
229

Zealand Falls Hut
231

Guyot Shelter
230

Mizpah
Spring
Hut
233

Mount
Washington

The Perch
Shelter
235

Gray Knob
Cabin
236

Crag Camp Cabin
237

Ethan Pond Shelter
232

Madison Spring Hut
238

Berlin

Lakes of the Clouds Hut
234

Pinkham Notch

Gorham

Gentian
Pond
Shelter
242

Imp Shelter
240

Carter Notch Hut
239

Rattle River
Shelter
241

Maine

MOOSE MOUNTAIN SHELTER

#	218	🛏	8
📍	NH	💧	Source north on AT, just past where loop and AT come back together
⛰	1,850 ft		
🠊	1,760.8	🚻	Y
📍	0.1 mi E	🐻	N
📅	2004	👥	DOC
🔨	N/A		

▲ This log shelter was built by the DOC with only hand tools. It is located between the south peak (2,290 feet) and north peak (2,300 feet) of Moose Mountain.

TRAPPER JOHN SHELTER

#	219
📍	NH
⛰	1,345 ft
🠊	1,766.5
📍	0.1 mi W
📅	1973
🔨	1990s
🛏	6
💧	Brook 15 yd to left of shelter
🚻	Y
🐻	N
👥	DOC

▼ ▼ Built at the site of an old homestead, a large ghost chimney still stands in front of this shelter, which is located north of Holts Ledge (1,930 feet) and an ATC-sponsored peregrine falcon rookery. Tentsites are also available. The privy uses an old chair as the seat.

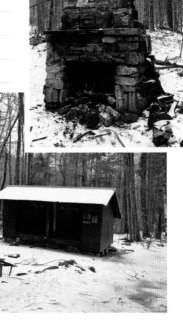

FIREWARDEN'S CABIN

220

◉ NH

▲ 3,230 ft

⟋ 1,773.2

◉ < 0.1 mi W

📅 1939

🔨 1979

🛏 8

💧 Unreliable Mike Murphy Spring 0.2 mi north on blue-blazed Daniel Doan Trail

🚻 Y

🐻 N

👥 DOC

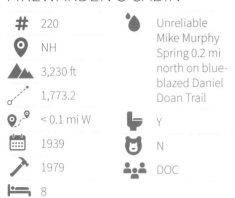
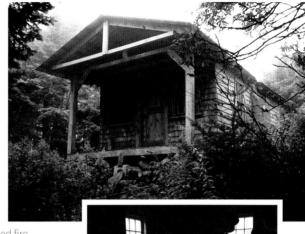

▶ ▶ Built by the state of New Hampshire as an enclosed fire warden's cabin, this structure was renovated for use as a shelter in 1979. The DOC refers to it as Smarts Ranger Cabin, but it is also called Firewarden's Cabin or Smarts Mountain Fire Warden's Cabin. The abandoned fire tower still stands on nearby Smarts Mountain. Tent platforms are also available.

HEXACUBA SHELTER

221

◉ NH

▲ 1,980 ft

⟋ 1,778.5

◉ 0.3 mi E

📅 1989

🔨 N/A

🛏 8

💧 Unreliable stream at blue-blazed junction to shelter; North Jacobs Brook 0.3 mi south on AT

🚻 Y

🐻 N

👥 DOC

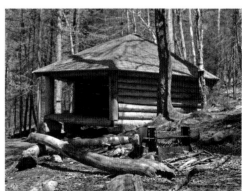

▶ This unique six-sided shelter, built by the DOC, has two open sides and a large center post that supports the roof. It also has a five-sided "Penta Privy." It is located south of Ore Hill Campsite, where Ore Hill Shelter, built in 2000, burned down in 2011.

JEFFERS BROOK SHELTER

#	222	🛏	10
📍	NH	💧	Jeffers Brook in front of shelter
⛰	1,350 ft	🚻	Y
⤢	1,794.2	🐻	N
📍	On AT	👥	DOC
📅	1981		
🔨	N/A		

▼ This shelter is located north of Oliverian Brook, which can be a difficult crossing in high water. A shelter plaque reads, "The members of Dartmouth's Cabin and Trail dedicate this shelter to the memory of John Baldwin '81 and Laurie Van Buskirk '80. In thanks for their friendship, enthusiasm, and love of the out-of-doors."

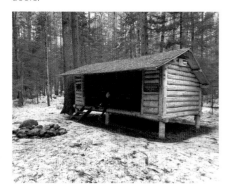

BEAVER BROOK SHELTER AND CAMPSITE

#	223	🔨	1994
📍	NH	🛏	10
⛰	3,750 ft	💧	Beaver Brook on spur trail to shelter
⌀	1,801.1	🚽	Y (composting)
📍	On AT	🐻	N
📅	1980s	👥	DOC

▼ There are great views of the famed Franconia Ridge in the White Mountains from this shelter constructed by the DOC and Appalachian Long Distance Hikers Association (ALDHA) when not socked in with fog from nearby Mount Moosilauke (4,802 feet)—the first time northbound hikers will be above tree line, and the last time for southbounders.

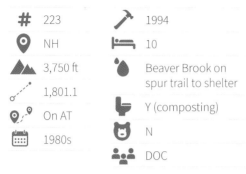

ELIZA BROOK SHELTER AND CAMPSITE

#	224	🛏	8
📍	NH	💧	Eliza Brook; all water should be treated
⛰	2,400 ft	🚽	Y (composting)
⌀	1,810.1	🐻	N
📍	On AT	👥	AMC
📅	2010		
🔨	N/A		

▼ This is the first shelter maintained by the main branch of the Appalachian Mountain Club (AMC). Established in 1876, the club maintains 15 shelters and huts along the AT in New Hampshire and the first three in Maine. The AMC is the oldest outdoor club in the United States. All of its chapters collectively maintain more than 1,800 miles of trail, including 350 miles of the AT in five states. Four tent pads are also available.

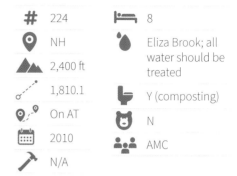

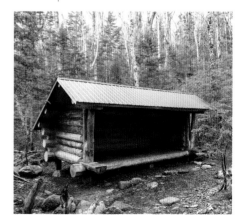

KINSMAN POND SHELTER AND CAMPSITE

# 225	**📅** 2007	**🚽** Y (composting)
📍 NH	**⚒** N/A	**🐻** Bear box
⛰ 3,750 ft	**🛏** 16	**👥** AMC
⌇ 1,814.1	**💧** Kinsman Pond; all water should be treated	
📍 0.1 mi E		

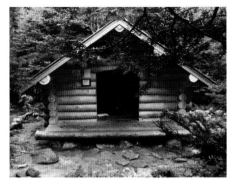

▶ Most shelters and campsites from here north to the Maine border charge a fee. The overnight fee for this one is currently $10 per person, and a caretaker is on duty. Two single and two double tent pads are also available. A sign nearby states that the shelter was "reconstructed in 2007 in honor of Donald E. Vandenburgh Sr. At age 85, Don continues hiking and maintains his lifelong enthusiasm for the outdoors and the Appalachian Mountain Club. He is an honorable man, a beloved husband and devoted father. Don's family assisted with this shelter as a lasting tribute to him with deep love and appreciation for his impact on their lives."

LONESOME LAKE HUT

# 226	**⚒** N/A	
📍 NH	**🛏** 48	
⛰ 2,760 ft	**💧** Available at hut when open	
⌇ 1,816	**🚽** Y	
📍 On AT	**🐻** N	
📅 1929	**👥** AMC	

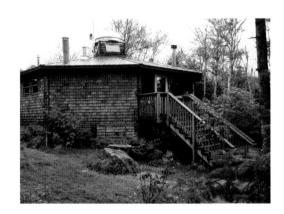

▶ Inspired by the huts in the Alps, eight AMC huts, spaced 6 to 8 miles apart, are positioned along the AT through the White Mountains. Hikers can reserve overnight bunks at the huts. Located in Franconia Notch State Park, this is the southernmost hut along the AT. It was originally a fishing camp, with cabins built by author W. C. Prime on Lonesome Lake in 1876. It became part of the hut system in 1929. The main building holds the kitchen and houses guests in separate bunkhouses. Hikers can enjoy spectacular views of Franconia Ridge and swimming in nearby Lonesome Lake. The hut is open full-service from early June to late October and self-service the rest of the year. The AMC huts offer work-for-stay for two thru-hikers a night (four at Lakes of the Clouds) on a first-come, first-served basis. In exchange for up to two hours of work, thru-hikers can sleep in the dining room and eat dinner and breakfast leftovers with the hut crew.

GREENLEAF HUT

#	227	🔨	N/A
📍	NH	🛏	48
⛰	4,200 ft	💧	Available at hut when open
	1,825.3	🚽	Y
📍	1.1 mi W	🐻	N
📅	1930	👥	AMC

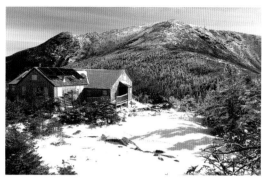

▶ This hut was named for Colonel Charles Greenleaf, who provided most of the funds for its construction. It is visible from the summit of Mount Lafayette. Perched at tree line overlooking Eagle Lake, the hut has views of nearby Mount Lafayette, the Kinsmans, and Franconia Ridge. Located down the steep Greenleaf Trail 1.1 miles from the AT, the hut is open self-service in May and full-service from early June to late October. It was the first hut to abandon the stone construction of earlier designs and the first to use burros to carry materials to the build site. The builders also pioneered running water and indoor toilets, starting the evolution of the AMC huts to the next level of service. Nearby Galehead and Zealand Falls Huts were constructed with the same interior design, which includes a central dining room, kitchen, and two bunkrooms on the sides.

GARFIELD RIDGE SHELTER AND CAMPSITE

#	228	📅	2011	🚽	Y (composting)
📍	NH	🔨	N/A		
⛰	3,900 ft	🛏	12	🐻	Bear box
	1,829.2	💧	Spring at junction to campsite; all water should be treated	👥	AMC
📍	0.1 mi W				

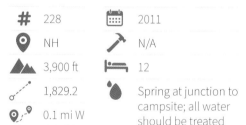

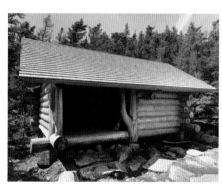

▶ The newest shelter in New Hampshire was assembled of white pine, capped with cedar, and accomplished through partnership with the United States Forest Service (USFS) and funding from the Appalachian Trail Park Office. There is an overnight fee ($10 per person), and there is a caretaker on duty. Two single and five double tent pads are also available. The new replacement shelter was preconstructed by John Nininger's Wooden House Company. Its unique design includes a wide curved-branch log and an H-shaped joined log at the open doorway. The high-elevation location is exposed and gets hammered with weather. The roof of the original shelter blew off one winter in the 1990s. The shelter came in by helicopter up to five logs at a time, with the weights varying between 200 and 400 pounds. There are no spikes in the shelter's construction, but there are four pieces of threaded rod that are tightened annually to pull the logs closer together and prevent gaps as the logs shrink.

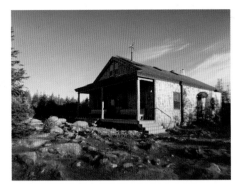

GALEHEAD HUT

#	229	🗓	1932	🚻	Y
📍	NH	⚒	1999–2000	🐻	N
⛰	3,780 ft	🛏	38	👥	AMC
⚲	1,831.9	💧	Available at hut when open		
📍	0.1 mi E				

◀ This hut, located in the heart of the Pemigewasset Wilderness on rugged Garfield Ridge, is the most remote in the AMC hut system. The original structure was torn down and a new hut was built on nearly the same site, using lightweight materials that were brought into the remote area. The new hut is designed to withstand up to 125-mile-per-hour winds. The foundation is fastened to the granite bedrock with rebar, and the hut has solar panels and a wind vane for producing power. During its construction, the USFS told builders that the hut—even though it is up a super-rugged 4.6-mile trail—must comply with the accessibility rules for new buildings in the Americans with Disabilities Act. The rustic 38-bed lodge was made accessible, complete with a ramp and grab bars in larger toilet stalls. The controversial design started many conversations about wilderness access and accessibility for people with disabilities. The hut has four coed bunkrooms and a large front porch. It sits just below Galehead Mountain and South Twin. It is open self-service in May and full-service from early June to late October.

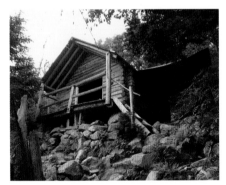

GUYOT SHELTER AND CAMPSITE

#	230	🗓	2019	🚻	Y (composting)
📍	NH	⚒	N/A	🐻	Bear box
⛰	4,580 ft	🛏	12	👥	AMC
⚲	1,834.7	💧	Spring at campsite; all water should be treated		
📍	0.8 mi E				

◀ This shelter is located between the remote peaks of Mount Bond (4,698 feet) and Mount Guyot (4,580 feet), on the edge of the Pemigewasset Wilderness. Of the AMC's 14 campsites and shelters in this area of the White Mountain National Forest, this one receives the highest use as a backcountry facility. In 2018 alone, it housed 3,513 overnight guests. AMC trail crews rebuilt the shelter in 1939 and 1977, with short-term fixes over the years, and then in 2019 it was razed and rebuilt again after its rotting logs became a safety issue. The replacement is an exact replica of the previous shelter, with the same guest capacity. The new structure is located farther off the ground in an attempt to prevent wood rot. It is also built out of white cedar logs, which are naturally resistant to moisture. The shelter was rebuilt with funding from the ATC, NPS, and AMC donors. John Nininger of the Wooden House Company in Newbury, Vermont, was hired to rebuild Guyot, his fifth such project for the AMC.

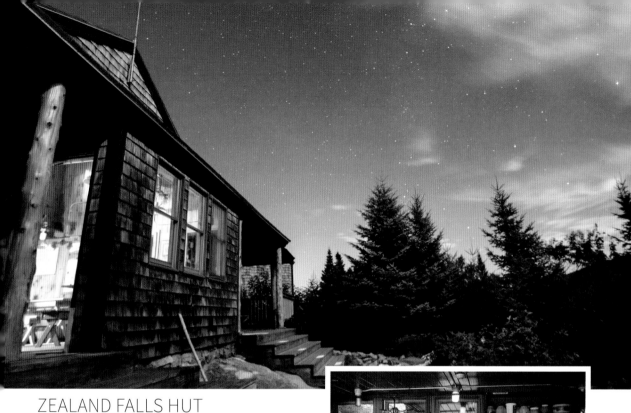

ZEALAND FALLS HUT

231

◉ NH

▲▲ 2,630 ft

∕⚬ 1,838.9

◉⟋ On AT

📅 1932

⚒ N/A

🛏 36

💧 Available at hut when open

🚽 Y

🐻 N

👥 AMC

▲ ▶ This hut is located in the eastern Pemigewasset Wilderness, next to Zealand Falls and near Zealand Mountain (4,265 feet), the Bonds, and other majestic peaks. It has two bunkrooms. It is open full-service from early June to late October and self-service the rest of the year. It has been open in the winter season for self-service since 1973. Unlike many of the huts in the White Mountains, Zealand Falls, like Lonesome Lake, has a lower altitude and a comparably easier approach. It has the lowest capacity of all the huts, sleeping little more than a third of the hikers that Lakes of the Clouds can sleep.

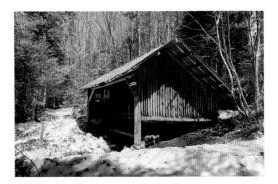

ETHAN POND SHELTER AND CAMPSITE

#	232	🛏	10
📍	NH	💧	Inlet brook to pond; all water should be treated
⛰	2,860 ft	🚽	Y (composting)
	1,843.7	🐻	Bear box
📍	0.1 mi W	👥	AMC
📅	1957		
🔨	2015		

▲ ▶ One of the oldest (non-hut) shelters in New Hampshire, this design uses vertically placed logs instead of the more common horizontal. The AMC reinforced the structure with native timbers in 2015. There is an overnight fee ($10 per person) and a caretaker on duty. Three single and two double tent pads are available. Heading north, hikers will enter the Presidential Range, with 25 miles of ridgeline—most of which is above tree line—between Crawford Notch and Pinkham Notch.

MIZPAH SPRING HUT AND NAUMAN TENTSITE

#	233
📍	NH
⛰	3,800 ft
	1,853
📍	On AT
📅	1965
🔨	N/A
🛏	60
💧	Nearby stream or available at hut when open
🚽	Y (composting)
🐻	Bear box
👥	AMC

◀◀ The newest AMC hut, finished in 1965 with supplies brought in by helicopter, was built in response to the backpacking boom of the 1960s and provided the important missing link for today's hut-to-hut hiking network. The shelter is nestled in a col between two 4,000-foot peaks. It sits in a boreal forest, a biome characterized by coniferous forests consisting mostly of pines, spruces, and larches. It has large, south-facing windows, eight smaller bunkrooms, and a library. The building is designed to withstand 200-mile-per-hour winds. It is open self-service in May and full-service from early June to late October. There are 10 tentsites and three double tent platforms. There is also an overnight fee ($10 per person).

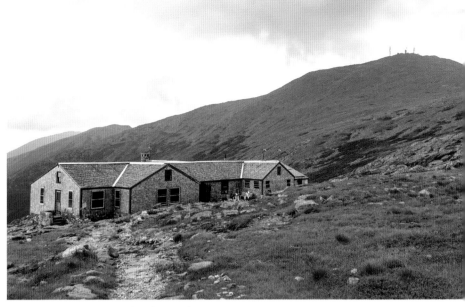

LAKES OF THE CLOUDS HUT

#	234		1,857.7		N/A		Y
●	NH		On AT		90		N
▲	5,012 ft		1915		Available at hut when open		AMC

◀▲The original structure, built in 1901, was a small shelter constructed in response to the deaths of two hikers caught in a storm on their way to an AMC meeting on top of Mount Washington. Located near its namesake, two small alpine tarns, Lakes of the Clouds was converted into a hut in 1915. It now sleeps 90 people a night in several bunkrooms with a hut staff of eight. It is the highest, largest, and most-visited hut in the White Mountains. It is open full-service from early June to mid-September. The Dungeon, a small basement shelter, is available for thru-hikers only and never closes. It has three double wooden bunks and is available on a first-come, first-served basis. Hikers have access to the bathroom and common area. When the hut is closed, the Dungeon should be used for emergencies only and not a destination. The hut sits on a rocky ridge just below Mount Washington and its famous observatory (6,288 feet) and below the summit of Mount Monroe (5,372 feet). The king of the Presidential Range, Mount Washington is the highest point in both New Hampshire and the Northeast and is world renowned for its extreme weather. Despite feeling remote, Mount Washington can be accessed by both car and the Mount Washington Cog Railway.

THE PERCH SHELTER AND CAMPSITE

#	235	🔨	2010	🐻	N
📍	NH	🛏	8	👥	RMC
⛰	4,313 ft	💧	On Perch Path, a short distance east of shelter		
	1,863.3				
📍	1.3 mi NW	🚽	Y (composting)		
📅	1948				

▲ One of the oldest high camps in New Hampshire (the first trails were cut in 1876), this birchbark shelter was originally built by famed trail builder J. R. Edmands in 1892. In 1912, its ownership passed to the Randolph Mountain Club (RMC). Today the club maintains two shelters and two cabins on the side of Mount Adams, as well as more than 100 miles of hiking trails in the White Mountain National Forest's northern Presidential Range and in the town of Randolph. The shelter was destroyed during a hurricane in 1938 and rebuilt as an open-face shelter in 1948. It was renovated extensively in 2010. There are also four tent platforms. An overnight fee ($15 per person for a non-RMC member) is collected by a nonresident caretaker in the evenings. No reservations are accepted; use is on a first-come, first-served basis. The shelter can be reached from Edmands Col via the Randolph Path to Israel Ridge to Perch Path. The fragile areas surrounding the RMC camps are located within restricted forest protection areas. Camping is not permitted within a quarter mile of the shelter.

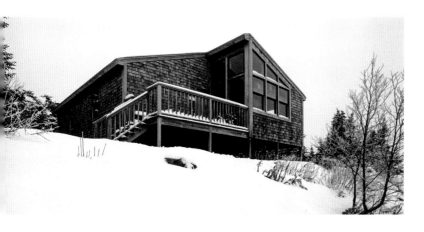

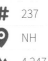 237

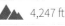 NH

 4,247 ft

1,863.9

 1.1 mi N

 1993

 N/A

20

Spring located 0.25 mi west on Gray Knob Trail; in summer, water is piped to cabin's back porch

 Y (composting)

N

RMC

GRAY KNOB CABIN

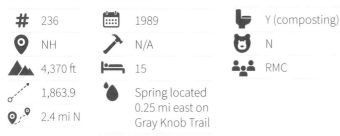

#	236		1989		Y (composting)
	NH		N/A		N
	4,370 ft		15		RMC
	1,863.9		Spring located 0.25 mi east on Gray Knob Trail		
	2.4 mi N				

◄◄This cabin has an overnight fee ($25 per person for a non-RMC member), and a caretaker is in residence year-round—the only cabin in the northern Presidential Range so occupied in winter. From Edmands Col, via the Randolph and Gray Knob Paths, there is a descent of 558 feet from the AT; from Thunderstorm Junction, via the Lowe's Path, there is a descent of 1,120 feet. The cabin was built by C. C. Stearns and E. Y. Hincks in 1905. The Hincks family used the cabin for many years, and when their lease with the Forest Service expired in 1939, they gave the camp to the town of Randolph. Maintained for many years by the RMC, the building was burned in 1989, and a new insulated cabin, whose design simulated the original, was constructed. Ownership was transferred to the RMC in 1990. The cabin is minimally heated in winter to evaporate moisture and prevent rotting; winter hikers should be prepared for freezing temperatures inside. When the cabin is full, hikers are directed to the Log Cabin, the RMC's fourth camp, an open-door Alaska trapper's cabin, located 0.8 miles below Gray Knob on the Lowe's Path.

▲ This cabin has an overnight fee ($25 per person for a non-RMC member), and there is a caretaker in July and August. From Thunderstorm Junction, it is 1.1 miles north via the Lowe's Path and Spur Trail, a steep descent from the AT of 1,240 feet. The cabin was built in 1909–10 as a private camp by Nelson H. Smith, who gave it to the RMC when his lease with the Forest Service expired in 1939. It sits on the edge of King Ravine, a site with fantastic views. The original decaying camp was burned in 1993 and replaced with a completely new design.

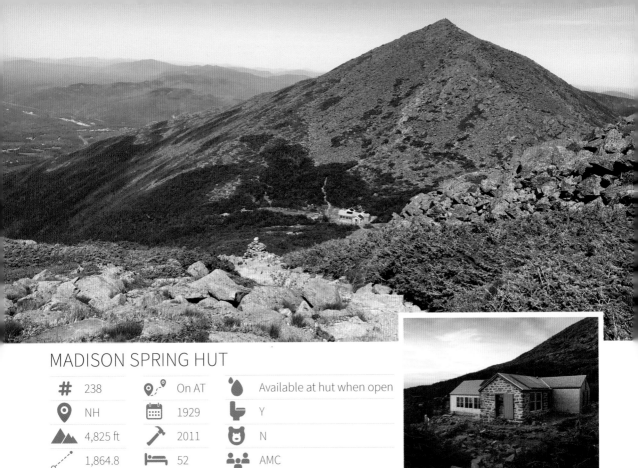

MADISON SPRING HUT

#	238	📍	On AT	💧	Available at hut when open
📍	NH	📅	1929	🚽	Y
⛰	4,825 ft	🔨	2011	🐻	N
⋰	1,864.8	🛏	52	👥	AMC

▲ ▶ The AMC's first hut and oldest hut site is located above tree line at the northern end of the Presidential Range. It is the second-highest hut in the chain and considered the most difficult full-service hut to access based on distance and elevation from a trailhead. Originally built in 1888, the hut hosted its first overnight guests in 1889. The shelter construction ran overbudget with a final cost of $739.50, and in 1906 it cost 50 cents per night. In 1905, a women's bunkroom was added. A new hut, No. 2, was built in 1911, and a stone-walled hut, No. 3, was built in 1922. In 1929, a construction crew tore down the original and used the materials to add a living and dining room, kitchen, and staff quarters to No. 3. The hut burned down in 1940 in a fire caused by the ignition of gasoline for the gasoline-electric power generator. Only the chimney and masonry walls remained. The last major construction was completed in 1941, and the current 2011 building preserves the 1929 structures. The hut is located in a col 0.5 miles south of the summit of Mount Madison, 0.6 miles west on Valley Way Trail, and the view overlooks the sheer walls of Madison Gulf. It has several bunkrooms with a staff of five people. It is open full-service from early June to mid-September.

CARTER NOTCH HUT

239
📍 NH
⛰ 3,288 ft
1,878.5
0.1 mi E
📅 1904
🔨 1914

🛏 40
💧 Available at hut when open
🚽 Y
🐻 N
👥 AMC

▼ Originally a small log cabin, this stone structure was rebuilt as a hut in 1914. It is the northernmost and easternmost hut and the oldest building in the hut system. Located on the Carter-Moriah Trail, it is near two small lakes in Carter Notch near Carter and Wildcat Mountains. There are two detached bunkhouses. It is open full-service from early June to mid-September and self-service the rest of the year.

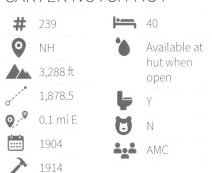

IMP SHELTER AND CAMPSITE

240
📍 NH
⛰ 3,250 ft
1,885.7
0.1 mi W
📅 1981

🔨 N/A
🛏 16
💧 Stream near shelter; all water should be treated
🚽 Y (composting)
🐻 Bear box
👥 AMC

▼ ▶ This shelter has an overnight fee ($10 per person) and a caretaker on duty. There are also four single tent pads and one double. It is located below North Carter Mountain (4,539 feet) and south of the side trail to Mount Moriah (4,049 feet).

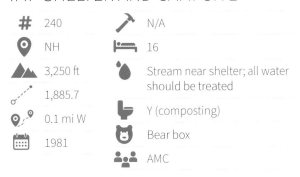

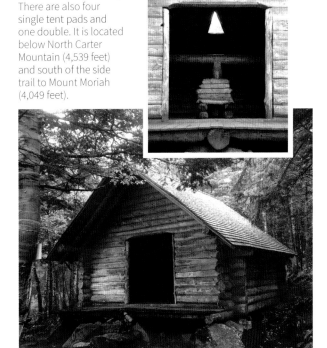

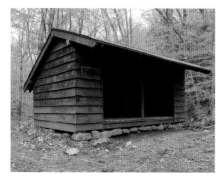

RATTLE RIVER SHELTER

#	241	🔨	N/A
📍	NH	🛏	8
🏔	1,260 ft	💧	Rattle River
⤴	1,891.8	🚽	Y
📍	On AT	🐻	N
📅	1980s	👥	USFS

▲ Built by the USFS, this is one of the northern-most shelters along the AT in New Hampshire. It is located in the White Mountain National Forest, and there is no fee or caretaker. It is the last plank-board shelter on the trail.

GENTIAN POND SHELTER AND CAMPSITE

#	242	💧	Inlet brook of Gentian Pond; all water should be treated
📍	NH		
🏔	2,166 ft		
⤴	1,905.5		
📍	0.1 mi E	🚽	Y (composting)
📅	1974	🐻	Bear box
🔨	2011	👥	AMC
🛏	14		

▼ ▶ This full-scribe native-log structure has a sleeping loft and a large front opening. There are also three single tent platforms and one double. It is located south of Success Mountain (3,170 feet). A mounted plaque on a rock reads, "Support for the Gentian Pond Camp-site has been provided by generous friends of a 1978 end-to-end hiker through a gift to the Appalachian Mountain Club Trails Program Endowment Fund. August 1986."

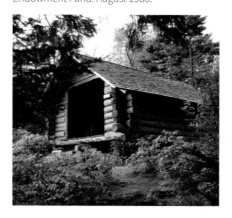

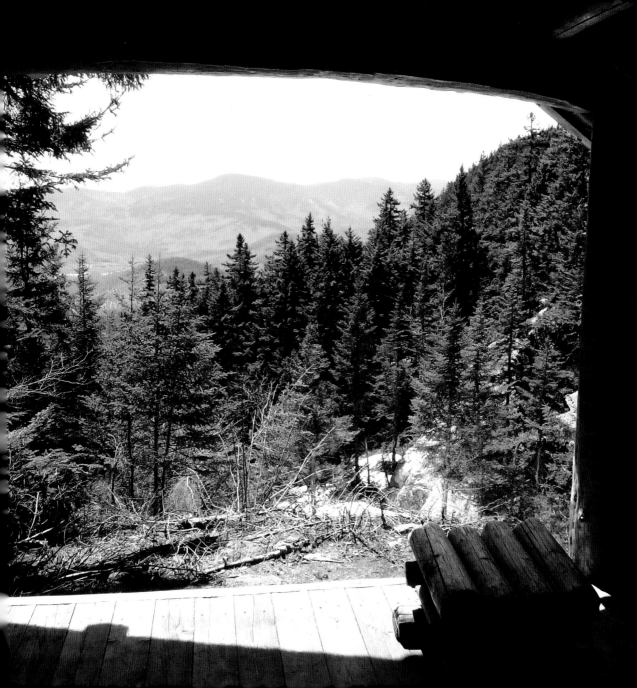

SHELTER JOURNALS

Shelter journals, also referred to as logs or registers, can be found at most shelters along the trail. The simple notebooks function as a communication system along the AT corridor. Before the widespread onset of cell-phone technology, the registers were the main way hikers could stay in touch. Hikers continue to use the journals to jot down their thoughts, write about things happening along the trail, doodle, or check in to see where other hikers are in their journeys.

The Priest Shelter, located near the summit of The Priest in Virginia, holds the tradition of

Shelter registry box, Mashipacong Shelter, New Jersey

Shelter registry holder, Jenkins Shelter, Virginia

hikers confessing their sins "to the Priest" in the shelter logbook. Poplar Ridge Lean-to in Maine has a shelter trivia book and answers frequently asked questions such as, "What happens when the privy pit fills up?" and "May I climb on the lean-to roof?"

Hikers are encouraged to sign in as a way to assist if there is ever a search-and-rescue effort in an area. Often the teams will look in shelter journals for a hiker's last known whereabouts. Trail clubs review the journals and replace them when full, return hiker-placed ones to their owners, save some, and send some to the ATC or the Appalachian Trail Museum.

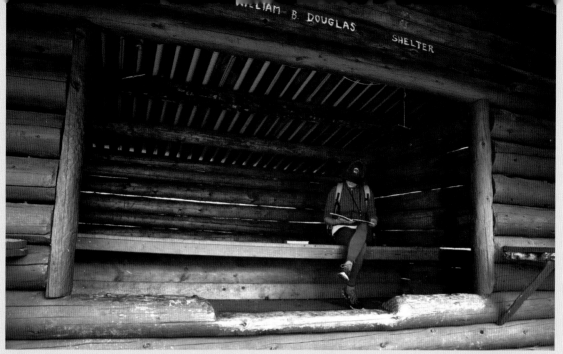

Emma "Sprout" Hileman enjoying the shelter log, William B. Douglas Shelter, Vermont

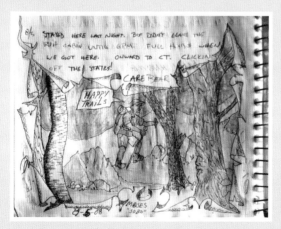

8/5 STAYED HERE LAST NIGHT. BUT DIDN'T LEAVE THE RUTH CABIN UNTIL 6PM. FULL HOUSE WHEN WE GOT HERE. ONWARD TO CT. CLICKIN' OFF THE STATES!

CARE BEAR
HAPPY TRAILS

8-5-08 MOSES 2080°

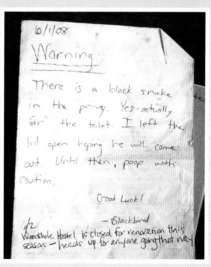

6/1/08

Warning

There is a black snake in the privy. Yes—actually "in" the toilet. I left the lid open hoping he will come out. Until then, poop with caution.

Good Luck!

— Blackbird

6/2 Woodhole Hostel is closed for renovation this season — heads up for anyone going that way

5/24/08 NICE S...
FOR LUNCH FROM...
WAR SPUR - CA...
ARE DISAPPEA...
TOO FAST...
TO SEE O...
IN A FEW D...
GOOD HIK...
SKETCH...
FOK...
WRWW...

PB+
CRACKERS
LEFTOVER

ON TO WAYNESBORO...
SPYDIE & NOAMP I HEAR YOUR
RIGHT BEHIND... SEE YA'LL
SOON!

—COOKIE MONSTAR—

6/13/08
Ah, alone again. Just you and me
spiral journal. And yet, I have
nothing to say.
—Half Elvis

DIRTY GIRL TRUCKIN' CHEWBACA PILOT

5/2

Big Cat Stratagy For

...ow. My left Ank...
...ouch...

...Y!!! this place rocks.

5/27
STOPPED FOR
A SNACK!
ONWARD TO
A HOT SHOWER
+ MULTIPLE
MEALS SOUTH
IN PEARISBURG
MET OVER 20
HIKERS GOING
NORTH TODAY!
Take Care
"SKETCH & POKEY"

WHEN DOES THE
NEXT GROUP
ARRIVE??

10/8 Mt. Katahdin! Awesome view from
White cap. I can't believe we can
see the end. Trail Magic today @
Road!!! ☮♡ Hippie Chick

10/8 The end that is not,
a new path leads from its peak:
inhale; exhale; om
—Poet

10/8 Vigil Auntie and Y... stopped in for mid-
Morning snack. Hell-on-Bad-Wheels — we
are headed to Carl Newhall this evening...
Maybe further... but probably not... C...
GA → ME '08

6/14 Bopey & Slim here for the night. GA → PA ← ME

6/14 Jackaroo here! Might stay, might move. Gonna wait on weather. Nobody loves me anymore. I'm lonely, I miss my little Sweet Pea! Can't wait to go see Shawn! — Jackaroo —
P.S. — I almost forgot! Goodbye Maryland!

P.S. What did the Pirate get when he went Hiking?

Ge-AAARRR-diah

HA! HA! I am so very funny!!

7/24/08 Zero for today, too much rain, good magic yesterday, giant cheeseburger + three pan keeps thanks to COFFEE

4/21 If you rook to me like a dove took to the wind, I'd have jumped from high trees and I'd dance with the king of the eyesores the rest of our lives would have fared well.

Johnny Thunder

4/21 AS THE HIGHEST STARS ALL CIRCLE FOR ETERNAL HARMONY SO THE PATHS OF OUR LIVES SHOULD FOLLOW UNCONFUSED TO BE AS THEY.
— ORION

The Shins

NOT PICTURED: H3L "HIKING FUN!"
Thanks Temper John & DOC!

MAINE

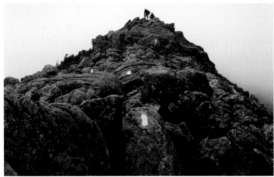

TOP: New Hampshire-Maine border; **MIDDLE:** Heading back down after summiting Katahdin; **ABOVE:** Roots, rocks, mud, and boards along AT; **RIGHT:** South Pond

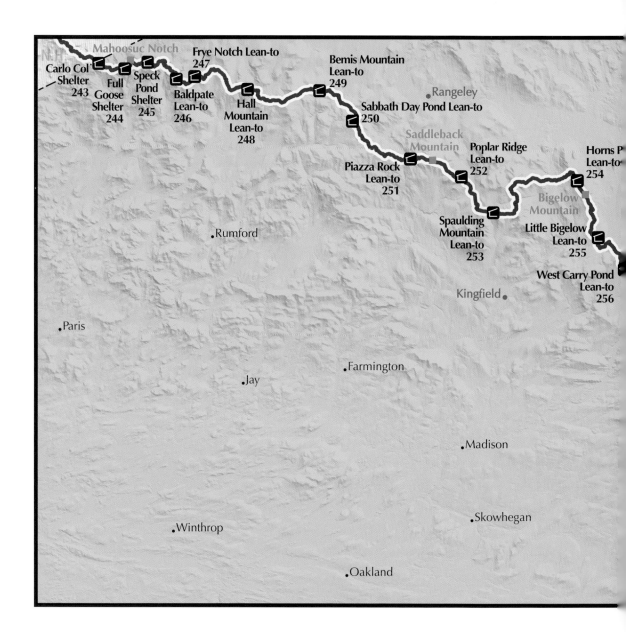

Carlo Col
Shelter
243

Full
Goose
Shelter
244

Speck
Pond
Shelter
245

Mahoosuc Notch

Frye Notch Lean-to
247

Baldpate
Lean-to
246

Hall
Mountain
Lean-to
248

Bemis Mountain
Lean-to
249

Rangeley

Sabbath Day Pond Lean-to
250

Saddleback
Mountain

Poplar Ridge
Lean-to
252

Horns P
Lean-to
254

Piazza Rock
Lean-to
251

Spaulding
Mountain
Lean-to
253

Bigelow
Mountain

Little Bigelow
Lean-to
255

West Carry Pond
Lean-to
256

Rumford

Kingfield

Paris

Farmington

Jay

Madison

Skowhegan

Winthrop

Oakland

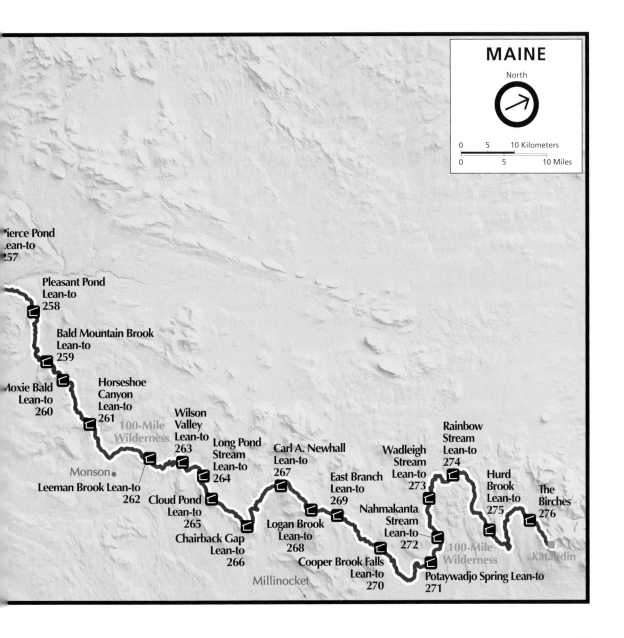

MAINE

North

0 5 10 Kilometers

0 5 10 Miles

Pierce Pond
Lean-to
257

Pleasant Pond
Lean-to
258

Bald Mountain Brook
Lean-to
259

Moxie Bald
Lean-to
260

Horseshoe
Canyon
Lean-to
261

100-Mile
Wilderness

Wilson
Valley
Lean-to
263

Long Pond
Stream
Lean-to
264

Carl A. Newhall
Lean-to
267

Wadleigh
Stream
Lean-to
273

Rainbow
Stream
Lean-to
274

Hurd
Brook
Lean-to
275

The
Birches
276

Monson

Leeman Brook Lean-to
262

Cloud Pond
Lean-to
265

Chairback Gap
Lean-to
266

Logan Brook
Lean-to
268

East Branch
Lean-to
269

Nahmakanta
Stream
Lean-to
272

100-Mile
Wilderness

Katahdin

Cooper Brook Falls
Lean-to
270

Potaywadjo Spring Lean-to
271

Millinocket

CARLO COL SHELTER AND CAMPSITE

⚲	1,910.7		
📍	0.3 mi W		
📅	1930s		
🔨	1976		
🛏	8		
💧	Spring down short trail in front of shelter; all water should be treated		
#	243	🚽	Y (composting)
📍	ME	🐻	Bear box
⛰	2,945 ft	👥	AMC

▲ The first shelter in Maine heading northbound, this is also the oldest shelter in the state. It is located south of Mount Carlo (3,565 feet) on Carlo Col Trail. There are also three small and two large tent platforms.

FULL GOOSE SHELTER AND CAMPSITE

#	244	📍	On AT	💧	Stream on trail behind shelter; all water should be treated
📍	ME	📅	1978	🚽	Y (composting)
⛰	3,030 ft	🔨	N/A	🐻	Bear box
⚲	1,915.1	🛏	8	👥	AMC

◄ This is the last shelter before the famous Mahoosuc Notch (right), known as the slowest and toughest single mile on the whole AT. There are also three small tent platforms and one large.

SPECK POND SHELTER AND CAMPSITE

245

📍 ME

⛰ 3,500 ft

⌟ 1,920.2

📍 0.1 mi W

📅 1968

🔨 2017

🛏 8

💧 Spring on blue-blazed trail to right past cooking area; all water should be treated

🚽 Y (composting)

🐻 N

👥 AMC

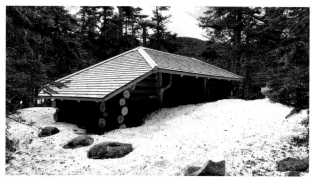

▲ Located on the Speck Pond Trail, this is the highest-elevation shelter in Maine. There is an overnight fee (currently $10 per person) and a caretaker on duty. There are also three small and three large tent platforms. Only cook stoves are allowed—no open fires. The new structure was designed by John Nininger of Vermont's Wooden House Company, who also designed Eliza Brook, Kinsman, and Garfield Shelters south on the AT in New Hampshire. He was also a member of the White Mountain Professional Trail Crew in the 1970s and helped build Carlo Col and Guyot Shelters in Maine. This shelter was built, then disassembled, delivered by tractor-trailer to a roadside staging site, and flown to the campsite, where an Appalachian Mountain Club (AMC) trail crew and backcountry caretakers worked with Nininger and his staff to reassemble it. The original shelter was also helicoptered in and stood for 49 years before being dismantled. Andy and Sue Fixman funded the new shelter in memory of their father, Marshall Fixman, a 59-year member of the AMC, avid hiker, and lover of the White Mountains and AMC huts.

BALDPATE LEAN-TO

#	246	🔨	N/A
📍	ME	🛏	8
⛰	2,645 ft	💧	Spring behind lean-to
📏	1,927.1	🚽	Y
📍	0.1 mi E	🐻	N
📅	1995	👥	MATC

▼ ▼ Located below the west peak of Baldpate Mountain (3,662 feet), this is the first shelter maintained by the Maine Appalachian Trail Club (MATC). Established in 1935, the club maintains 30 shelters and 267.2 miles of the AT from New Hampshire's Grafton Notch to Maine's Katahdin. The shelter was built by the MATC to replace the old Grafton Notch Lean-to, which was only a short walk from Highway 26. It is named for the mountain on which it is located.

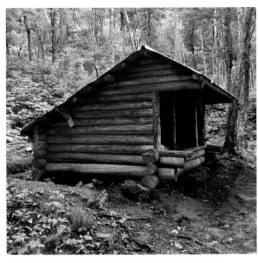

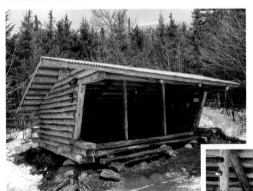

FRYE NOTCH LEAN-TO

#	247	🔨	N/A
📍	ME	🛏	6
⛰	2,280 ft	💧	Frye Brook in front of lean-to
📏	1,930.6	🚽	Y
📍	On AT	🐻	N
📅	1983	👥	MATC

▲ Located between Little Baldpate Mountain (3,442 feet) and Surplus Mountain (2,875 feet), this lean-to was built by the MATC to replace the old Frye Brook Lean-to, which was eliminated from the trail route by relocation. It is located at the head of Frye Book in a deep notch, hence the name.

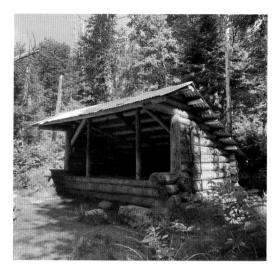

HALL MOUNTAIN LEAN-TO

#	248	🛏	6
📍	ME	💧	Spring south of lean-to on AT
⛰	2,635 ft	🚽	Y
⸰⋯	1,941.1	🐻	N
📍⋯	On AT	👥	MATC
📅	1978		
🔨	1999		

▲ Located north of Wyman Mountain (2,945 feet), this lean-to was built by the MATC to replace Squirrel Rock Lean-to, which was eliminated from the trail route by relocation. It is named for the mountain on which it is located.

BEMIS MOUNTAIN LEAN-TO

#	249	🛏	8
📍	ME	💧	Small spring to left of lean-to
⛰	2,790 ft	🚽	Y
⸰⋯	1,953.9	🐻	N
📍⋯	On AT	👥	MATC
📅	1988		
🔨	N/A		

▼ Located north of the west peak of Bemis Mountain (3,592 feet), this lean-to was built by the MATC to replace Elephant Mountain Lean-to, which was eliminated from the trail route by relocation. It is named for the mountain on which it is located.

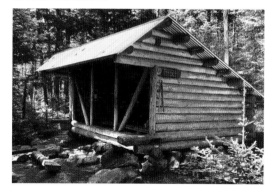

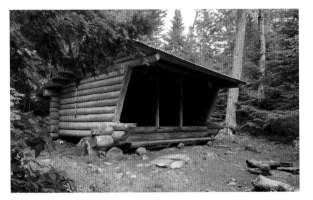

SABBATH DAY POND LEAN-TO

#	250	🔨	N/A
📍	ME	🛏	8
⛰	2,390 ft	💧	Sabbath Day Pond in front of lean-to
⸱⋯⸱	1,962.2	🚻	Y
📍	On AT	🐻	N
📅	1993	👥	MATC

▲ This lean-to was built by the MATC to replace the original shelter built by the Civilian Conservation Corps (CCC), which was located on the same site. It is named for the pond at which it is located. There is great swimming at the sand beach on Long Pond, 0.3 miles south on the AT.

PIAZZA ROCK LEAN-TO

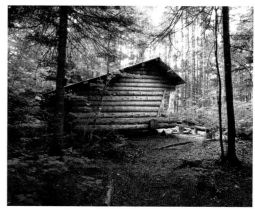

#	251	🔨	N/A
📍	ME	🛏	8
⛰	2,080 ft	💧	Stream passes through campsite
〰	1,973.4	🚽	Y
📍	On AT	🐻	N
📅	1993	👥	MATC

▶ This shelter is home of the famous "Your Move" privy, with two seats and a cribbage board between them. It is located south of Saddleback Mountain (4,120 feet), one of the highest mountains in Maine. The AT runs along the ridge of Saddleback, crossing the summits, all above tree line. Saddleback Maine, a former ski area, is located on the northwest and west slopes of the mountain. Built by MATC volunteer employees of L.L. Bean to replace the old Piazza Rock Lean-to that was located nearby, the shelter is named for the huge rock slab outcropping located on a 200-yard side trail near the shelter.

POPLAR RIDGE LEAN-TO

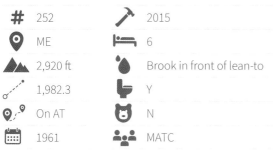

#	252	🔨	2015
📍	ME	🛏	6
⛰	2,920 ft	💧	Brook in front of lean-to
〰	1,982.3	🚽	Y
📍	On AT	🐻	N
📅	1961	👥	MATC

▶ This lean-to was built by the MATC to replace the decrepit CCC-built shelter of the same name on the same site. The old shelter was originally named Saddleback Jr. Shelter, but it was changed in the 1930s to reflect the fact that it is located on the side of Poplar Ridge. The front sill log was replaced, and the "baseball bat" sleeping platform was replaced with boards in 2015. The baseball bat style of sleeping platform used to be more common in this section of the trail. A framed picture by Dollie Rust in the shelter reads, "In memory of Geraldine 'Gerry' Largay, age 66, trail name Inchworm. She spent her last night in safety here at the Poplar Ridge Lean-to. This is the last photo taken of her, the morning she left northbound, July 22, 2013. A few hours later she went off trail for a quick break and never found her way back. A massive search and rescue effort was unsuccessful. Her remains were discovered by accident on October 14, 2015."

SPAULDING MOUNTAIN LEAN-TO

#	253	🛏	8
📍	ME	💧	Small spring to right of lean-to
⛰	3,140 ft	🚻	Y
⤴	1,990.3	🐻	N
📍	On AT	👥	MATC
📅	1989		
🔨	N/A		

▼ This lean-to is located south of Spaulding Mountain (4,010 feet). North of the lean-to, a 0.6-mile side trail leads to the summit of Sugarloaf Mountain (4,249 feet) and the abandoned summit ski hut. The lean-to was built by the MATC to replace the decrepit CCC-built shelter of the same name that was located nearby. It was named for the mountain on which it is located.

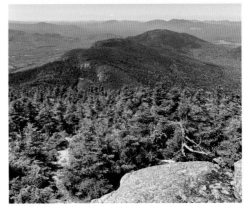

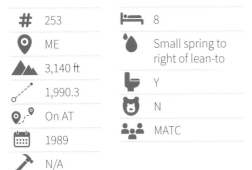

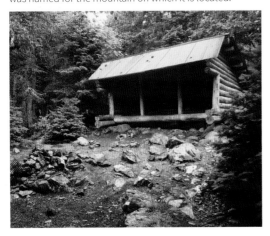

HORNS POND LEAN-TOS

#	254	🛏	16
📍	ME	💧	Horns Pond or spring (often dry) north on AT
⛰	3,160 ft		
⤴	2,008.9	🚻	Y
📍	On AT	🐻	N
📅	1998	👥	MATC
🔨	N/A		

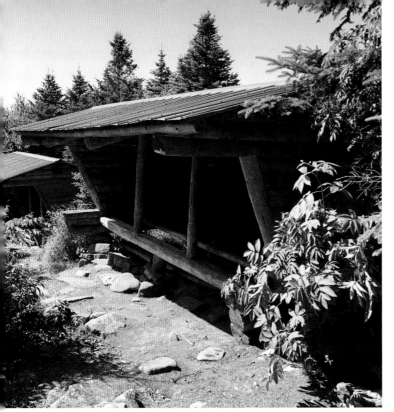

LITTLE BIGELOW LEAN-TO

 # 255

 ME

 1,760 ft

 2,019.1

On AT

1986

N/A

 8

Spring 50 yd in front of lean-to

Y

N

MATC

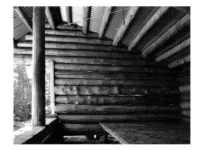

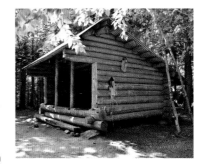

▲ ▲ ▲ There are two shelters at this location, and both sleep eight each. They were built by the MATC, which flew precut shelter logs to the site by helicopter in the summer. An MATC caretaker is in residence, and fishing is permitted at the pond near the shelter. The area can be heavily trafficked. There are also tent pads and group campsites, as well as two privies with views of Sugarloaf Mountain in the distance. An older log lean-to, built in 1936, is located at the trail junction. Instead of being torn down, it is now reserved for day use only; it does not have a floor covering the rocky ground.

▶ ▶ Located north of Bigelow Mountain (4,145 feet) and Little Bigelow Mountain (3,035 feet), this lean-to was built by the MATC to add to the shelter chain. Lots of campsites are also available, and there is good swimming along the shelter side trail. At the shelter, follow the signs for "pools." Bigelow Mountain is known as Maine's "Second Mountain" and was once saved from land developers when the state of Maine purchased 33,000 acres of wilderness preserve. The lean-to was named for the mountain on which it is located.

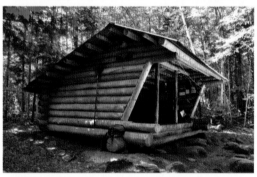

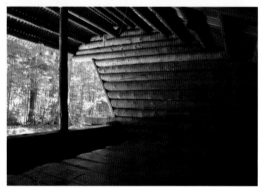

WEST CARRY POND LEAN-TO

# 256	📅 1989	🚽 Y
📍 ME	🔨 N/A	🐻 N
⛰️ 1,340 ft	🛏️ 8	👥 MATC
⸜ 2,026.8	💧 West Carry Pond or springhouse left of shelter	
📍 On AT		

◄◄◄ This shelter is located between the east and west side of West Carry Pond, which offers good swimming. It is south of the Arnold Trail to Arnold Point Beach. Built by the MATC as a replacement for the former CCC-built Jerome Brook Lean-to to better space the shelter chain, it was named for the pond where it is located.

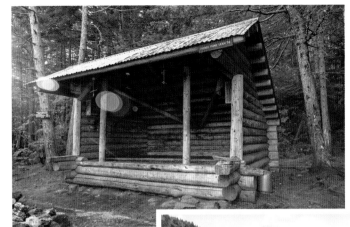

PIERCE POND LEAN-TO

257

📍 ME

🔺 1,150 ft

╱ 2,036.8

📍 On AT

📅 1970

🔨 N/A

🛏 6

💧 Pond or stream on side trail to Harrison's Pierce Pond Camps

🚽 Y (moldering)

🐻 N

👥 MATC

▲ ▶ This lean-to was built by the MATC to replace the original CCC-built shelter and named for the pond in front of it. It is the last shelter before the Kennebec River Ferry. The river can rise to dangerous levels unexpectedly from the dam upstream. In 1985, northbound hiker Alice H. Ference drowned while attempting to ford it. In response, the Appalachian Trail Conservancy (ATC) and MATC established the ferry as the official AT route and hired the operators. Steve Longley operated it for 20 years, David Corrigan (pictured) operated it from 2007 to 2016, and Greg Caruso took over in 2016. Craig Dickstein, an MATC volunteer, manages it when the ferryman has a day off. The service has shuttled more than 22,000 hikers safely across the dangerous river by canoe since it started. It originally cost $10, but hikers were still attempting to cross, so it was changed to free. Hikers are strongly encouraged to use the service. A hiker drowned as recently as May 2018 trying to cross. During the regular ferry season, hours and dates are posted at this shelter. Swimming is available in the pond nearby. It is advised to always use the buddy system when swimming in Maine ponds. Many can have 40-degree "cells" underwater that can be dangerous. A 20-year-old thru-hiker drowned in 2012 when caught by one of those cells.

PLEASANT POND LEAN-TO

#	258	🔨	1991
📍	ME	🛏	6
⛰	1,320 ft	💧	Small brook crossed on trail to lean-to or pond
⟋	2,046.5		
📍	On AT	🚽	Y
📅	1958	🐻	N
		👥	MATC

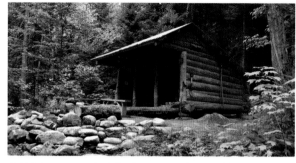

▲ This lean-to was built by the MATC and named for Pleasant Pond. There is a sandy beach 0.2 miles from the shelter.

BALD MOUNTAIN BROOK LEAN-TO

#	259	🔨	N/A
📍	ME	🛏	8
⛰	1,280 ft	💧	Bald Mountain Brook in front of lean-to
⟋	2,055.5		
📍	0.1 mi E	🚽	Y
📅	1994	🐻	N
		👥	MATC

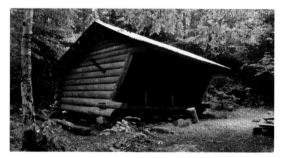

▲ This shelter, named for the brook that flows nearby, was built by the MATC to replace Joe's Hole Lean-to, which was placed in a very poor location.

MOXIE BALD LEAN-TO

#	260	📍	On AT	💧	Nearby stream or Bald Mountain Pond in front of shelter
📍	ME	📅	1958		
⛰	1,220 ft	🔨	1991	🚽	Y
⟋	2,059.6	🛏	6	🐻	N
				👥	MATC

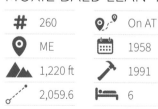

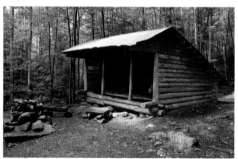

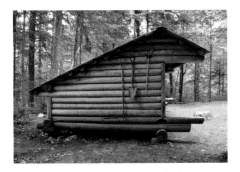

HORSESHOE CANYON LEAN-TO

# 261	📅 1991	🚻 Y
📍 ME	🔨 N/A	🐻 N
⛰ 880 ft	🛏 8	👥 MATC
⊶ 2,068.5	💧 Spring at junction or river in front of and below lean-to	
📍 On AT		

▲ Located on a blue-blazed trail, this lean-to is south on the trail from the East Branch of the Piscataquis River. It was built by the MATC and named for a gorge on the West Branch just downhill. The crossing of the West Branch south of the lean-to can be dangerous, although this ford is not especially risky if a hiker crosses Bald Mountain Stream and the West Branch separately, above their confluence.

◀▲ This lean-to is located south of Moxie Bald Mountain (2,629 feet) and the West Branch of the Piscataquis River, a knee-deep ford that can become very dangerous during high water. Do not attempt to cross after heavy rains. It was built by the MATC on the shore of Bald Mountain Pond and named for the mountain at whose base it is located. The original CCC-built lean-to burned in 1946. Moose frequent the surrounding area.

LEEMAN BROOK LEAN-TO

#	262	🔨	N/A
📍	ME	🛏	6
⛰	1,060 ft	💧	Stream in front of lean-to
⟋	2,080.5	🚽	Y
📍	On AT	🐻	N
📅	1987	👥	MATC

▼ This lean-to, named for the brook that flows in front of it, was built by the MATC to replace Old Stage Road Lean-to, which was abandoned after a relocation of the trail. It is the first shelter located in the 100-Mile Wilderness, an informally named section that runs from Monson to Abol Bridge just south of Baxter State Park. It is a small corridor of protected wilderness surrounded by large tracts of public and private land controlled by private land-management companies, family ownerships, the AMC, the Nature Conservancy, and the state of Maine. Never a totally remote section of the AT, it is crossed by several logging roads. An MATC sign upon entering the section reads, "There are no places to obtain supplies or get help until Abol Bridge 100 miles north. Do not attempt this section unless you have a minimum of 10 days supplies and are fully equipped. This is the longest wilderness section of the entire AT and its difficulty should not be underestimated. Good hiking!"

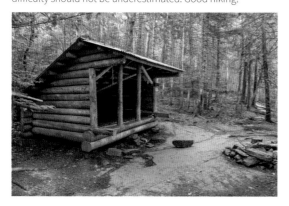

WILSON VALLEY LEAN-TO

#	263	🛏	6
📍	ME	💧	Small spring in front of shelter on opposite side of AT
⛰	1,000 ft		
⟋	2,087.9		
📍	On AT	🚽	Y
📅	1993	🐻	N
🔨	N/A	👥	MATC

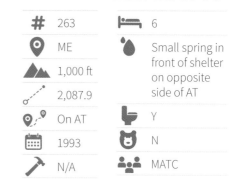

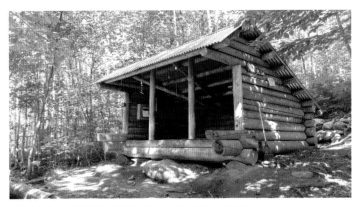

LONG POND STREAM LEAN-TO

#	264	📍	On AT	💧	Small stream next to lean-to
📍	ME	📅	1991	🚽	Y
⛰	930 ft	🔨	N/A	🐻	N
↗	2,092.6	🛏	8	👥	MATC

▲ This lean-to, named for the stream, was built by the MATC to replace the old Long Pond Stream Lean-to, which was detoured by relocation. Scenic Slugundy Gorge and Falls are located 0.1 miles south on the AT. Swimming is allowed.

▲▶ This lean-to is located north of the two fords of Little Wilson Stream (750 feet) and Big Wilson Stream (600 feet). A major railroad runs not far downhill from the shelter, between it and Big Wilson Stream. It was built by the MATC and named for the valley of Big Wilson Stream, in which it is located.

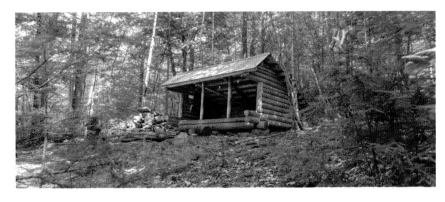

CLOUD POND LEAN-TO

#	265	0.4 mi E		Cloud Pond in front of shelter or spring north of side trail to lean-to	Y	▼ ▼ Built by the MATC to replace a shelter built by owners of cabins on Lake Onawa in the 1940s and named for the pond, this lean-to is located north of Barren Mountain (2,670 feet).	
ME	1992				N		
2,420 ft	N/A				MATC		
2,096.6	6						

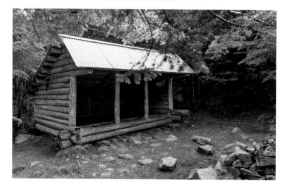

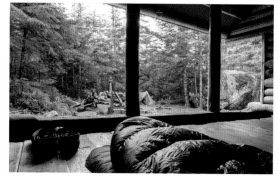

CHAIRBACK GAP LEAN-TO

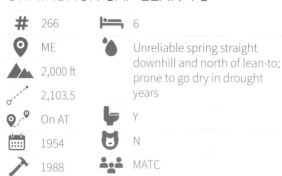

#	266	🛏	6
📍	ME	💧	Unreliable spring straight downhill and north of lean-to; prone to go dry in drought years
⛰	2,000 ft		
⟋	2,103.5		
📍	On AT	🚽	Y
📅	1954	🐻	N
🔨	1988	👥	MATC

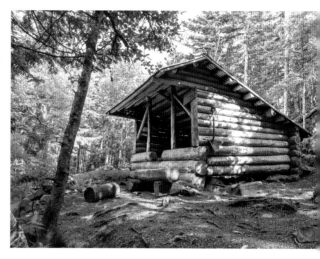

▶ This is one of the oldest shelters in Maine. Located south of Chairback Mountain (2,219 feet), it was built by the MATC in a pass between Chairback and Columbus Mountains.

CARL A. NEWHALL LEAN-TO

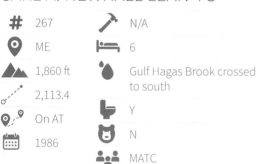

#	267	🔨	N/A
📍	ME	🛏	6
⛰	1,860 ft	💧	Gulf Hagas Brook crossed to south
⟋	2,113.4		
📍	On AT	🚽	Y
📅	1986	🐻	N
		👥	MATC

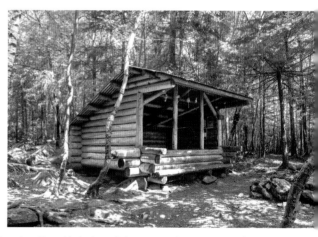

▶ Built by the MATC to replace White Brook Lean-to, bypassed by relocation, this is the only lean-to on the AT in Maine that is named for an individual. Carl Newhall led the MATC shelter-building program through the 1970s and early 1980s. It is located north of the Gulf Hagas Trail, which leads to a 500-foot-deep canyon carved over time by water that includes many beautiful waterfalls. Gulf Hagas, a 3-mile-long slate gorge carved by the West Branch of the Pleasant River, is often called the "Grand Canyon of the East." Screw Auger Falls is 0.2 miles from the AT. The Rim Trail passes through The Hermitage, a protected area and national landmark owned by The Nature Conservancy. The Hermitage is one of the few last stands of virgin old-growth forest in New England. Giant white pines can be found in the area, as well as eastern hemlock and balsam fir.

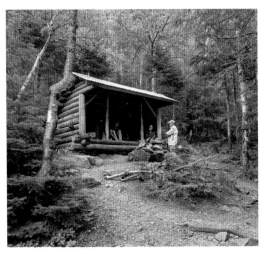

LOGAN BROOK LEAN-TO

#	268	🛏	6
📍	ME	💧	Logan Brook behind lean-to; cascades are farther upstream
⛰	2,480 ft		
⊶	2,120.6	🚻	Y
📍	On AT	🐻	N
📅	1983	👥	MATC
🔨	N/A		

▲ Located north of White Cap Mountain (3,654 feet), with views of Katahdin, this lean-to was built by the MATC to replace White Cap Mountain Lean-to, bypassed by a relocation. It is named for the brook in front of the shelter.

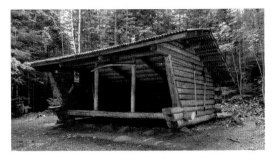

EAST BRANCH LEAN-TO

#	269	🔨	N/A
📍	ME	🛏	8
⛰	1,225 ft	💧	East Branch Pleasant River in front of lean-to
⊶	2,124.2		
📍	On AT	🚻	Y
📅	1996	🐻	N
		👥	MATC

▲▼ Located south of the East Branch Pleasant River, this shelter was built by the MATC to replace East Branch Tote Road Lean-to, bypassed by a relocation. It is named for the nearby river.

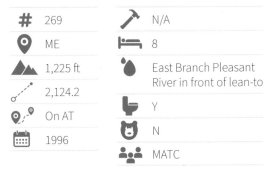

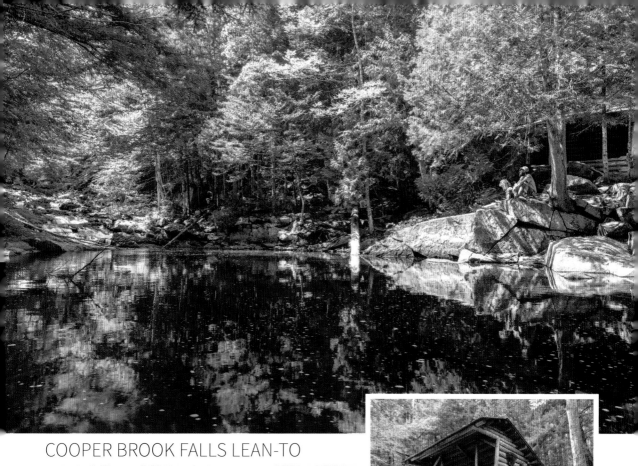

COOPER BROOK FALLS LEAN-TO

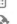 270

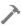 ME

 880 ft

2,132.3

 On AT

1956

1985

6

Cooper Brook in front of lean-to

Y

N

MATC

 ▲ ▶ This lean-to was built by the MATC and named for the falls in front of it. A tentsite is also available. The waterfront location has numerous pools and falls. A good swimming hole and cascades are located immediately upstream from the water source.

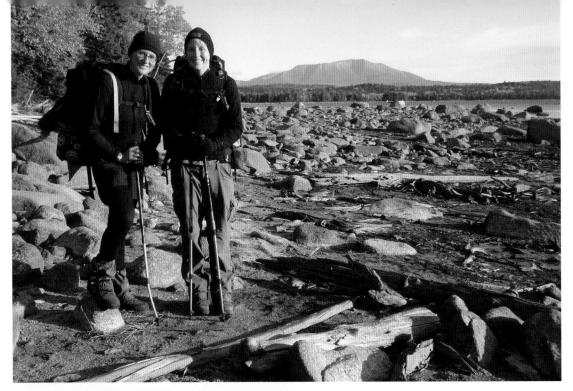

POTAYWADJO SPRING LEAN-TO

#	271	**🛏**	8
📍	ME	**💧**	Bubbling Potaywadjo Spring, 15 ft in diameter, to right of lean-to
⛰	710 ft		
⋰	2,143.7	**🚽**	Y
📍	On AT	**🐻**	N
📅	1995	**👥**	MATC
🔨	N/A		

▲ Located south of Pemadumcook Lake, which has a great view of Katahdin from its rocky beach, this lean-to was built by the MATC volunteers of L.L. Bean, who maintain this section of the AT. It was named for the extraordinary spring nearby.

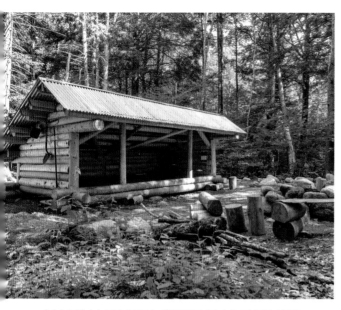

NAHMAKANTA STREAM LEAN-TO

#	272	🔨	N/A
📍	ME	🛏️	8
⛰️	600 ft	💧	Stream in front of lean-to
➚	2,148	🚽	Y
📍	On AT	🐻	N
📅	2017	👥	MATC

▲ The newest shelter in Maine built by the MATC and one of the newest shelters on the entire AT, this lean-to is also the lowest-elevation shelter in the state. It is located between Nahmakanta Stream and Nahmakanta Lake.

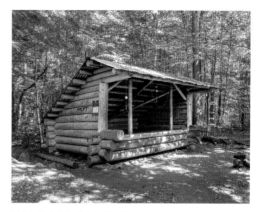

WADLEIGH STREAM LEAN-TO

#	273	🛏️	6
📍	ME	💧	Spring at beach at Nahmakanta Lake
⛰️	685 ft	🚽	Y
➚	2,153.8	🐻	N
📍	On AT	👥	MATC
📅	1981		
🔨	N/A		

▲ Located north of Wadleigh Stream (680 feet) and a sandy beach at the south end of Nahmakanta Lake, this lean-to was built by the MATC and named for the nearby stream.

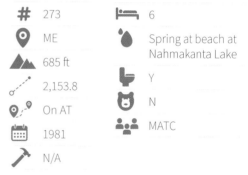

RAINBOW STREAM LEAN-TO

#	274	🔨	1987
📍	ME	🛏	6
⛰	1,020 ft	💧	Rainbow Stream in front of lean-to
⊶	2,161.9	🚽	Y
📍	On AT	🐻	N
📅	1971	👥	MATC

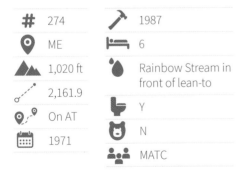

▶ This shelter was built by the MATC and named for the stream in front of it. A hammock and tent spots are available above and behind the shelter. There is also a carved totem pole at the site.

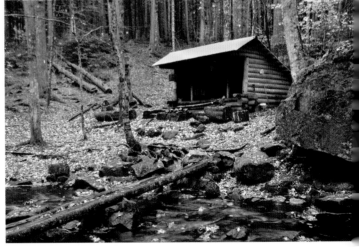

HURD BROOK LEAN-TO

275

📍 ME

⛰ 710 ft

↗ 2,173.4

📍📍 On AT

📅 1959

🔨 1975

🛏 6

💧 Hurd Brook

🚻 Y

🐻 N

👥 MATC

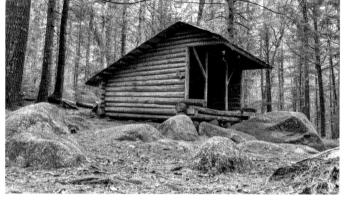

◀▶ Built by the MATC and named for the nearby brook, this is the last shelter before Abol Bridge, the end of the 100-Mile Wilderness, and Baxter State Park, home of the northern terminus of the AT and Katahdin. It is also one of the last shelters in Maine with the "baseball bat" style of sleeping platform that used to be common throughout the state. The platform is constructed of two- to three-inch-thick pine logs placed side by side. The ford of nearby Hurd Brook can be dangerous and swift in high water; use caution.

THE BIRCHES

276

📍 ME

⛰ 1,070 ft

↗ 2,186

📍📍 0.1 mi E

📅 2002

🔨 N/A

🛏 8

💧 Katahdin Stream in front of rangers cabin

🚻 Y

🐻 Bear cable

👥 Baxter State Park

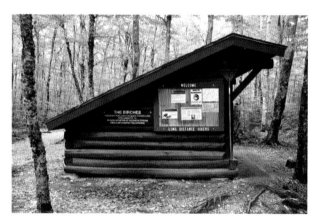

▶ Built to replace Daicey Pond Shelters, these shelters are limited to long-distance hikers who have hiked at least 100 contiguous miles, up to and including entering Baxter State Park. Only northbound AT hikers, starting at least as far back as Monson, are allowed to stay at the shelters. Southbounders and flip-floppers need to make reservations elsewhere in the park. There are two shelters that sleep four each. Additional tenting for four is available ($10 per person) at nearby Katahdin Stream Campground. There is a one-night maximum, and there is no water at the shelters. These are the last shelters passed before summiting Katahdin (5,267 feet), the highest mountain in Maine and the northern terminus of the AT. Katahdin, which means "the greatest mountain," was named by the Penobscot Native Americans.

LEAVE NO TRACE

With an estimated three to four million visitors a year, the impact of hikers can take its toll on the beloved AT. Since 1994, the nonprofit Leave No Trace Center for Outdoor Ethics, an ATC partner, has existed to educate and promote conservation ethics in the outdoors. The Leave No Trace principles are a set of outdoor ethical guidelines that help prevent and minimize recreational impact on nature. These seven values have been adapted to different activities, ecosystems, and environments around the world:

1. Plan ahead and prepare.
2. Travel and camp on durable surfaces.
3. Dispose of waste properly.
4. Leave what you find.
5. Minimize campfire impacts.
6. Respect wildlife.
7. Be considerate of other visitors.

Staying at shelters on the AT reduces hiker impact on the trail by concentrating use in a relatively small area while other areas stay

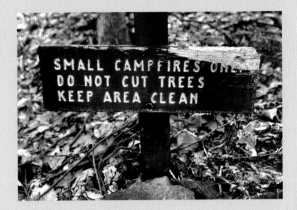

pristine. To reduce social impacts, hikers are advised to not travel in groups larger than 10. When traveling in a group of more than five, hikers are encouraged to avoid staying in shelters, leaving them for lone hikers and smaller groups.

Vandalism to these structures, many of them historic, is always a sad sight to see. Hikers spend such short periods of time in these places, yet their markings can last forever. It is prohibited to "tag" shelters, signs, or trees with graffiti or carvings. If hikers must leave a memento, they can do so in a shelter's trail register.

Hikers are urged to carry out all trash, but unfortunately, certain items like unburied toilet paper continues to be a problem. All human waste, pet waste, and toilet paper must be deposited in

LEFT: Curley Maple Gap Shelter, Tennessee
ABOVE: Tom Floyd Wayside, Virginia
RIGHT: Mount Moosilauke, New Hampshire

WASHPIT

WASHPIT

- PLEASE WASH AND RINSE YOUR DISHES HERE; NOT AT THE WATER SOURCE

- PACK OUT ANY FOOD SCRAPS LEFT ON SCREEN

- PLEASE AVOID SOAP

THANK YOU

privies; buried in a six- to eight-inch-deep hole away from the trail and at least 200 feet from shelters, campsites, and water sources; or carried out. Dishes should be washed at least 200 feet away from water sources, shelters, and campsites; food scraps should be packed out; and strained dishwater should be dispersed broadly (unless a wash pit or "sump" is provided for depositing the strained dishwater).

As the trail continues to evolve and more hikers continue to use it, the basic Leave No Trace principles are more important than ever.

With a conscious and committed effort, hikers can use hiking and camping techniques that minimize impact. Everyone must do their part and encourage others to do the same in protecting and conserving this national treasure for future generations. More information can be found at appalachiantrail.org/LNT.

OPPOSITE, LEFT: Little Rock Pond Shelter, Vermont

OPPOSITE, TOP: Trapper John Shelter, New Hampshire

OPPOSITE, BOTTOM: Calf Mountain Shelter, Virginia

RIGHT: Garfield Ridge Shelter, New Hampshire

BELOW: Hogback Ridge Shelter, North Carolina

October 2011

Welcome to the new Garfield Ridge Shelter.

We put a lot of long days, weeks, and months into building it and are proud of it. Each log was chosen for its beauty and notched by hand. The heaviest logs weighed 400 pounds and moving them was hard work.

Please respect our efforts and think twice, or three times, before carving or writing on its beautiful walls.

We'd like Garfield to look this good for the decades and thousands of visitors to come.

THANK YOU
- Garfield Ridge Construction Crew.

SHELTER GRAVEYARD

The term "ghost shelters" refers to structures that once existed on the AT but are no longer there. These shelters were recorded at some point in guidebooks and early documents, were photographed, or left a paper trail. It is impossible to compile a comprehensive list of these structures, since many crude backcountry shelters came and went and many were never recorded. Countless shelters have disappeared over the trail's lifetime. Some were abandoned to reroutes; others fell into disrepair or were dismantled, removed for various reasons, or burned in place.

All of these former shelters have stories to tell that could easily fill another book. Earl Shaffer Shelter, for example, was constructed by Shaffer sometime between 1959 and 1961 in Pennsylvania. The first person to report a thru-hike of the AT, Shaffer asked that his name be taken off the

shelter in 1983 because he felt it had become "too fancy" after a wooden floor replaced the old dirt floor. One of a half-dozen shelters built by Shaffer, it was the last one standing on the AT when it was removed in 2008. Honoring the 60th anniversary of Shaffer's famous 1948 thru-hike, the shelter was dismantled by 40 local volunteers and reassembled inside the Appalachian Trail Museum in nearby Pine Grove Furnace State Park. The two-story Peters Mountain Shelter now stands nearby.

Earl Shaffer Shelter now resides in the Appalachian Trail Museum in Pennsylvania's Pine Grove Furnace State Park.

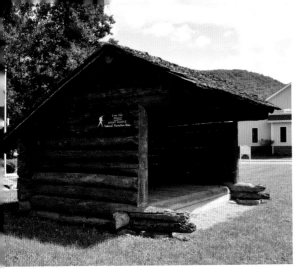

ABOVE, LEFT: Deep Gap Shelter was removed from the trail in 1992. It is now on display in the trail town of Damascus, Virginia, home of the famous Trail Days.

ABOVE, RIGHT: White Brook Lean-to in Maine was abandoned by a trail relocation in 1975. It continues to sit at its original location, now off the AT.

RIGHT: White Brook Lean-to is shown on its completion day in 1954.

BELOW, LEFT: Apple House Shelter in North Carolina was dismantled in 2012 because its location was too close to a busy road.

BELOW, RIGHT: Watauga Lake Shelter was removed in 2019 due to heavy bear activity, despite being closed for years to hikers.

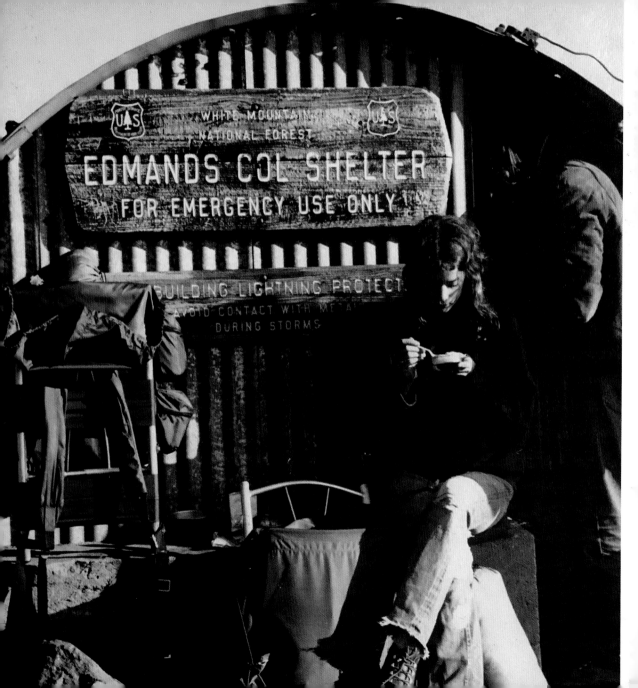

OPPOSITE: Built after World War II, Edmands Col Shelter once sat high in the White Mountains of New Hampshire but was eventually removed. Edmands Col, between Mounts Jefferson and Adams, is directly on the AT. The shelter was within 50 feet of the trail, as it was designed to be an easily found refuge from storms rather than a camping site.

TOP, LEFT: Located in Great Smoky Mountains National Park, Little Indian Gap Shelter was built near what is now known as Indian Gap.

TOP, RIGHT: Antietam Shelter was one of the older shelters remaining in Pennsylvania. In 2019, it was removed and relocated as a display in nearby Cowans Gap State Park.

LEFT: Three Springs Lean-to was located in northern Virginia on a stretch of the AT just north of FEMA's Mount Weather Emergency Operations Center. It was torn down in the late 1970s, when the trail was relocated away from the site.

BELOW: The Civilian Conservation Corps built Raccoon Run Shelters in Pennsylvania's Michaux State Forest in 1934. The shelters were maintained by the PATC, but they were torn down in the 1980s when the AT was relocated away from its current route. They were among many shelters too close to a road and often frequented by nonhikers. Myron Avery and his famous measuring wheel are pictured.

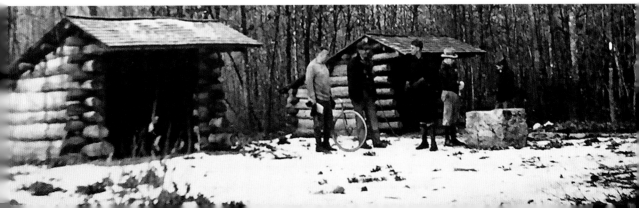

PHOTOGRAPHY CREDITS

All images taken by Sarah Jones Decker (sarahjonesdecker.com), except for the following:

Courtesy of Appalachian Trail Conservancy: pp. 17, 18, 19, 20, 22, 25, 298, 299 (all except top right), and all maps.

© **Tom Banks:** p. 37 (left).
© **Amelia "Treeline" Cary:** pp. 210 (top left), 213 (bottom), 222 (bottom), 224 (top), and 237.
© **Louis Chorzempa:** p. 297 (top right).

© **Morgan Decker:** p. 14.
© **Erin Paul Donovan (scenicnh.com):** pp. 249 (left), 256 (top), 257, and 260 (left).
© **drewthehobbit / Shutterstock. com:** pp. 226 (top) and 243.
© **David Field:** p. 171 (top).

© **Marie Forcier:** p. 301.

© **James Fraumeni:** pp. 261 and 270 (top).

© **Melissa "Click!" Goodwin (melissagoodwinphotography. com):** pp. 43 (bottom), 81 (bottom), 84 (bottom right), 86 (top), 93 (bottom), 99 (top), 118–119, 130 (top), 159 (top), 167 (bottom), 172 (top left), 181 (top left), 183 (top left and bottom left), 187 (bottom), 189 (both), 206 (bottom), 209 (right), 233 (top left and top right), 255 (top), 267, 279 (top), 282 (both), 283 (both), 284 (bottom left and right), 285 (both), 286 (all), 287 (both), 288 (bottom), 289 (both), 290 (top), 291 (top), 297 (bottom left), 299 (top right), and 303.

© **Carl Herz:** p. 256 (bottom left and bottom right).

© **Emma "Sprout" Hileman:** pp. 57 (left), 66, 224 (bottom), and 227 (right).

© **Henry Horn:** p. 168.

© **Steven McBride (stevenmcbride.com):** pp. 6–7, 90 (both), 91 (top), and 92 (bottom).

© **Jake "Shaggy" McCambley:** pp. 230, 234 (top), and 294 (left).

© **Susan Jones Moore:** p. 8.

© **Diana "Bigglesworth" Niland:** pp. 239 (left), 275 (top), and 276 (bottom left).

© **Joshua Niven (joshuaniven. com):** pp. 86 (middle), 218 (bottom), 253 (top), 271 (left), 284 (top), and 300.

© **Steve "Miner Hiker" Oliphant:** p. 56 (bottom).

© **Kris "Scout" Powers:** pp. 10, 87, 135, 170, and 254 (bottom left).

Courtesy of Randolph Mountain Club/Guy Shorey: p. 11 (top).

© **Jeff "Powder River" Sellenrick:** p. 130 (bottom).

© **Marie "Bobwhite" Sellenrick (groundbirdgear.com):** p. 110 (top).

© **Richella Simard (richellasimard.com):** pp. 241 (middle row, left), 251 (bottom), 254 (top left), 271 (right), 273 (left), 274 (top), and 295 (left).

© **Richella Simard & Marie Forcier:** pp. 247 (bottom), 249 (right), and 272 (bottom left and right).

© **Hollis Smith:** p. 169 (right).

© **Mark "Gandalf" St. John:** pp. 11 (bottom), 56 (top), 127 (top), and 251 (top).

© **Jon "Chestnut" Taylor:** pp. 28, 252 (bottom), 254 (top right), 259 (bottom right), and 274 (bottom).

Courtesy of USFS / Becky Bruce-Vaughters: p. 203.

© **MarkVanDykePhotography / Shutterstock.com:** p. 133.

© **Dick Welsh:** p. 297 (middle).

© **Mike "Sketch" Wurman (asketchandaprayer.com):** pp. 223 (bottom), 227 (left), 233 (bottom left), 235 (bottom), 246 (top left), 252 (top), 258 (both), 259 (left), 270 (bottom left), 272 (top), 275 (bottom), and 278 (top left).

© **Tara "Morning Moose" Zabriskie (mooseyproductions.com):** pp. 33 (bottom), 128 (both), 129 (both), 131, 132 (top right), 137 (all), 138 (all), 142 (bottom), and 241 (top row, middle).

ACKNOWLEDGMENTS

A huge THANK YOU to:

My husband, Morgan, and our daughter, Josephine. You are my everything.

My grandparents, Clint and Ellen Jones, for being my forever heroes.

My family. All of them.

My '08 trail family and my hiking partner, Kris "Scout" Powers. What a long, strange trip it was.

Ingrid Shwaiko, for her awesome design skills and the creation of the shelter icon system that really made this book.

My trail besties, Tara "Morning Moose" Zabriskie, Emma "Sprout" Hileman, and Melissa "Click!" Goodwin, for meeting me all over the trail to hike, take pictures, and laugh through *all* the challenges of this project.

My local hiking buddy, Katherine "Side Trail" Bender, for always showing up. We do it for the vistas. And the tacos.

All of my photographer friends who hit the trail for this project and helped make it a reality: Tom Banks, Amelia "Treeline" Cary, Marie Forcier, James Fraumeni, Steven McBride, Jake McCambley, Diana "Bigglesworth" Niland, Richella Simard, Jon "Chestnut" Taylor, and Mike "Sketch" Wurman. I could not have done it without your energy, support, and talent. And all the photographers who submitted work for this project, including Erin Paul Donovan, Joshua Niven, Jeff "Powder River"

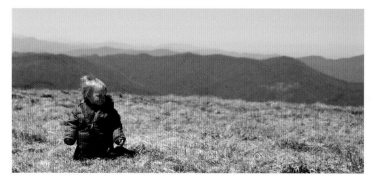

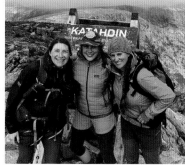

Sellenrick, Marie "Bobwhite" Sellenrick, and Mark "Gandalf" St. John.

All my friends and family who joined me for hikes: Julia Ostermann, Kris Moon, Paul Moon, Justin "Wolverine" Spitzer, Wendy Wright, Sarah Murphy, Desi Schwartz, Jeanette Biczel, Brenda Biczel, Janet Lake, Doni Lucas, Dave Jones, Sandy Jones, Erica Gassmann, Rose Nelson, Lisa Cutshall, and Shawn Zabriskie.

All of my grad school professors for pushing me to find my style behind the lens. Steve Mosch for introducing me to my art heroes, Bernd and Hilla Becher, whose work continues to inspire my process and photography.

Brian King, Laurie Potteiger, all the trail clubs, and Mills "Granddaddy Spartan" Kelly, for helping me get it right.

Jim Muschett and Rizzoli International Publications, for believing in and supporting this huge idea, and Lori S. Malkin for figuring out this puzzle and making it all make sense visually.

The ATC, trail clubs, volunteers, caretakers, rangers, ridgerunners, and all of the protectors of the AT. Thank you for making it possible.

★　★　★　★　★ LOVE LIFE ★　★　★　★　★

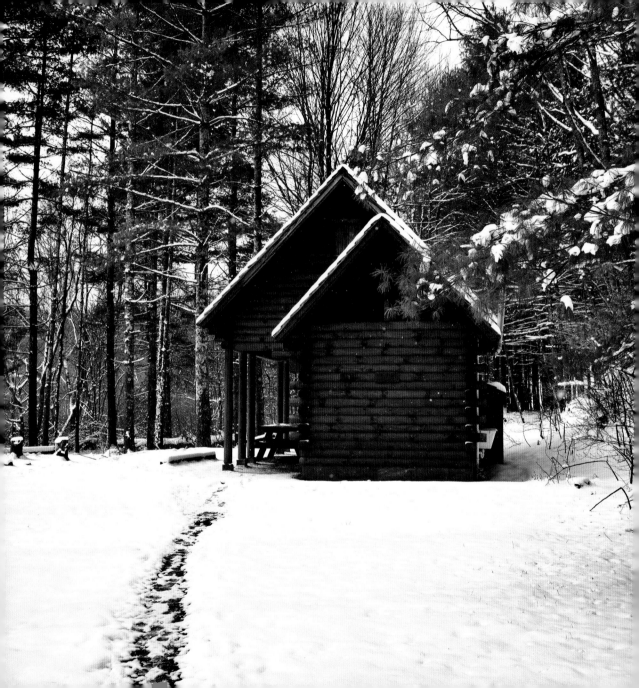